731.75
741

Publisher: Marc Parent

Editorial Director: Anne Zweibaum

Editorial Assistant: Soline Massot

Art Direction: Christian Kirk-Jensen / Danish Pastry

Picture Research: Megakles Rogakos

Copy-editor: Bernard Wooding & Marie-Paule Rochelois

Photoengraving & Printing:
Musumeci Industrie Grafiche S.p.A.

© FINEST S.A / EDITIONS PIERRE TERRAIL, PARIS 2002
25, rue Ginoux 75015 Paris - France

ISBN: 2-87939-252-7

Printed in Italy

art tomorrow

edward lucie-smith

TERRAIL

···❖ chapter one
art for the 21st century page 6

···❖ chapter two
museums and public spaces page 26

···❖ chapter three
the heritage of pop page 48

···❖ chapter four
representation of reality page 76

···❖ chapter five
looking at the past page 108

···❖ chapter six
the politics of shock page 162

···❖ chapter seven
the body and identity page 184

···❖ chapter eight
art and science page 216

···❖ chapter nine
new geography page 246

+ index page 266

art for the 21st century

chapter one ····▶

1 Jeff Koons, *Lips*, 2000.
Oil on canvas (Unfinished) 300 x 430 cm

2+3 Fabrizio Plessi, *Waterfire*, 2001.
Video installation: 15 digital images on led
displays and computers 15 x (64 x 144 pixel)

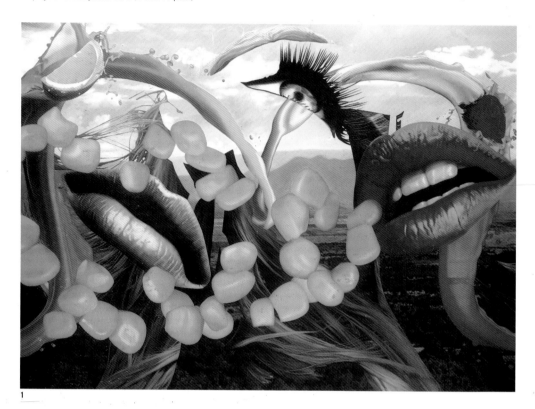

1

The purpose of this book is both modest and ambitious. Modest, because it aims to offer a guide, couched in simple terms, to the latest developments in art, relying on facts rather than grand theories. Ambitious, because it aims to relate these facts to broad tendencies in society – tendencies that the art world either embraces with indiscriminate and sometimes ignorant fervour or that it tries to ignore altogether when they prove to be inconvenient. In addition, it will attempt to explode a few entrenched myths, both about the use of the adjective 'contemporary' when applied to the visual arts and about the concept of an 'avant-garde'.

By examining these issues, I hope to arrive at a few predictions about how art might develop in the future. Because this book is concerned with the future as much as with the past, it does not look much further back than 1990. One great weakness of many recent texts on contemporary art has been their paradoxical insistence on clinging to what is no longer new. Pop Art is now a historical phenomenon, though still a very influential one. Andy Warhol (1928–1987), still celebrated by many as an artist of the present moment, died as long ago as 1987. Since his demise many things have happened in art. Nevertheless the Pop sensibility lives on because it is now so closely integrated with modern urban culture. Recent paintings by Jeff Koons (b. 1955) are examples of this – they could just as easily have been made in the 1960s, the first heyday of the style.

Nevertheless, many things have changed. Perhaps the first thing that needs to be examined in order to understand these developments is the relationship between contemporary art and official institutions. Since the first public appearance of the Modern Movement – the irruption of the artists of the Fauve group into the Salon des Indépendants of 1905 – the perception has been that contemporary art and the great mass of society surrounding it are always and irrevocably opposed; that progressive art protests against the sensibility of a complacent bourgeoisie; and that official institutions exclude or persecute experimental artists.

One cannot plausibly make that claim today. Since the middle of the 20th century there has been a huge growth of events that celebrate contemporary art and make it available to a mass public. These include the venerable Venice Biennale, which, after undergoing numerous transformations in response to whatever was the Italian political situation of the day, has re-emerged as a major forum for the exchange of artistic ideas. Equally important have been the series of Documenta exhibitions held in Kassel. Documenta was originally founded to mark Germany's renunciation of Fascist hostility to Modernism, but also to demonstrate the difference between the culture of the west and that of regions under Soviet domination. Kassel itself lies very close to the frontier that once divided the Federal Republic from the DDR. To these one must add the São Paulo Bienial, which was founded in 1957 and has made a wide range of contemporary art available to Latin American audiences, together with more recent enterprises such as the biennials in Havana and Istanbul.

Fabrizio Plessi's installation in the Piazza San Marco, created for the Venice Biennale of 2001, was a good example of the way in which these exhibitions now offer leading artists the chance to make spectacular gestures of a

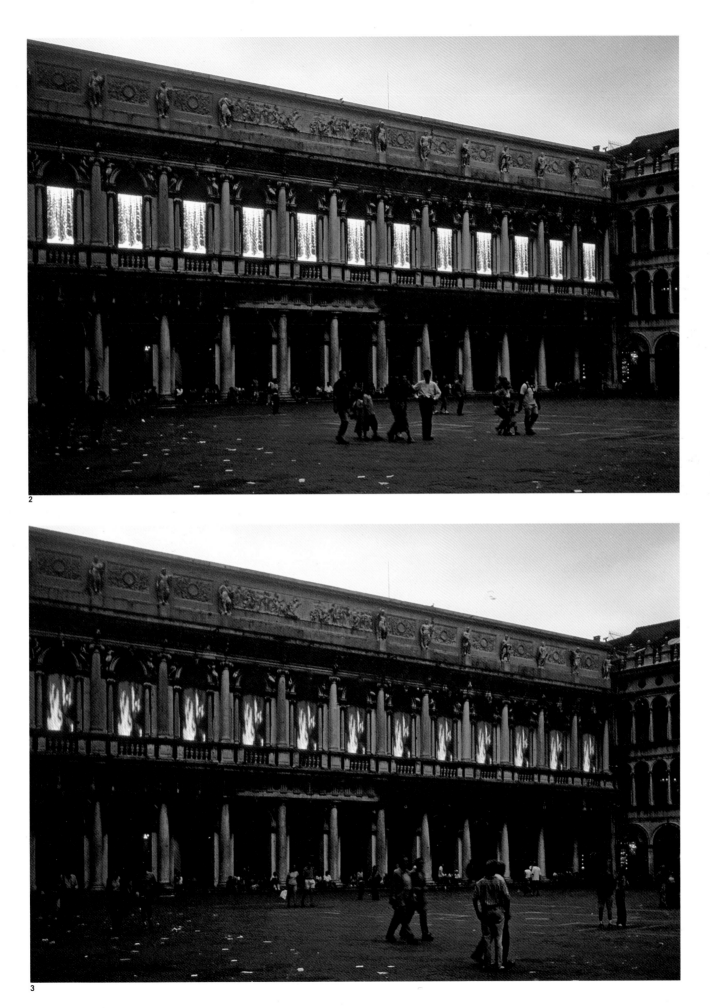

2

3

4

4 Tania Bruguera,
Untitled, 2000.
Installation

semi-official sort. Similarly, Tania Bruguera's (b. 1968) installation for the Havana Biennial of 2000 demonstrated the way in which a political regime very different from the one prevailing in Italy can find profit in allying itself to contemporary art. The biennial exhibitions in Cuba have played a major role in establishing the island as a major cultural centre, despite the diplomatic isolation imposed on Castro's government.

Even more striking has been the growth of museums, both in number and size – one thinks here of architectural triumphs such as Frank Gehry's Guggenheim Museum in Bilbao and Tate Modern in London, designed by Herzog and de Meuron. The popularity of these institutions, and their capacity to attract huge numbers of visitors, indicate that the contemporary visual arts occupy an increasingly central position in our society. This impression is reinforced

by the widespread publicity given to major art prizes, such as the Turner Prize in England or the Hugo Boss Prize in the United States.

In addition to examining the relationship between contemporary art and official institutions, it is important to look at its relationship to geography, and also to politics, both regional and global. It is often said, for example, that contemporary art has 'globalised' itself – that it is now a universal currency. At the same time, somewhat in contradiction to this, certain regions or cities are named as being especially important for the development of art. Paris was the undisputed capital of the visual arts until World War II. The hegemony subsequently passed to New York. Some people still see New York as the place where all new enterprises in artistic creation have to be validated, while others think this centrality is now passing to London. Others still say that modern means of communication have rendered the idea of a single, dominant creative centre obsolete.

Looking at the idea of globalisation within a historical and political context, rather than a purely technological one, may lead to depressing conclusions. During the first half of the 20th century, committed Modernists always claimed that their ideas were universally valid. It was nevertheless true to say that, in practical terms, these concepts did not have an unlimited currency. They prevailed in Western Europe, until the advent of the dictatorships in Germany and Russia, when their advance was checked. They were also successful in the United States and gained at least a toehold in Latin America, though there such ideas were often radically transformed for populist ends – as was the case with the Muralists (Rivera, Siqueiros and Orozco) in Mexico. Elsewhere, Modernism remained almost entirely unknown. During the second half of the century, much greater progress was made – it became possible not only to speak of the revival of Modernist concepts in Germany, then later in Russia and throughout Eastern Europe, but also to point to the appearance of artists whose work was allied to contemporary thinking almost throughout the globe: in Japan, China, Korea and throughout the Far East for example. Major museums in Europe and the United States often made a great parade of the support they offered to contemporary artists from non-European cultures.

Here, once again, it is necessary to be prudent. An examination, for example, of the life histories of the most prominent of these non-European creators reveals that the majority have spent the greater part of their careers outside the countries where they were born,

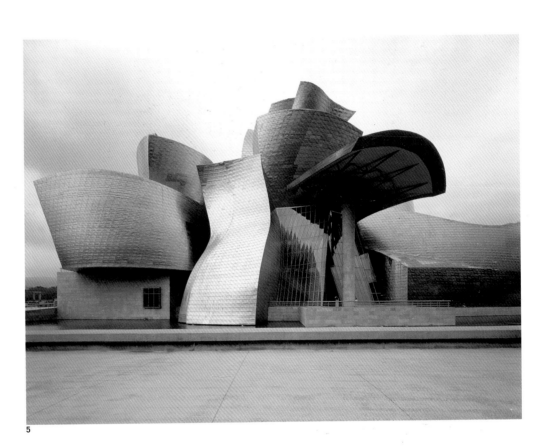

5

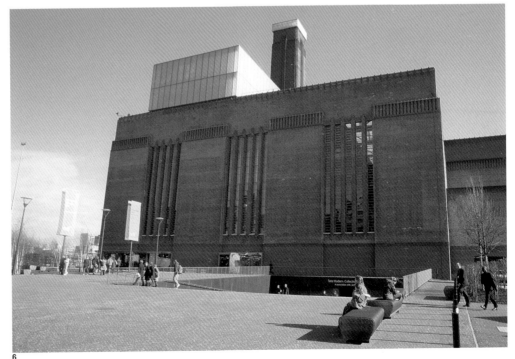

6

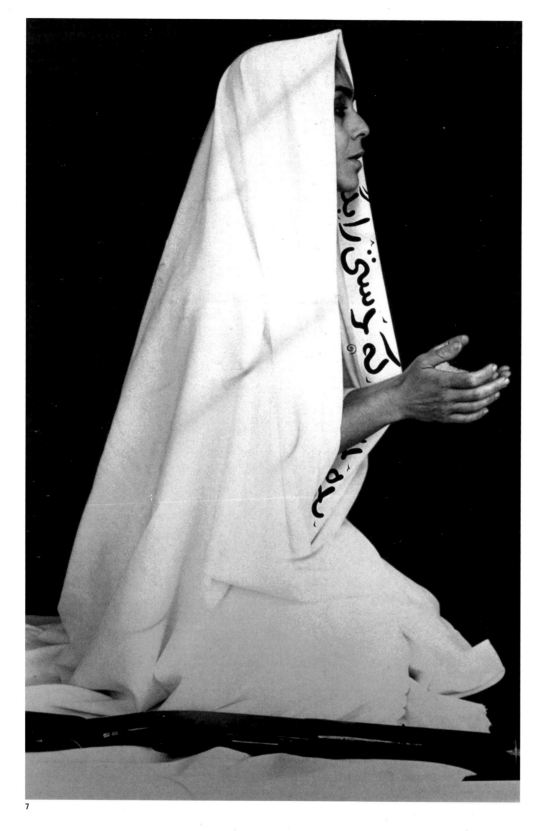

7

7 Shirin Neshat,
Women of Allah, Series 1995.
Gelatin silver print and ink: Gruppo Teseco SPA

8 Joseph Beuys,
Ecology & Socialism, 1980.
Chalk on blackboard with metal stand, 190 x 135 cm

and close to the main centres of artistic of power. The best-known contemporary artist from Iran at the moment of writing is undoubtedly Shirin Neshat (b. 1957), but Neshat has spent almost the whole of her career in the United States. The website for the 1999–2000 Carnegie International had this to say about her: 'Although Shirin Neshat lives and works in the United States, her artwork explores issues of her native Islamic society, especially the position of women. She uses the specifics of her background culture to create works that communicate universal ideas about loss, meaning, and memory.'

This seems to me an interesting example of the way in which western institutions avoid or gloss over questions that it is really their responsibility to answer. How much weight should one give to nature and how much to nurture? For example, Neshat's elegant videos (made in Morocco, not in her native country) and equally elegant photographs in fact examine the Iranian situation from the outside, and deliver answers that are acceptable to western feminism. They are heavily influenced by the expectations of a non-Iranian audience.

From this vantage point, it is possible to look in several directions. One can, for instance, begin to examine current relationships between contemporary art and politics. The dialogue between the artistic and the political did not start with the rise of Modernism, as the careers of 19th-century masters such as Jacques-Louis David, Eugène Delacroix and Gustave Courbet clearly demonstrate. However, Modernism did intensify such exchanges, flirting first with right-wing radicalism (the Italian Futurists were in some respects forerunners of the Fascism of Benito Mussolini), then shifting to the left after the outbreak of World War I. The relationship was always an uneasy one: the Surrealist group, a dominant creative force during the 1920s and 1930s, never succeeded in cementing an alliance with Soviet Communism, while the Soviets persecuted their own avant-garde artists with varying degrees of severity from the mid–1920s until the rise of Gorbachev's *perestroika* in the 1980s.

The triumph of American art during the years that immediately followed World War II saw the political element replaced by an exploration of personal subjectivity and even the rise of Pop did not return art in the United States to political themes. What changed the artistic landscape was the return to subject-matter which took place from the mid-1970s onwards, when Minimal Art, which can be described as the final phase of true Modernism, ran into the buffers and something very different began to

take its place. The person chiefly responsible for bringing about this change of climate was the German artist Joseph Beuys (1921–1986), who had begun his artistic career in the 1960s as a member of the Fluxus group, which consisted largely of Americans living and working in Germany. Beuys was the first to realise that museums of contemporary art, and large-scale contemporary art events such as the Kassel Documenta, could provide extremely effective platforms for political and social views that might have gone unheard in other circumstances. Beuys described the political part of his activity as 'social sculpture' and his charismatic personality made him a magnet for the young, especially in his native Germany. His views were a curious mixture: he combined radical egalitarianism with a concern for nature mysticism (influenced by Rudolph Steiner) and his own role as a modern shaman whose mission is to cleanse society through mysterious rituals and ordeals.

Beuys's practical example in the end had more effect than his specific doctrines. He was largely responsible for creating a situation in which contemporary art became a preferred vehicle of expression for minority causes of all kinds. This return to content placed artists in a situation closely parallel to that of their pre-Modern forerunners, even if the actual means of expression were now very different from those employed by the moralising Salon artists whom the Modernist revolution had displaced.

However, far more even than their predecessors in the 19th-century Salons, contemporary artists who tackle social and political issues are preaching to the converted. Or rather, to be more precise, that part of their now greatly extended audience that does not in fact wholeheartedly agree with them seems to greet what they have to say with casual indifference, treating the message as no more than an interesting phenomenon – one that is not necessarily relevant to the lives the spectators themselves lead. Yet there is also another political dimension to contemporary art: that of its role as a vehicle for cultural competition. Nations feel diminished if their artists are not among the most prominent and discussed of their time. In 2001, the French Foreign Ministry commissioned a report from Alain Quemin, a professor of sociology, as to why French art was increasingly sidelined. His facts and conclusions were depressing. He noted, for example, that in the list of the one hundred most popular contemporary artists drawn up by the German magazine *Capital*, American artists made up 34 percent of the total, German artists 30 percent, British artists 7.5 percent and French artists only 4 percent. Quemin

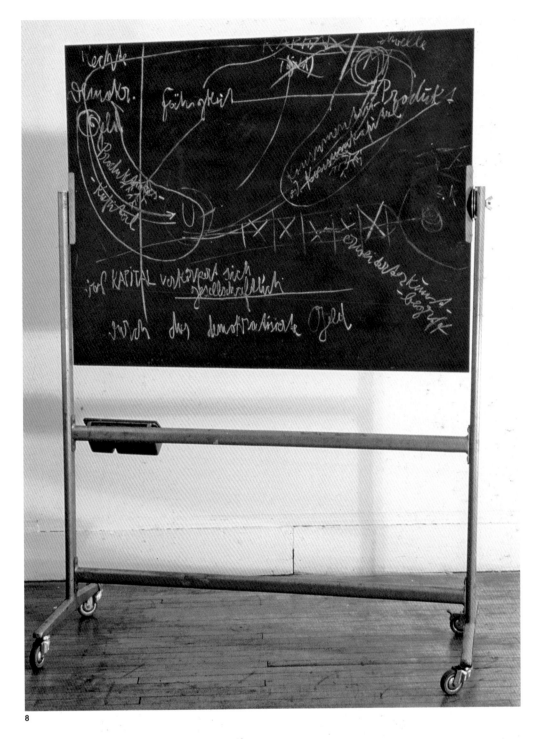

8

blamed not neglect, but its opposite, 'the system of millions of pounds of annual subsidies and official promotion'.[1] Catherine Millet, director of the magazine *Art Press*, thought that Quemin's report was fair and accurate. 'We have few private collectors and everything rests with the state,' she said. 'This makes French art look like official art.'[2] The comment points to a dilemma. Art is a vehicle for cultural prestige, but contemporary art is uneasy about its change of status from a position outside the established order to one cosily within it.

This, too, is a theme that a book of this kind can profitably examine, since it is closely linked to the meaning of the term 'avant-garde'. One characteristic of new, experimental art, from the appearance of Fauvism onwards, has been its desire to shock – to destabilise the established order. It is this that made the military metaphor implicit in the term 'avant-garde' seem especially appropriate. What art historians have been slow to trace, however, is a gradual slide from one dimension to another. The Fauves were shocking not for their actual content, but for the way in which they challenged established ways of seeing. With the Expressionists, then the Surrealists, psychological, as opposed to purely perceptual, challenges began

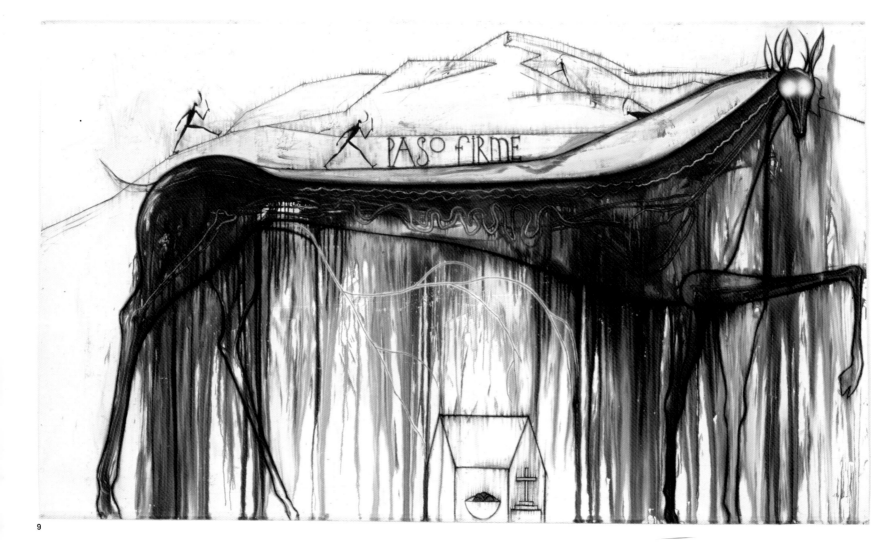

9

9 José Bedia,
Paso Firme, 2001.
Oil on canvas, 183 x 312 cm

10 Malcolm Nelson Jagamarra,
Milky Way Dreaming, 2000.
Acrylic on canvas, 125 x 90 cm

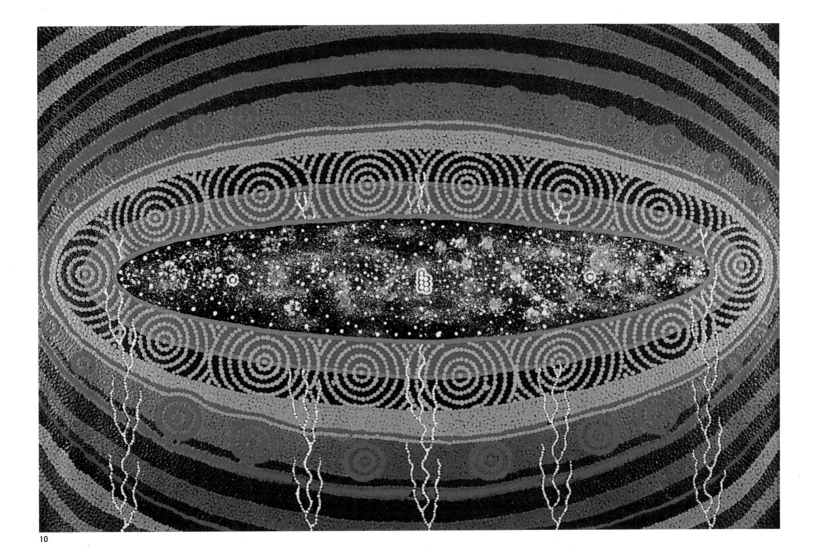

10

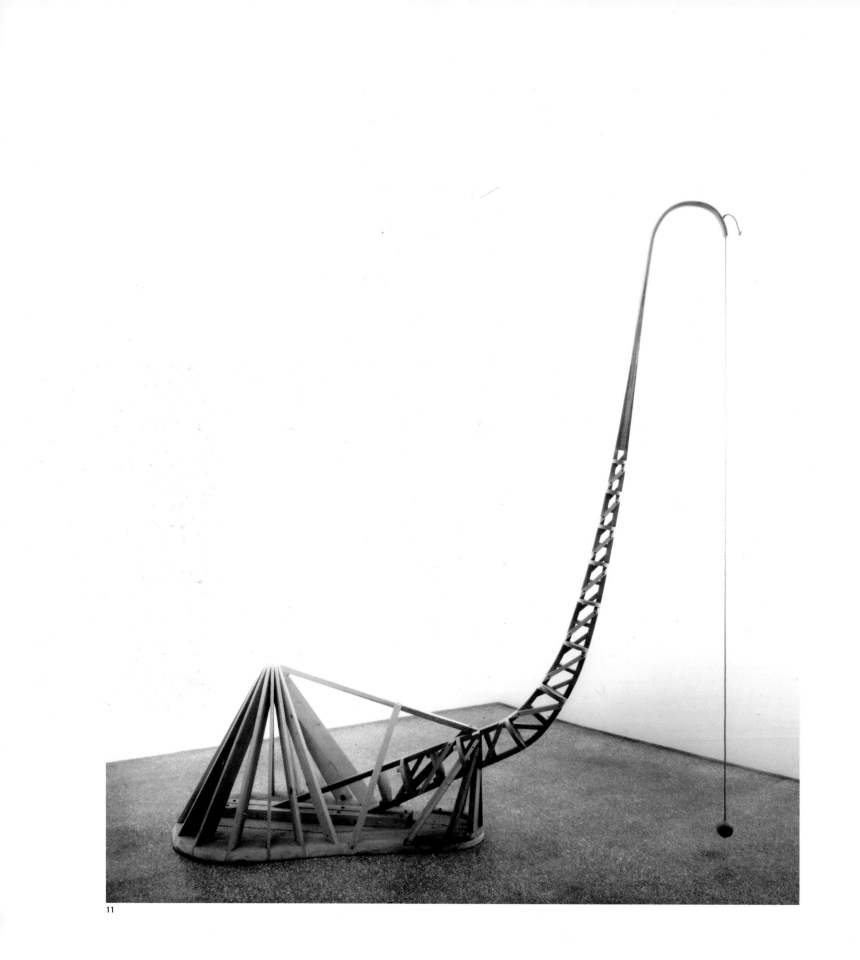

11

to play a role in defining a commitment to avant-garde ways of thinking.

Today, stylistic challenges have lost their impact. It is generally accepted that 'anything can be art' and that contemporary art exists in what has been called a 'post-media situation' – that is, in a situation where neither style nor medium is the message, only content. Naturally, this has led to an increasingly agitated search for ways of disturbing an audience that takes such attempts at disturbance in its stride. Avant-garde art, certainly from the rise of Surrealism onwards, has concerned itself with the exploration of sexuality, seeing the sexual drive as the most fundamental of human instincts. Recently there has been much emphasis on those aspects of sexuality that seem most likely to offend even the most jaded, paedophilia and scatology being those most obvious.

On the other hand, observers such as myself have also begun to notice a certain rigidity in the definitions applied to artistic activity, implying that avant-gardism, far from being a challenge, has become a normative element in the world of contemporary art. Things are, or are not, avant-garde because they fit into established categories, rather than because they challenge categorisation of any kind. Making a video or an environmental piece, for instance, is an avant-garde activity per se, while making a painting is a not.

An examination of the concept of avant-gardism leads fairly directly to an analysis of the relationships between contemporary art and material culture. For example, how do the new forms of art sustain themselves in Third World economies? The success of Cuba in making a place for itself in the world of avant-garde art, in particular through successive Havana Biennials, offers an interesting case history. The Biennials are firmly linked to politics. Through them, Cuba presents itself as the champion of the plural cultures of the Third World – cultures in which, more often than not, distinctively non-western elements mingle with western ones. In showcasing these cultures, however, Havana has tended to attract a western audience, and artists who succeed in the context provided for them in Cuba tend to get taken up by galleries and dealers in New York, Paris, London, Milan, Frankfurt and Cologne. Native Cuban artists, such as Tania Bruguera and José Bedia (b. 1959), who achieve international recognition seldom remain in Cuba – they are forced to go abroad to make the most of the success that has been offered to them.

The question of Third World or minority art forms and their place in avant-garde culture becomes especially acute when one examines the history of certain artistic groupings that attracted a great deal of attention during the closing decades of the 20th century. Two cases in point are the new Aboriginal art of Australia and the African-American art of the United States. Aboriginal art, in its present form, is not something that arose spontaneously. It was encouraged by whites trying to find new sources of income for deprived outback communities. From a purely practical point of view, its success in large part depended on the transference of designs originally associated with ephemeral forms such as body painting and sand painting to acrylic on canvas – materials with no role in traditional Aboriginal culture. It also depended on a fortuitous resemblance between the combinations of coded signs used to represent Aboriginal dreamings, such as the one by Malcolm Jagamarra illustrated here, and western abstraction – an interesting though tenuous link in this respect being that Wassily Kandinsky, one of the fathers of abstraction in 20th-century art, seems to have taken ideas and signs from the primitive shamans whose work he studied during the time he spent working as an anthropologist in Vologoda, in the far north-west of Russia. These Aboriginal paintings have a purely western market, if one views white Australia in those terms, and there are no museums or galleries in the outback where Aborigines can enjoy their own cultural products.

The situation of African-American art is more complex. African-Americans are faced with difficult choices: Do they want to identify with their own ethnic grouping (to the point perhaps where they refuse to address those who are outside it)? Do they want to belong to the mainstream? Or should they seek some compromise between these two alternatives? The most successful African-American sculptor of recent years, Martin Puryear (b. 1941), has firmly chosen the second of these options, though commentators nevertheless continue to search for 'African' elements in his work. As demonstrated by Betye Saar (b. 1926) and her daughter Alison Saar (b. 1956), the artists who have been most successful in negotiating a compromise have usually been women, because their work is as much feminist as it is African-American, and feminist concepts provide their work with a firm intellectual structure.

African-Americans are only one of a number of cultural minorities within the US and will soon no longer be the largest. The status of African-American art in the 21st century will undoubtedly be challenged by the vibrant hybrid Hispanic/North American culture – a product of the huge increase in the country's Hispanic population. An example of this kind of art is the

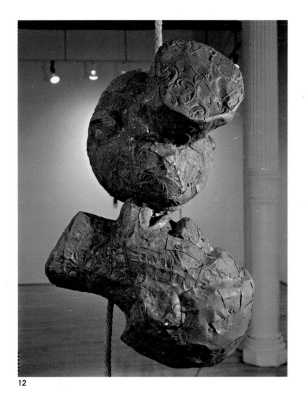

12

11 **Martin Puryear,**
Untitled, 1997-2001.
Mixed media: pine, cypress, ash, rope, 365 x 335 x 110 cm

12 **Alison Saar,**
Kiss on a Rope, 2001.
Mixed media: wood, tin, rope, 185 x 40 x 45 cm

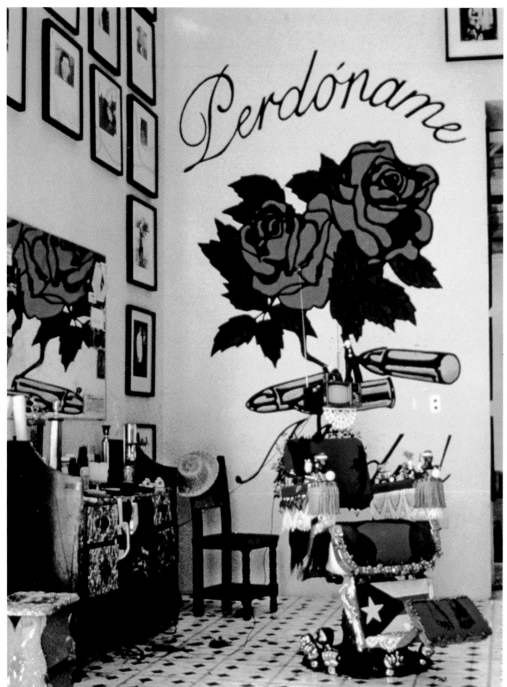

13

13 Pepón Osorio,
No Crying Allowed in the Barbershop, 1994.
Installation

14 Thomas Grünfeld,
Misfit-Giraffe, 2000.
Taxidermy, 210 x 130 x 80 cm

The paradox with video and related forms of expression was that the means available to artists were also largely those developed to cater for the needs of the amateur filmmakers and photographers that made up the large consumer market. Few video artists had access to anything that could truthfully be described as cutting edge, and their efforts were regularly outstripped both technically and, very often, imaginatively by the makers of television commercials, pop music videos and video games. Borrowing, as it does, many of its techniques from electronic entertainment, contemporary art is itself seen more and more as a branch of entertainment and less and less as a repository for spiritual and moral values. Yet 'entertainment', in this definition, also includes an element of spiritual uplift, comparable to the popular evangelism that appears on television. This movement towards entertainment is in fact part of a lengthy process that dates back to the 18th century, when the first generation of professional art critics, such as Diderot, assimilated what they saw in paintings to their experience of the theatre.

The rise of video and the increasing sophistication of digital imaging techniques have, however, had a profound impact in one area. Because images are becoming easier to alter and manipulate, our belief in their inherent 'authenticity' is increasingly challenged, as is our sense of their essential uniqueness. The digital copy is indistinguishable from its original. Meanwhile, thanks to the efficiency of the new electronic means of communication it is no longer necessary to think of the work of art being firmly located in one place. In certain circumstances, it can be anywhere and everywhere. The religious aspect of contemporary art is therefore something built on extremely unstable foundations.

Less noticed by commentators, but arguably more important than the rise of video and allied means of image-creation, is an increasing effort on the part of many younger artists to marry new art to new science. In particular, a number of artists have become fascinated by the advances being made by scientists exploring new discoveries in genetics.

At the same time, some artists have also become fascinated by what could be described as 'pseudo-science', and have started making works that allude to alchemy, or to the strange and often fraudulent objects found in 16th-century *Wunderkammern* or in the booths of 19th- and early 20th-century fairground showmen. Examples are the hybrid creatures concocted by the German artist Thomas Grünfeld (b. 1956). The Postmodern elements of doubt and mistrust inherent in the electronic image

work of Pepón Osorio (b. 1955), who is a member of New York's Puerto Rican community.

Analysis of material culture leads directly to the question of technology. In the concluding decades of the 20th century there was much talk about 'technological art'. In general, technology was seen as something closely linked to an expansion of the means of representation available to artists – in other words, discussion of technology centred on artists' video and, to a lesser extent, on digital still photography. Holography, which had once seemed a promising vehicle of expression for avant-garde artists, had slipped from view, largely because of its technical complexity and expense.

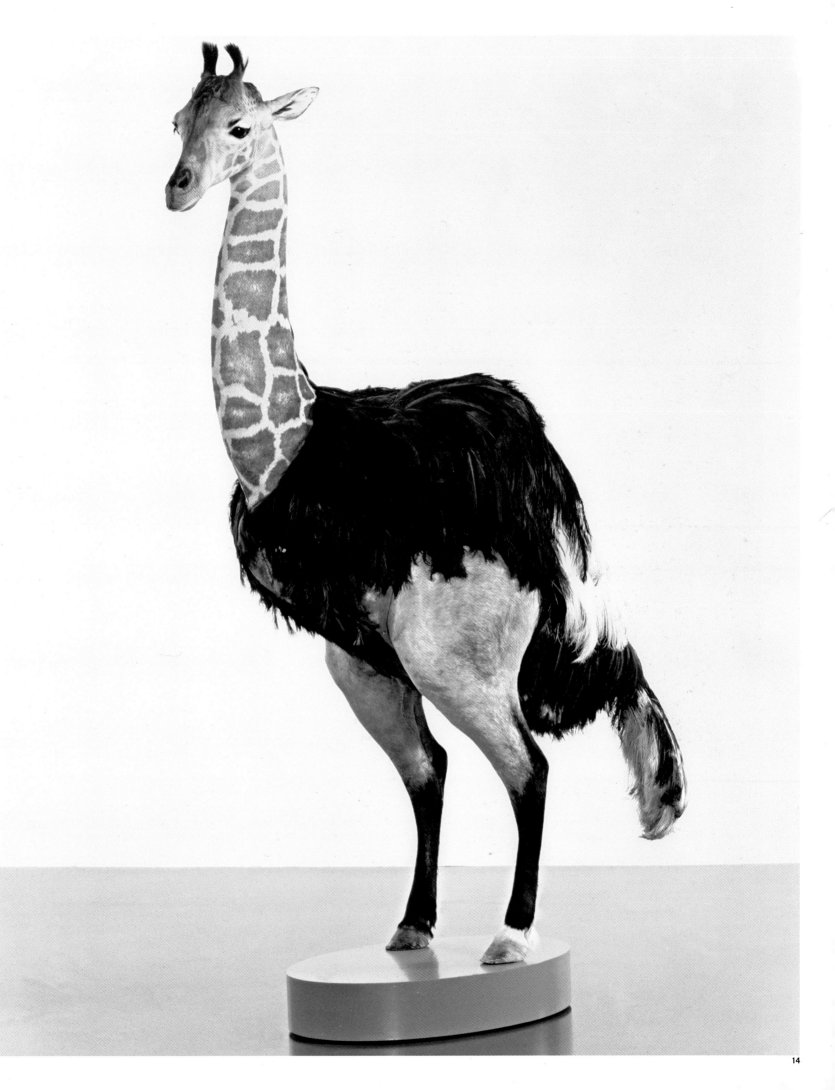

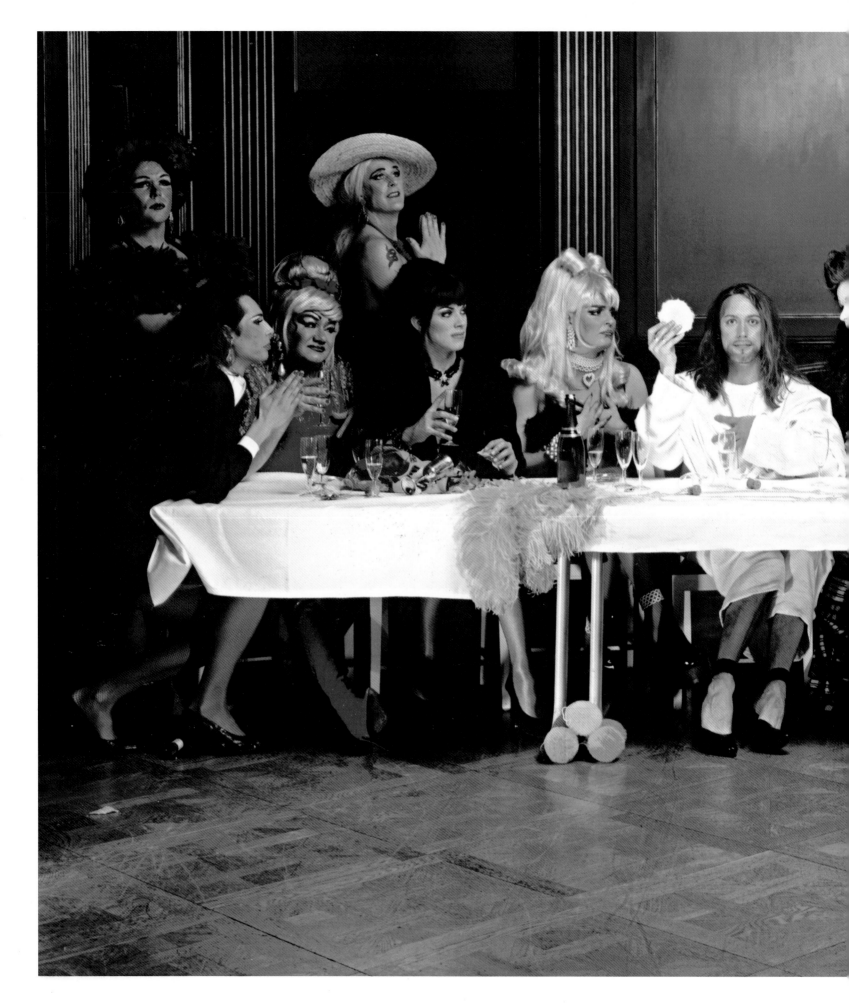

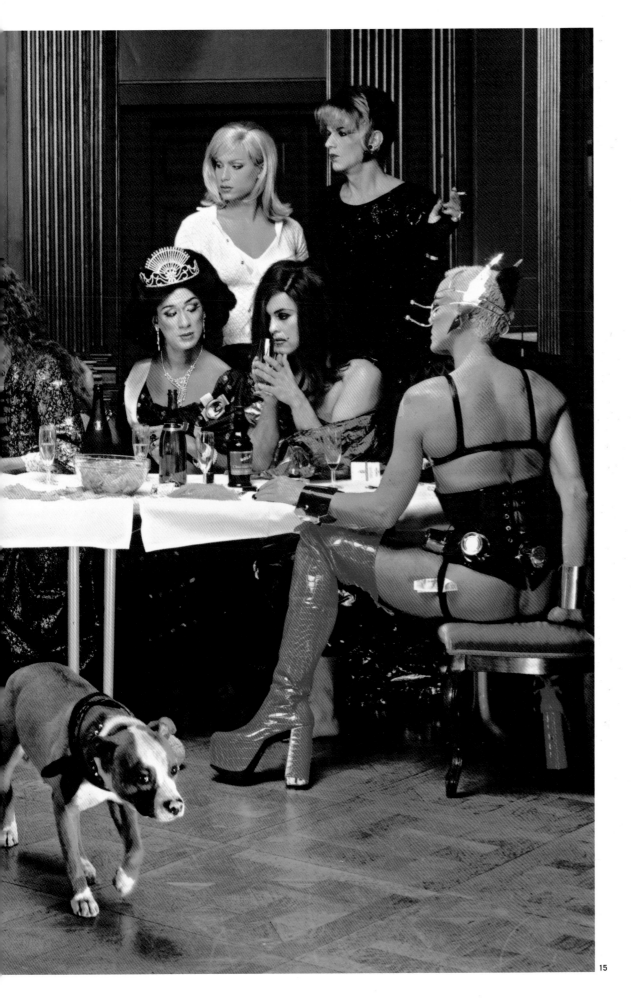

15

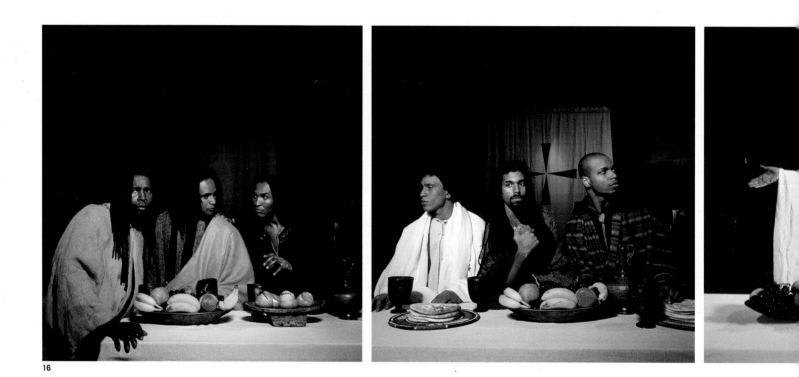

16

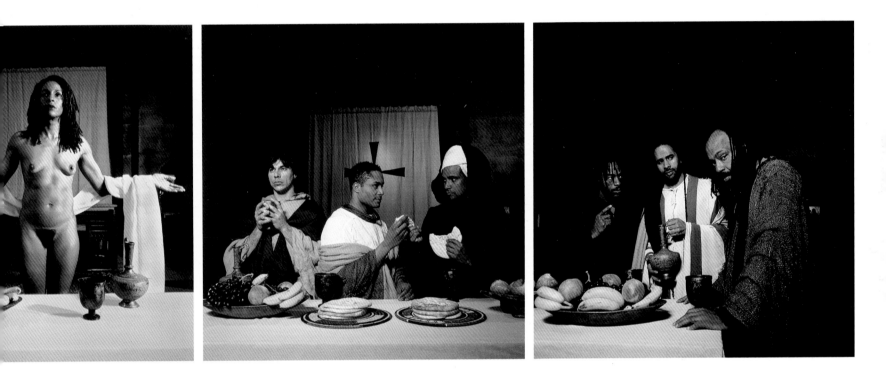

16 Renée Cox,
Yo Mama's Last Supper, 1996.
5 cibachrome prints on paper, 75 x 380 cm

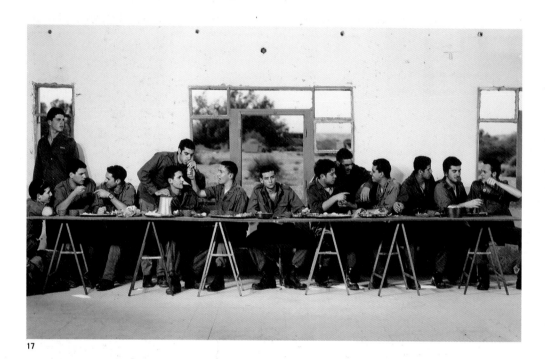

17

also find a different, more self-conscious expression in artworks of this type.

The contemporary art scene has nevertheless also witnessed, in many parts of the world, a powerful return to conservative attitudes expressed both through the use of traditional techniques and a return to equally traditional images. In a sense, the revival of traditional means of art-making seems less important than a new attitude towards imagery. The great icons of the pre-Modern past – Last Suppers, Crucifixions, martyrdoms of all sorts, plus representations of Greek and Roman legends – have all begun to find a new vitality in the artistic cosmos of the 21st century. Very often these prototypes are used in new and aggressive ways, as demonstrated by the versions of the Last Supper created by three gifted photographers – Elisabeth Ohlson (b. 1961) in Sweden, Adi Nes (b. 1966) in Israel and the African-American Renee Cox (b. 1958) in the US – as

part of a polemic for feminist theory, racial equality or the establishment of gay rights. Cox's *Yo Mama's Last Supper* (2000) shows her own nude figure in place of that of the Saviour. Interviewed about the piece on the website Salon.com, Cox said: 'It becomes a protest, but that wasn't my intention. It was more about a critique. It also comes from research that I did – about the Catholic Church and how affairs were handled around slavery and Catholicism . . . Are there messages underneath? No, there are not. It's just that African-Americans are invisible, especially in Renaissance art. And Christianity is big in the African-American community, but there are no representations of us. I took it upon myself to include people of colour in these classic scenarios. That is the most important thing.'

These images seized from traditional high culture now challenge the borrowings from popular forms, such as advertisements or the movies, which have been staples in contemporary art since the triumph of Pop in the early 1960s. The conjunction raises some interesting questions. For example, is a traditional religious image – a Madonna and Child – in fact less familiar, less central to most people's experience, than, say, an image of Marilyn Monroe or Douglas Gordon's (b. 1960) new version of Alfred Hitchcock's film *Psycho*?

For a number of critics, recognition of this apparently conservative tendency would imply abandonment of the long-cherished concept of an avant-garde as something that exists in perpetual opposition to whatever might seek to stifle creative experimentation. This seems to me to be putting the question in the wrong way. At the beginning of a new century one of the things we have to ask ourselves is whether the rebellious attitudes of the last century have not in fact become the orthodoxies that now impede progress. In recent years, one thing I have heard too often is the cry 'But that's not avant-garde!' What the existence of true avant-gardism implies is total fluidity of response and constantly changing methods of assessment and measurement. This book therefore sets out to look at the art we now have in new ways, in the hope of discerning what it might become in the future.

17 Adi Nes,
Last Supper, 1999.
Colour-print on paper, 90 x 135 cm

18 Douglas Gordon,
24H Psycho, 1993.
Video installation (screen: 230 x 300 cm)

1 Charles Bremner, 'French artists left out of the world picture', *The Times,* 13 June 2001, p. 16.
2 Ibid.

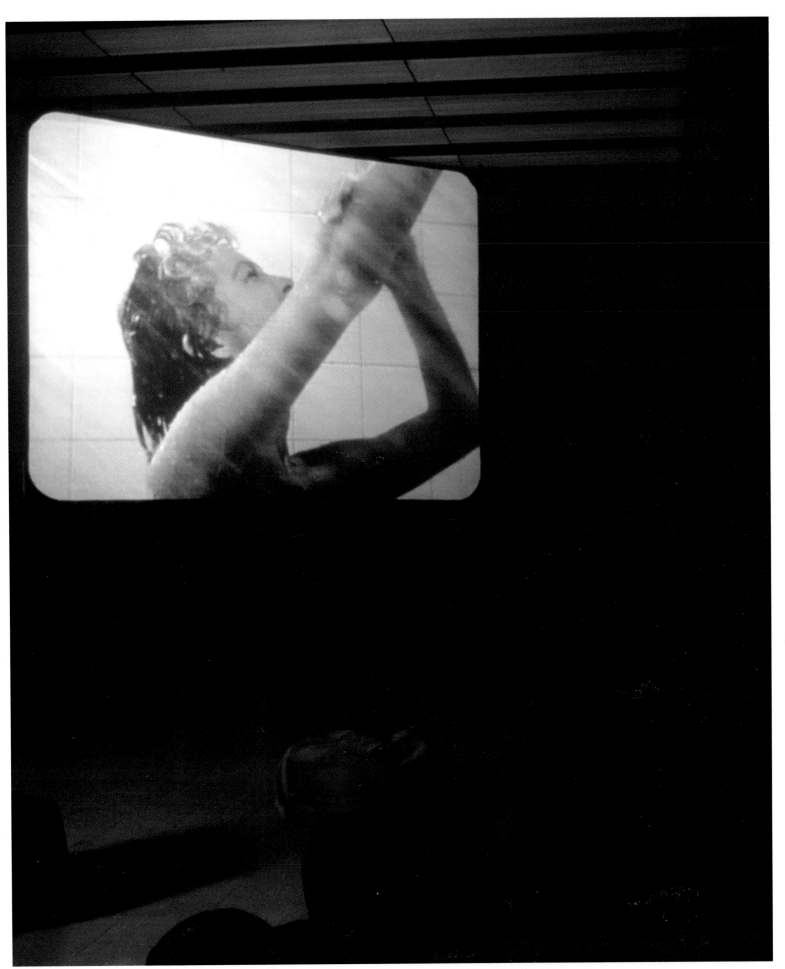

museums
and public spaces

chapter two ••••⟩

Throughout the final decades of the 20th century an undeclared struggle was taking place between contemporary artists and the official cultural establishment. The 19th century had been reasonably prolific in very large-scale works of art. These included the imperial commissions given to Jacques-Louis David, notably his huge *Coronation of Napoleon* (1805–07); Théodore Géricault's *Raft of the 'Medusa'* (1819); Thomas Couture's *The Romans of the Decadence* (1847); Gustave Courbet's *The Painter's Studio* (1855); and Georges Seurat's *Sunday Afternoon on the Island of La Grande Jatte* (1884–86). All of these, in their different ways, were intended to be public statements, although in some cases – Géricault's *Raft* and Courbet's *Studio*, for example – they also contained implicit criticisms of the government of the day.

The Modern Movement in art brought with it a withdrawal from the public arena. Though the leading Modernists showed their work in exhibitions that drew large crowds, such as the successive versions of the Salon des Indépendants in Paris and the epoch-making Armory Show in New York (1911), there was always the implication that this was art addressed to an elite, and paintings in particular tended to shrink in size. The tendency was only partially reversed by the political events of the 1930s, when Picasso's *Guernica* (1937) caused a sensation at the Paris Universal Exhibition with its fierce criticism of the opponents of the Spanish Republican government. Works of this sort are, however, still made occasionally. An example is Anthoy Gormley's (b. 1950) huge *Angel of the North* (1995) near Gateshead in England, a sculpture designed to create a feeling of geographical and cultural identity in a place that had hitherto lacked one. The work, however, does have one novel feature – it is essentially a work designed to be seen from a car traversing the network of motorways that surround it.

When the centre of artistic innovation moved from Paris to New York as the result of World War II, practitioners of the new American style – Abstract Expressionism – showed a penchant for very large canvases. These works, however, tended to be private rather than public statements, charting the condition of the artist's psyche. Abstract Expressionism did, however, have an official aspect, in that American museums and cultural agencies promoted it as emblematic of the triumph of American culture, which seemed to go hand in hand with America's rise as the dominant world power.

These paintings were still, in any case, artefacts that fitted within long-established formulae for the display of works of art. The artists who produced them were accustomed to cooperation, of however fractious a kind, with official agencies, since most of them were alumni of the federal programmes designed to help artists set up by Franklin D. Roosevelt's administration during the Depression.

This situation began to change during the 1960s, when artists connected with the rebellious counter-culture of the time began to see museums as upholders of the prevailing establishment order. The Minimalists, who now look like the last gasp of the original Modernist ethos, sought ways of making art that was beyond the grasp of existing institutions. Typical of this phase were various major Land Art projects, such as Michael Heizer's (b. 1944) *Double Negative* (1969), a vast excavation in the Nevada desert; Robert Smithson's (1938–1973) *Spiral Jetty* (1970) on the shores of the Great Salt Lake in Utah; and Walter de Maria's (b. 1935) *The Lightning Field* (1977), four hundred stainless steel poles, each 20 feet high, arrayed in a rectangular grid in an unpopulated region of New Mexico.

Despite the ambitious scale of these projects, few people saw them at first hand. Smithson's *Spiral Jetty*, the most ambitious of them all, is chiefly known from aerial photographs taken at the time it was made. Shortly afterwards the waters of the lake rose and covered it. Meanwhile the artists concerned were gradually coopted into the museum system. Their absorption was hastened by the fashion for using disused industrial spaces for the display of contemporary art. One of the earliest and most successful examples of this was the Temporary Contemporary (now the Geffen Contemporary) in Los Angeles, opened in 1983 as a stopgap while the new Los Angeles Museum of Contemporary Art was being designed and built. This vast building had originally been a city warehouse and service garage, and it proved particularly suitable for large-scale installations.

19 Anthoy Gormley,
Angel of the North, 1995-1998.
Reinforced steel, 2200 x 5400 x 220 cm

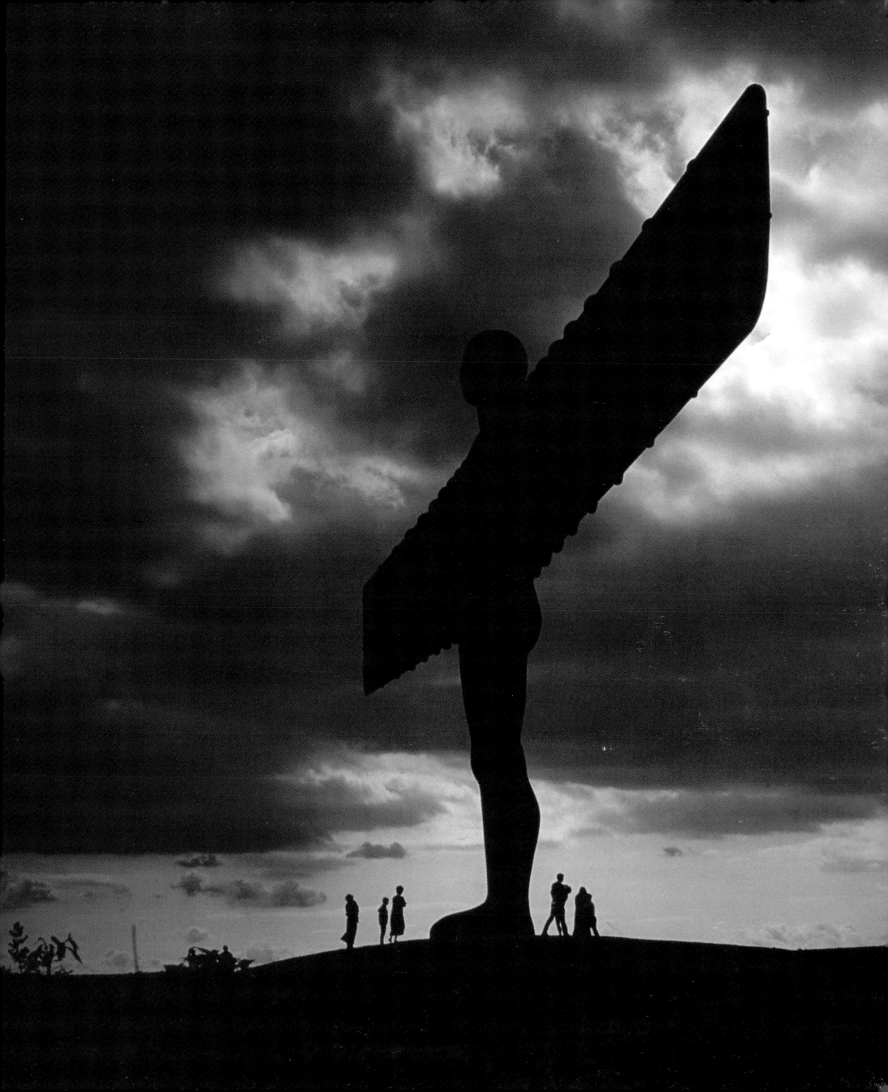

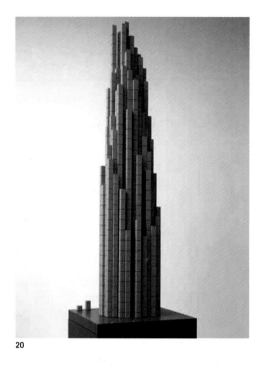

20

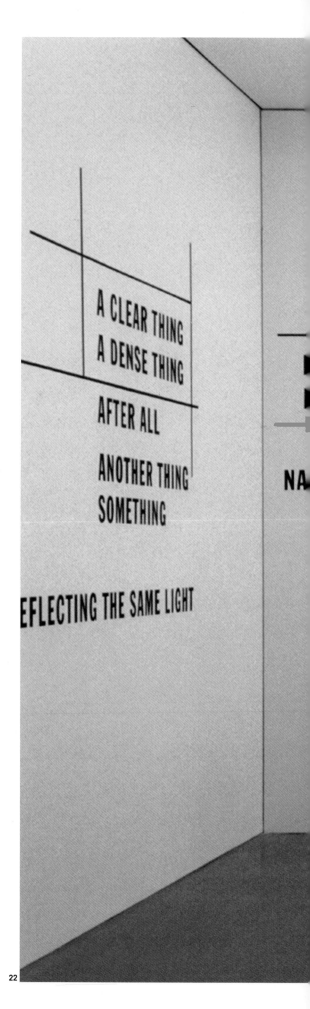

21

20 Sol LeWitt,
maquette for *Vertical Progression* No. 7, 1998.
Painted wood, 65 x 85 x 30 cm

21 Keith Milow,
Canon, 1996.
Oil on aluminium, 60 x 40 cm

22 Lawrence Weiner,
Nach Alles (After All), 2000.
Installation view

Michael Heizer, for example, was able to move a version of his *Double Negative* indoors. Minimal Art and its close relation, text-based Conceptual Art, do, however, continue to be made, and many critics continue to see in works like Sol LeWitt's (b. 1928) *Progression* (1998), Lawrence Weiner's (b. 1942) *Nach Alles* (2000) the purest expression of the true avant-garde spirit. In fact, as Keith Milow's (b. 1945) wittily ironic *Canon* (1996) suggests, these works do now tend to have an academic air.

Despite this, or perhaps even because of it, some forms of Minimal sculpture are peculiarly well suited to the magnificent new museum buildings that are now being created. A particular beneficiary of this new twist in the continuing story of the relationship between contemporary artists and the museum has been the American Minimalist sculptor Richard Serra (b. 1939), whose mammoth steel sculptures featured in the late 1990s both at the Geffen Contemporary and in the opening displays of the Guggenheim Museum in Bilbao (1997). At the latter, Serra's *Snake* (1998) laid emphatic claim to the space provided for it by the Canadian-born, Los Angeles-based architect Frank Gehry (b. 1929).

The titanium-clad Guggenheim Museum in Bilbao has been one of the most universally praised buildings of its time. It is also the paradigm of what museum buildings are currently about. The story it tells is on the face of it simple and yet, on closer examination, extremely complex. It represents, for example, the way in which museums, and in particular museums of contemporary art, have become the cathedrals of our time, centres for a new form of worship, which now takes a central place in our culture. Every architect with a truly international reputation has to have a museum or two to his credit. In this sense the Bilbao Guggenheim follows the example set by Frank Lloyd Wright's original Guggenheim Museum in New York, since it is almost as much a monument to its creator as something built for practical use. Despite this, it also represents a successful attempt to revitalise a particularly run-down and grimy industrial city, fulfilling a function that is increasingly used to justify the creation of new museums of all kinds. The idea is that they can be used to kick-start a cultural renaissance in the regions or neighbourhoods where they are located and, moreover, they can stimulate real economic growth. Another strand in the narrative, however, is that of cultural imperialism disguised as internationalism. The new Guggenheim has served to reinforce the idea of the continuing hegemony of American art at a time when this was being increasingly challenged outside the

VON GEWICHT
VON WENIGER GEWICHT

LLES
ETWAS ANDERES
ETWAS

STEHEN AM SELBEN ORT

ETWAS SCHWARZES
ETWAS WEISSES
NACH ALLES

ETWAS
IRGENDETWAS

SIND IN JEDEM
BESTIMMTEN MOMENT
ZU SEHEN

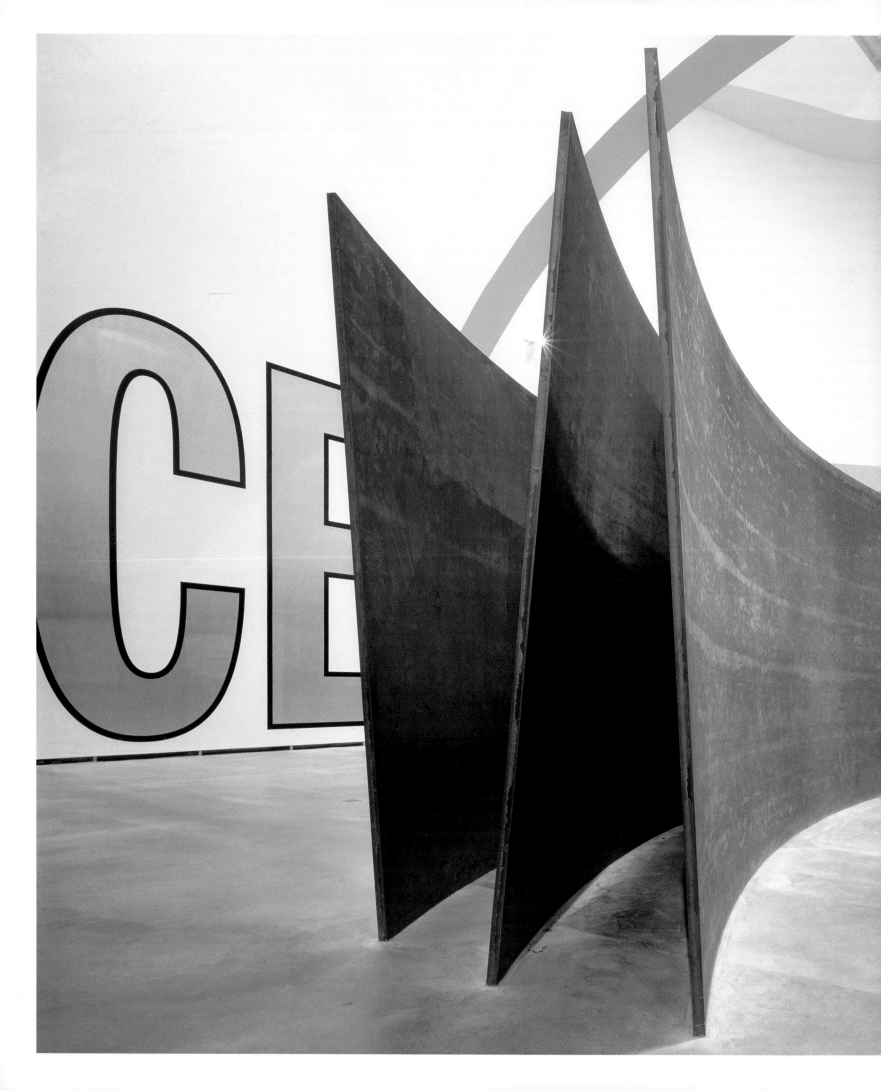

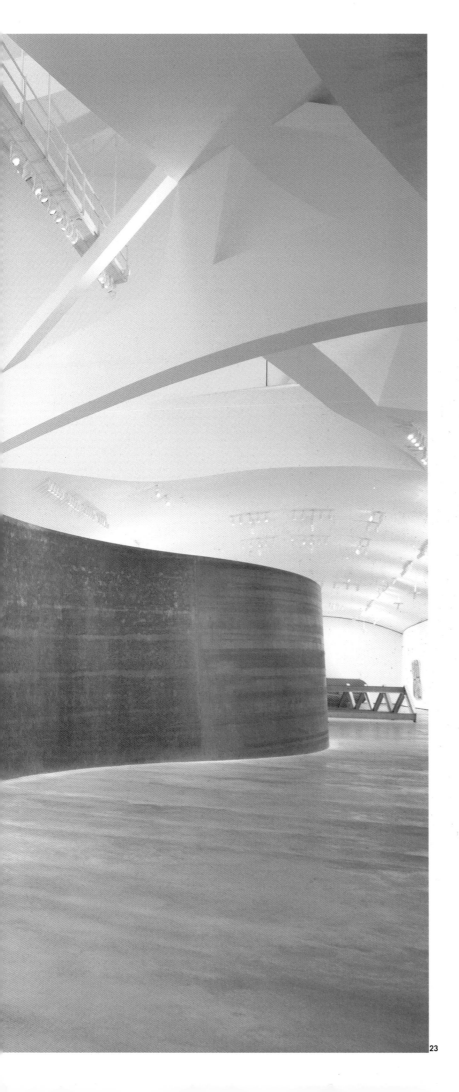

23 Richard Serra,
Snake, 1994-1996.
Corten steel, 400 x 3165 x 680 cm

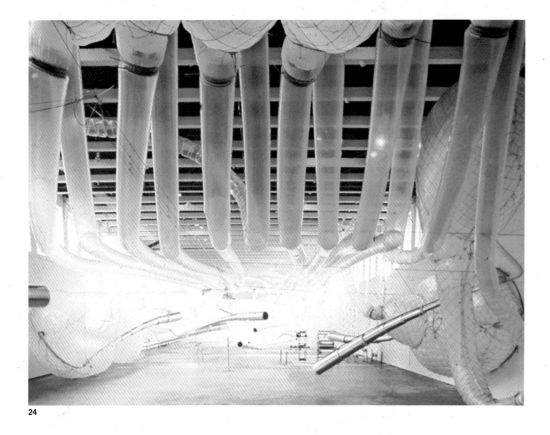

24

24 Tim Hawkinson,
Überorgan, 2000.
Installation: inflatable bags and music,
9000 x 900 cm

25 Juan Muñoz,
Double Bind, 2001.
Installation, 3500 x 8000 x 2500 cm

United States. As such it is especially well suited to the display of work by artists such as Serra, who represent the last gasp of the old Modernist order.

The Guggenheim 'franchise' can, however, be used for other purposes as well. The Guggenheim has just opened a new space in Las Vegas, in association with St Petersburg's Hermitage Museum. The deal is that the Hermitage supplies traditional art and artefacts, just as it does to the Hermitage Rooms at Somerset House in London, while the Guggenheim supplies contemporary art. This amounts to an acknowledgement that contemporary art has entered the realm of Vegas showbiz, and takes its place alongside the white Siberian tigers of Siegfried and Roy and the performances of popular music stars such as Barbra Streisand.

The new museum spaces, whether adapted from existing industrial buildings like Tate Modern and the Geffen Contemporary, or built completely from scratch like the Bilbao Guggenheim, are increasingly gigantic in size. Artists are encouraged to make works that are specifically designed to meet the challenge this poses. The vast Turbine Hall, the entrance space of Tate Modern, housed first a series of towers by Louise Bourgeois (b. 1911) then an installation by Juan Muñoz (1953–2001). Muñoz's elaborate installation *Double Bind* made use of ascending and descending elevators and half-concealed life-size figures. It seemed to invite the visitor to explore a parallel

universe – the world of a science-fiction movie. The museum envisages a continuing series of such displays, which will be responses to the kind of space that, up until now, few avant-garde artists have had at their disposal. Obviously the art will be affected by the setting – the Turbine Hall, in addition to offering an opportunity, will impose its own rules.

A similar situation exists at the Massachusetts Museum of Contemporary Art, a sprawling factory-turned-museum in North Adams, Massachusetts, which is more familiarly known as Mass MOCA. Here the American artist Tim Hawkinson (b. 1960) was offered a gallery 275 feet long by 55 feet wide by 24 feet high. His response was a work called the *Überorgan,* a self-playing reed organ with thirteen airbags, each the size of a bus. On its website, the museum compares the gallery and its contents to 'the chest cavity and internal organs of a very large living organism. The beamed ceiling reads like a ribcage, and the translucent, biomorphic bags encapsulated in orange netting are unknown glands or organs delicately traced with blood vessels.'

The *Überorgan,* powered by a Mylar roll scored with dabs of black paint that winds over an array of photoelectric sensors, gives forth blasts of sound based on old-fashioned hymn tunes. It is thus not simply something the spectator looks at, but something which performs for him. The museum that houses it is at pains to emphasise its lack of seriousness: 'Its low-tech sophistication and hand-made craftsmanship, its complexity and truly vast scale are all put at the service of a playful, mirthful, even goofy end.'

This attitude, like the association of a Guggenheim branch museum with a Vegas casino, is symptomatic of what is happening to art. Art is now expected to sing for its supper, as it quite literally does here. The gigantic spaces offered to artists are not necessarily linked to lofty ideals.

There is nevertheless a whole range of possible attitudes. Museums, and not-for-profit art-spaces in general, have become the chief, and generally the only possible, venue for certain artistic manifestations that can only exist in the kind of context that they provide. Sometimes collaborations between artists and architects have a practical purpose, as in *The Light Inside* (1998), a light-installation created by James Turrell (b. 1943) to enliven the dour underground passageway that links the two sections of the Museum of Fine Art in Houston, although Turrell himself remains emphatic that what he has done is an independent artwork, not just an ad hoc solution to an architectural problem.

For the most part, however, these manifestations are gratuitous creations. They exist sim-

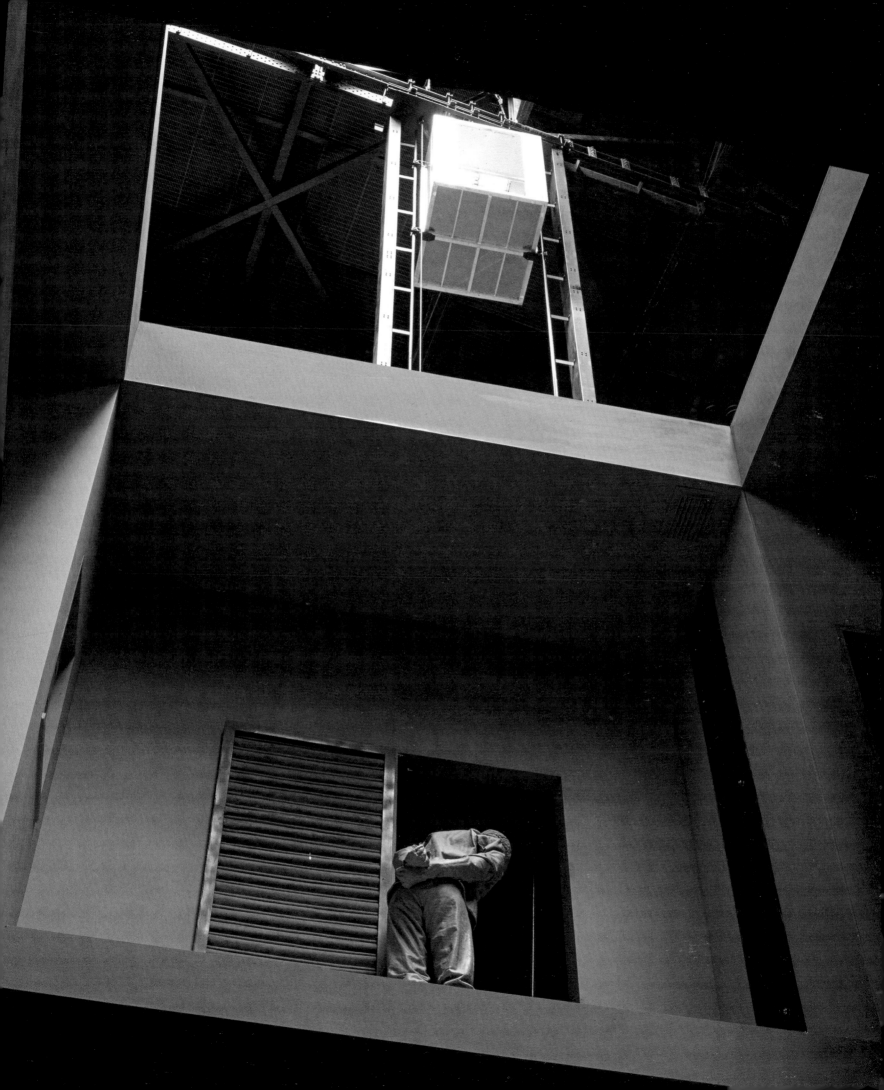

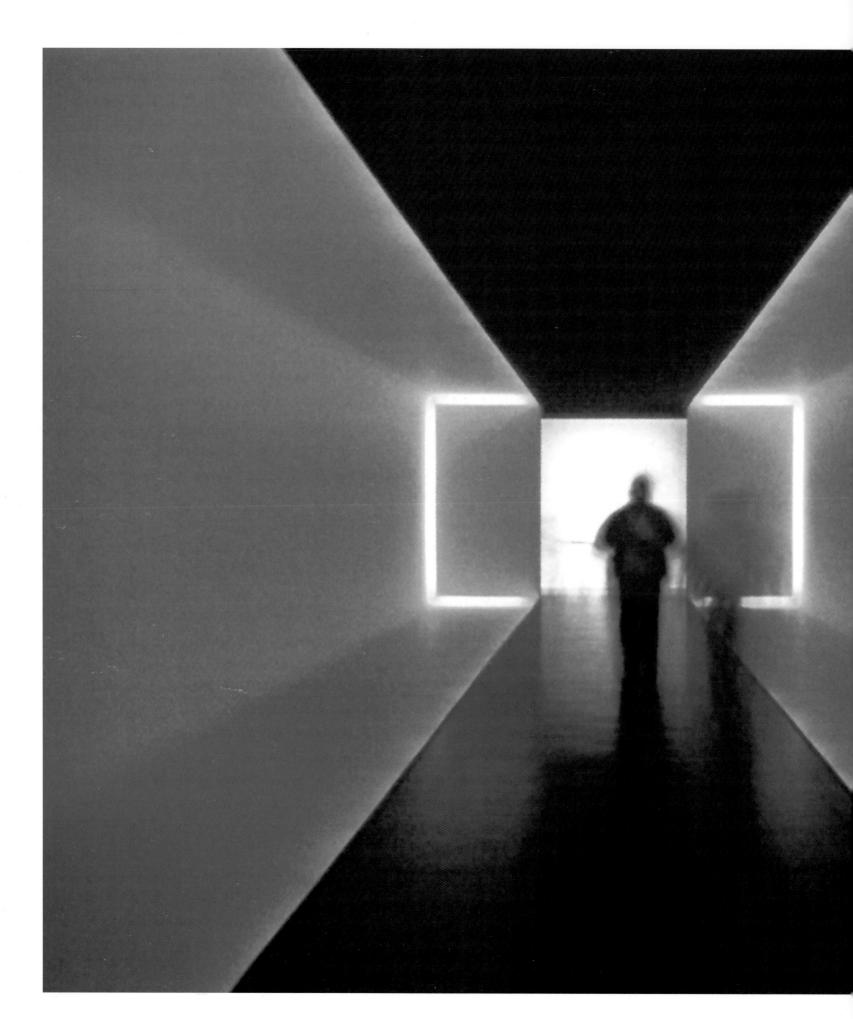

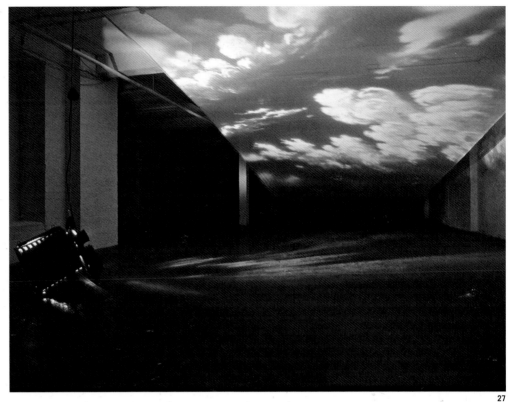

ply to evoke wonder, to provide pleasure and perhaps sometimes to stimulate reflection on some aspect of human existence. Ron Haselden's (b. 1944) *Maid of the Mist* (1994) used relatively simple and indeed obsolete theatrical equipment to produce a series of quasi-magical effects. Alternating images of clouds and fire were created by projecting light through hand-painted glass discs that rotated in front of the light source. These projections, in turn, were triggered by microphones hidden in various parts of the building and also placed at floor level. Sound was amplified within the space, which thus became an echo chamber. The whole work thus reacted interactively with anyone who entered the space.

The veteran Japanese artist Yayoi Kusama (b. 1929) used even simpler methods in her *Narcissus Garden* (2000) installation shown at the Hayward Gallery in London. Here the effect was created through the use of curved reflecting surfaces, close cousins of the distorting mirrors used in fairground labyrinths. In *Floating Time* (2000), another Japanese artist, Tatsuo Miyajima (b. 1957), who lives and works in New York, projected floating numbers, along with saturated fields of colour, onto platforms raised just above floor level. The numbers drifted across these surfaces, counting down repeatedly from nine to one. The implication was that time was plural, and acquired different personalities at different moments in its progression. Though the work debuted in a

26 James Turrell,
The Light Inside, 1999.
Installation: electric lights, wires, metal, paint

27 Ron Haselden,
Maid of the Mist, 1994.
Projectors, painted glass-discs, microphones, amplifier

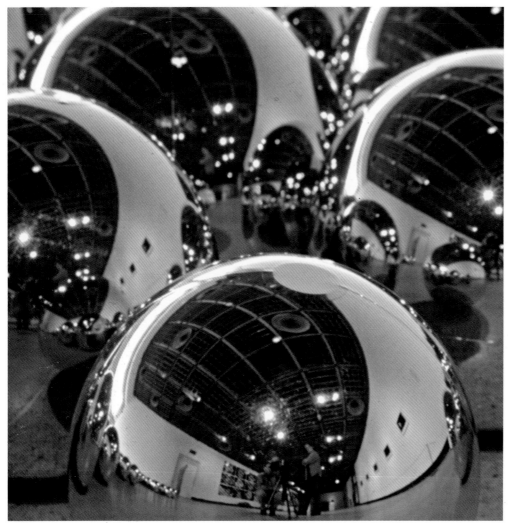

28

commercial space, the Luhring-Augustine Gallery in New York, it too seemed best suited to a public place.

With each of these three works, what the spectator is offered is not a tangible object that can be looked at steadily, but an ungraspable, constantly modulating sensual experience. Increasingly it seems to be the job of museums of contemporary art, and also of large public manifestations such as the biennials mentioned above, to offer fleeting experiences of this sort.

This is also true of most of the installations made by the British artist Anya Gallaccio (b. 1963). In her *Chasing Rainbows* (1998), for example, thousands of glass crystals were spread on the floor of the exhibition space. These acted as minuscule prisms, separating light into its constituent hues. The result was a rainbow hovering in semi-darkness, which, like the rainbows seen in nature, evaded close inspection and then disappeared altogether if the viewer tried to come too close to it. The artwork refused to be either controlled or captured, and existed only for the duration of the exhibition.

Sometimes this approach can descend into the use of what are really only fairground tricks. Tim Noble (b. 1966) and Sue Webster (b. 1967) have collaborated on a series of installations made of piles of trash. With the clever use of projectors and coloured gels, these throw shadows on the wall in the shape of heads and human figures. Such works are really just elaborations of the old game in which someone creates a duck's head or some other shape of the same kind with the use of a light source and his or her hands.

Another form of installation, equally at home in public spaces and equally unsuited to almost any other context, is a structure that is not interactive but that nevertheless encapsulates some kind of narrative. Installations of this type are now being created by artists from all over the world, and often make specific reference to the non-European cultures to which the artists belong. *House of Hope* (1997) by the Thai artist Montein Boonma (b. 1955) was exhibited at Deitch Projects in New York. This appealed to more than one sense, since Boonma used oriental spices and herbs to scent the space his construction occupied. Essentially this construction was a 'house' made of hanging strings of glass beads, in a space whose surrounding walls were adorned with painted bands representing clouds. The artist intended this as a memorial to his recently deceased wife but, as with many contemporary art works, it was impossible to divine this without reading the press release.

28 Yayoi Kusama,
Narcissus Garden, 1966-2000.
Installation

29 Tatsuo Miyajima,
Floating Time, 2000.
Installation: computer graphics, projectors,
wooden platform 400 x 300 cm

30 Anya Gallaccio,
Chasing Rainbows #2, 1998.
Glass bead and light

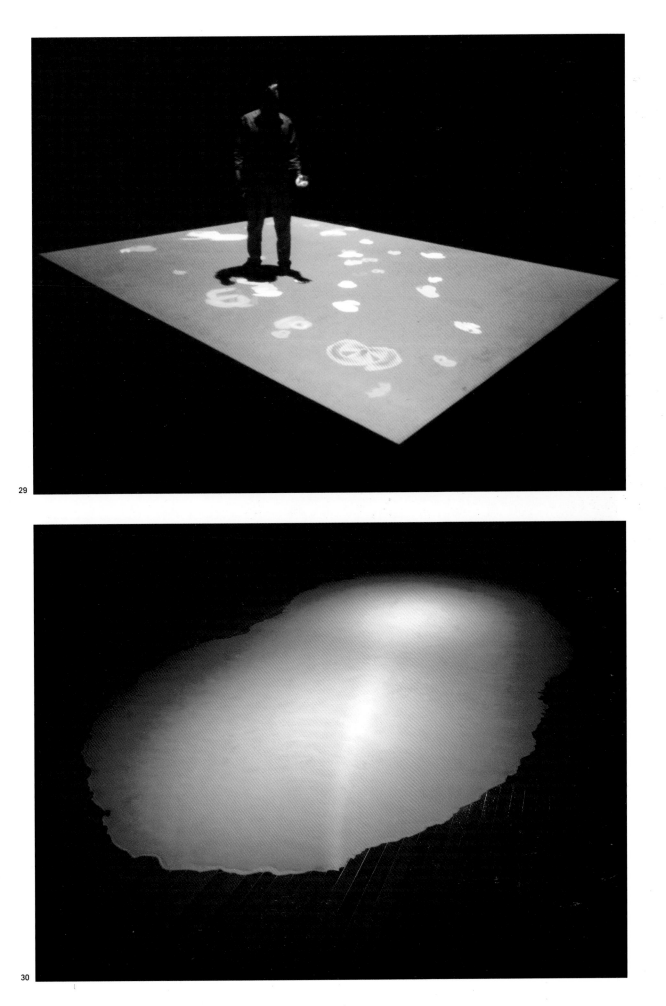

29

30

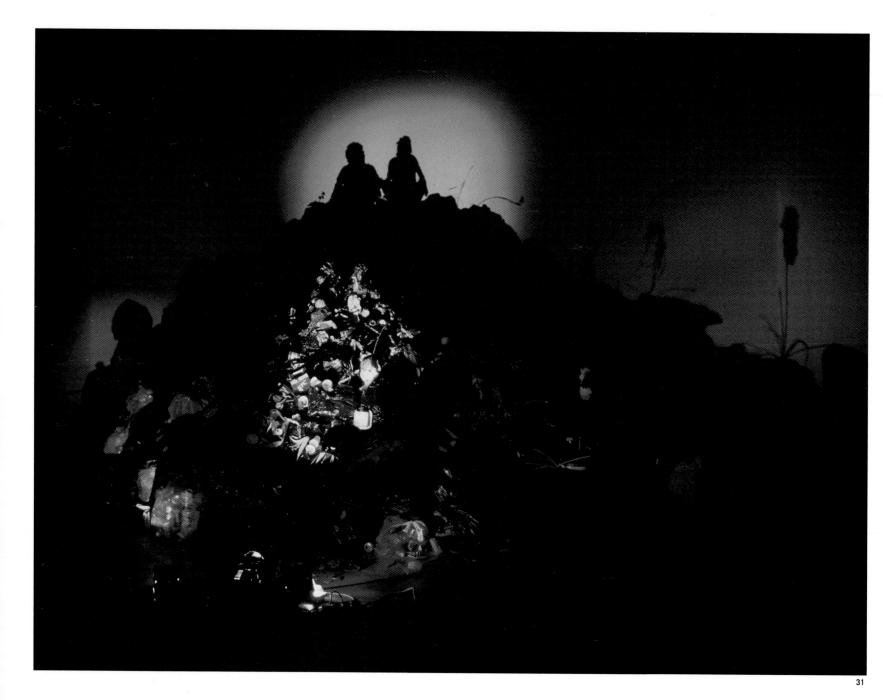

31 Tim Noble and Sue Webster,
The Undesirables, 2000.

32 Montein Boonma,
House of Hope, 1997.
Mixed media: steel grill, herbs, Chinese medicines

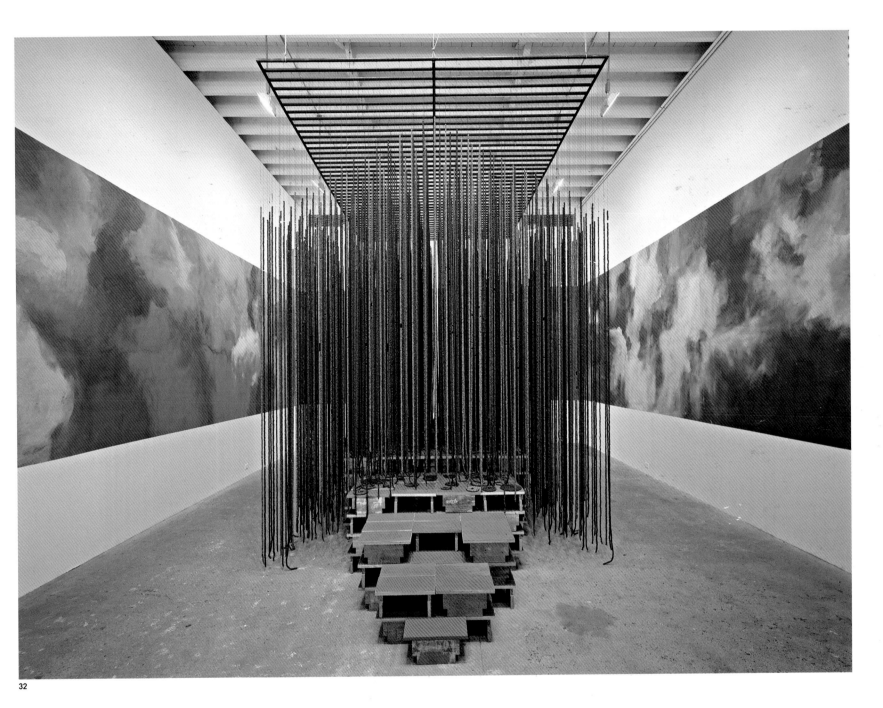

32

33

34

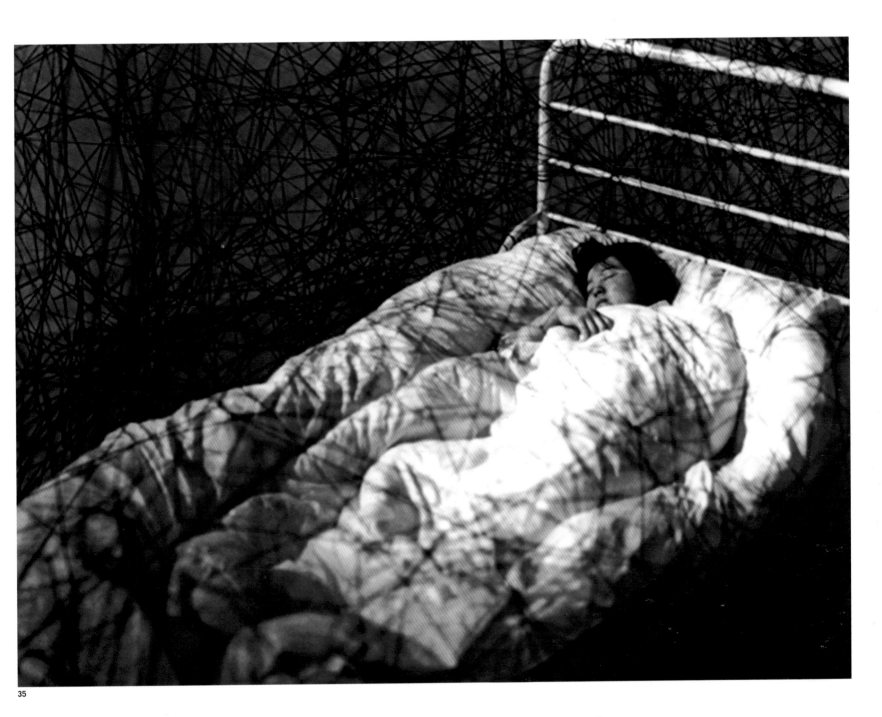

35

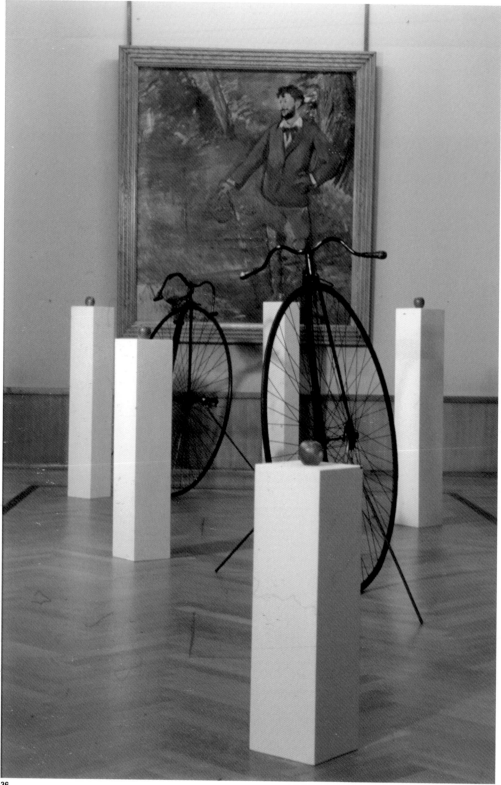

36 Braco Dimitrijevic,
Triptychos Post Historicus: Edouard Manet,
Portrait of Carolus-Duran, 1876, 2001.
Installation, 320 x 200 x 520 cm

Narrative installations cover a wide field of cultural reference. *Portrait of an Unknown Person* or *Peter Carl Fabergé's Nightmare* (1990) by the Russian duo Brodsky and Utkin (Alexander Brodsky and Ilya Utkin, both b. 1955) alludes to a celebrated composition by the Belgian Surrealist painter René Magritte (1898–1967), in which an apple seems to fill an entire room, and also to the Russian tsarist court goldsmith Fabergé (1846–1920), celebrated for his jewelled royal Easter eggs. Louise Sudell's *Electricity & Amor* (1999) contains not only an invented story about a lovesick construction worker wearing a helmet with a lightning rod fixed to its top, but also a reference to Benjamin Franklin's demonstration of the properties of lightning rods in the presence of the French king and his court in 1752. Others, such as *Breathing from Earth* (2000), a work by Chiharu Shiota (b. 1972), a Japanese artist now living and working in Germany, deal with personal obsessions and dream states, in this case with what a western audience will see as references to the legend of Sleeping Beauty, which, more than a century ago, enthralled leading Symbolists such as Sir Edward Burne-Jones (1833–1898). Installation art is therefore often simultaneously public and elitist – a situation that has already prevailed for some time and seems likely to continue.

A newer development is the tendency to make the museum itself into a paradigm. In practical terms this can operate in several ways. There are, for example, recent installations by Braco Dimitrijevic (b. 1948), some made for the Barber Institute in Birmingham, England, where the installation is a commentary on a painting the museum already possesses. A more usual approach is to mimic aspects of museum culture that were originally nothing to do with art. Old-fashioned science and natural history displays have proved to be fair game. Noble and Webster's *The New Barbarians* (2000) seems to have escaped from a diorama about primitive man, and this is also the case with a sculptural group by the American artist Tony Matelli (b. 1971), who was at one time an assistant of Jeff Koons. *Very, Very First Man: Necessary Alterations* (1998–99) shows one ape-like hominid trying to fasten a tail to the body of another ape-like hominid, thus reversing the processes of evolution.

In fact, it is the very aspects of museum display that have been discarded in the name of modernity that seem to fascinate younger artists. A celebrated example of this is the teeming miniature diorama *Hell* (2000) by the brothers Jake and Dinos Chapman (b. 1962 and 1966). This consists of over 5,000 miniature figures enclosed in the nine glass cases that are arranged in the form

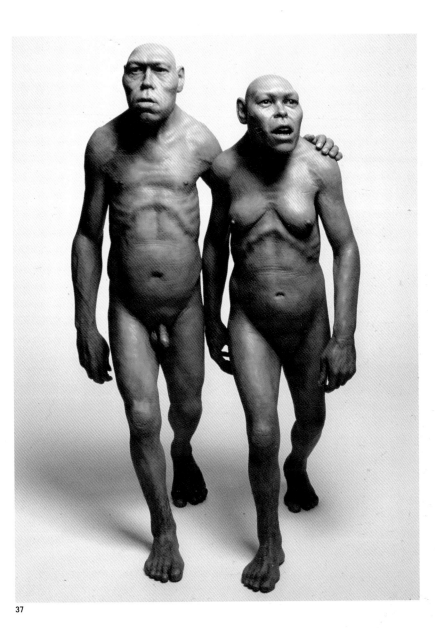

37

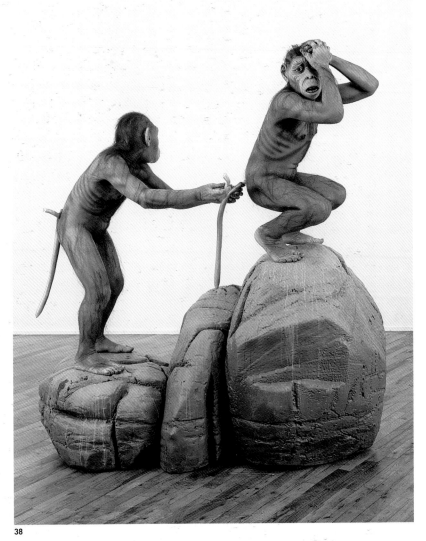

38

37 Tim Noble and Sue Webster,
The New Barbarians, 1997.
Fibreglass and translucent resin, 140 x 70 x 80 cm

38 Tony Matelli,
Very, Very First Man:
Necessary Alteration, 1998-1999.
Fibreglass and urethane, 183 x 168 x 97 cm

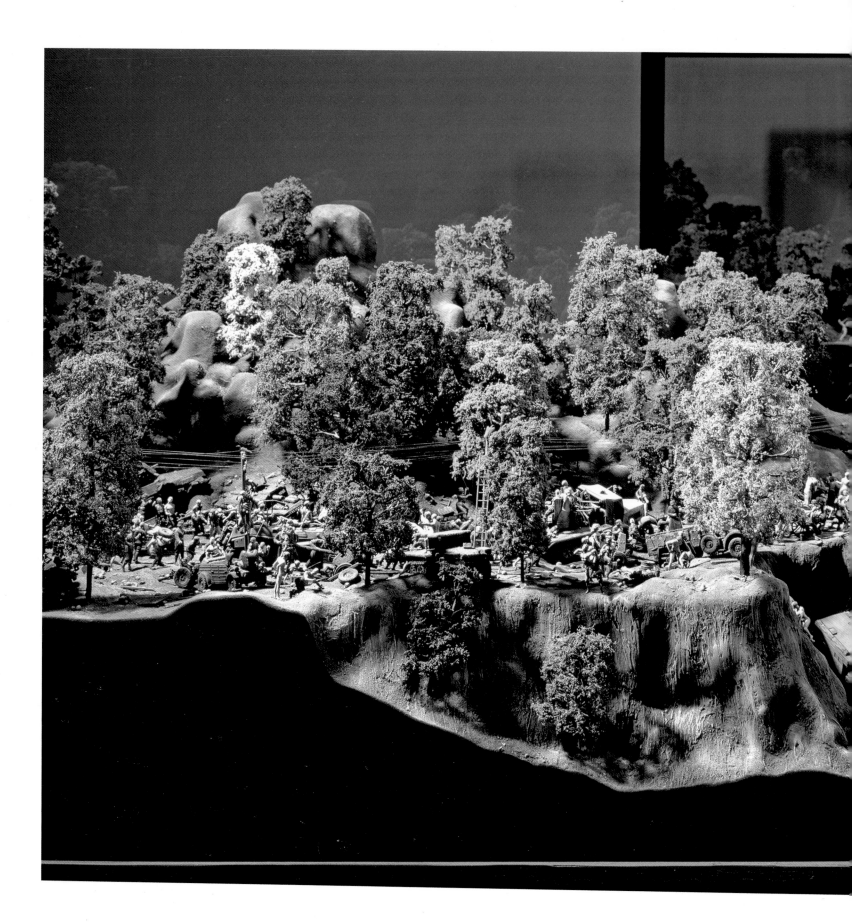

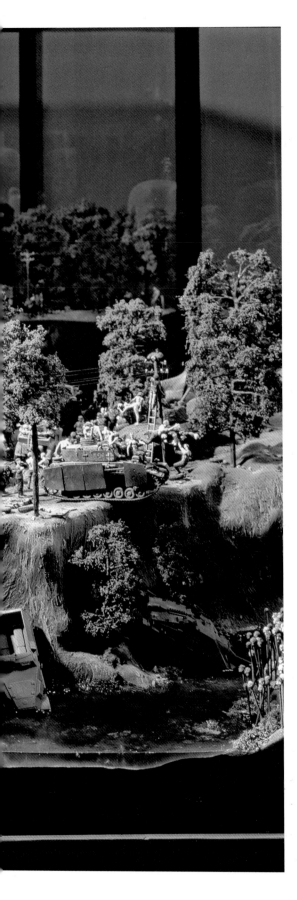

of a swastika. Some of the figures are dressed in Nazi uniforms, other show the genetic mutations familiar from earlier full-scale sculptures by the Chapmans. They indulge in grotesque acts of brutality, inspired by Goya's *Disasters of War*, the paintings of Hieronymus Bosch (c. 1450–1516), and photographs and accounts of the Nazi death camps. The main source, however, is clearly the elaborate battlefield panoramas that used to be a prominent feature of old-fashioned military museums. Though the Chapmans have declared that their aim is to make things 'with zero cultural value, to produce aesthetic inertia – a series of works of art to be consumed and then forgotten', this description hardly applies to the work just described. Like its Victorian predecessors, it implies the existence of a moral universe.

The Chapmans were not the first to use miniature dioramas of this kind as a vehicle for art. Another pair of artists, The Martinchiks (Svetlana Martinchik, b. 1965, and Igor Stepin, b. 1967), had already employed the idea for their depiction of the people and customs of an imaginary planet called Aiishana (1994). Once again the source was clearly the models favoured by old-fashioned museums dealing, not in this case with military history, but with archaeology and anthropology. Even before this, as early as the 1970s, the American artist Charles Simonds (b. 1945) had used a version of the same device – small, exquisitely made architectural models representing the remains of imaginary civilisations. This idea is so deeply embedded in our contemporary cultural consciousness that it also appears in works which at first glance seem to be abstract. An example is Simon Bill's (b. 1958) *Lost City Atlantis* (2000), where an apparently abstract design resolves itself into a city plan.

What all these varying approaches do, when considered as a whole, is to confirm the powerful hold that the idea of the museum now exerts on the popular imagination. Museums and major exhibition spaces, far more than the churches or theatres that once took on this role, have become a focus for the community. They have also become, like cathedrals and pilgrimage churches in medieval Europe, emblems of urban, regional and national identity. People visit them for a wide variety of reasons – to be informed about art perhaps, but also to be entertained and/or uplifted and overawed. At the same time, however, the relationship is an uneasy one, since museums often demonstrate an elitist contempt for the mass audience, or at any rate encourage such an attitude in many of the artists they display and for whom they are now a chief source of patronage.

40

41

39 Jake and Dinos Chapman,
Hell, 1999-2000.
Mixed media: glass-fibre, plastic/9 parts/
8 x (245 x 120 x 120 cm), 1 x (120 x 120 x 120 cm)

40 Svetlana Martinchik and Igor Stepin known as:
The Martinchiks,
Planet Aiishana:
The Ho People, 1994.
Mixed media: plasticine, wood, water, plexiglass,
map, 300 x 554 x 58 cm

41 Simon Bill,
Lost City Atlantis, 2000.

39

the heritage of pop

chapter three ••••

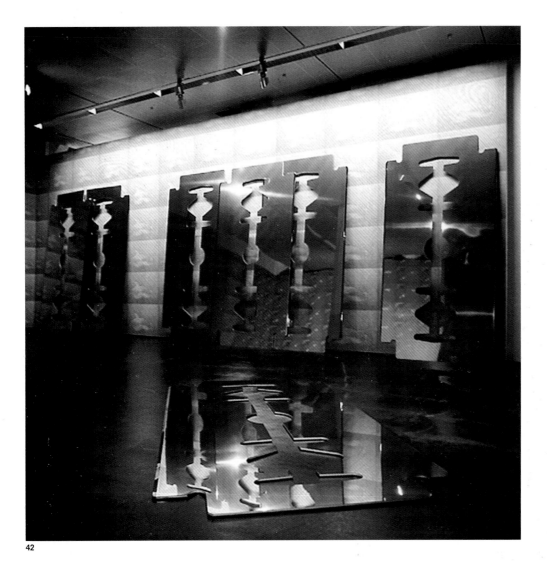

42

the whole matter of using stylistic criteria as a means of classification into disfavour. Currently Pop elements appear in many contemporary art works. Few of these, however, are directly comparable to the work made in the 1960s. Sylvie Fleury's (b. 1961) giant razor blades (2001) are exceptional in being very close to items made by Claes Oldenburg (b. 1929, later collaborating with his wife Coosje van Bruggen (b. 1942) during the 1960s and 1970s.

One leading characteristic of Pop Revival, if one can call it that, is its liking for a kind of sugary infantilism. Examples are Rob Pruitt's (b. 1964) glitter-dusted pandas (2001), Nancy Chunn's (b. 1969) *All Fall Down* (2000) and Rachel Feinstein's (b. 1971) *Yesterday* (2000). Nancy Chunn's work, though it resembles a somewhat zany Christmas card, may contain an element of irony or sarcasm – one can deduce this from her best-known series, which was entitled *Front Pages* (1996) and consisted of a year's worth of the front pages of *The New York Times*, altered and overprinted with rubber stamps that commented on the day's headlines. In *All Fall Down*, a flock of celebratory cupids flutter gleefully in the heavens, apparently raining blessings on various emblems of the consumer culture. On closer examination, however, what they are presiding over is a scene of mass destruction, an interpretation reinforced by a bold inscription at the lower right: 'May It Be Over'. The graphic style is familiar from its commercial employment not only for holiday greetings but also for related items such as gift wrap.

Rob Pruitt's depictions of pandas are celebratory, not ironic. The artist's interest in the motif can be traced back to a childhood spent in Washington, DC, where, from 1972 onwards, a pair of pandas sent from China were a major attraction in the local zoo. The diamond-dust surfaces derive from late works by Andy Warhol that employ the same technique. Warhol applied it not to pandas, but to portraits of his own contemporary and rival, Joseph Beuys. Rachel Feinstein's work has something in common with that of Jeff Koons, in that the source of *Yesterday* seems to be some kind of debased ornament made of porcelain – an ornament whose ancestry can be traced back quite a long way, to the groups and statuettes of shepherds and shepherdesses turned out in the 18th century by leading German porcelain factories such as Meissen and Nymphenburg. The original Pop style eschewed historical allusions of this sort, even when, as in this instance, they are carefully kept at arm's length. The convention used for the figures resembles that to be found in Nancy Chunn's work. In both cases,

Late 20th-century art experienced real difficulty in finding ways to reflect the nature of contemporary society. Until comparatively late in the century, narrative art forms were regarded as the antithesis of avant-garde activity in the arts, and as being indeed, the province of everything that was anti-modern. The first post-World War II art style to tackle the question of mass culture was Pop Art, and this may account for Pop's extraordinary durability. It even survived the shift in critical thinking that brought

42 Sylvie Fleury,
Razor Blade, 2001.
Aluminium dibond and high-grade steel / ed:8,
290 x 145 x 1 cm

43 Rob Pruit,
Pa, 2001.
Enamel paint and glitter on canvas,
244 x 183 cm

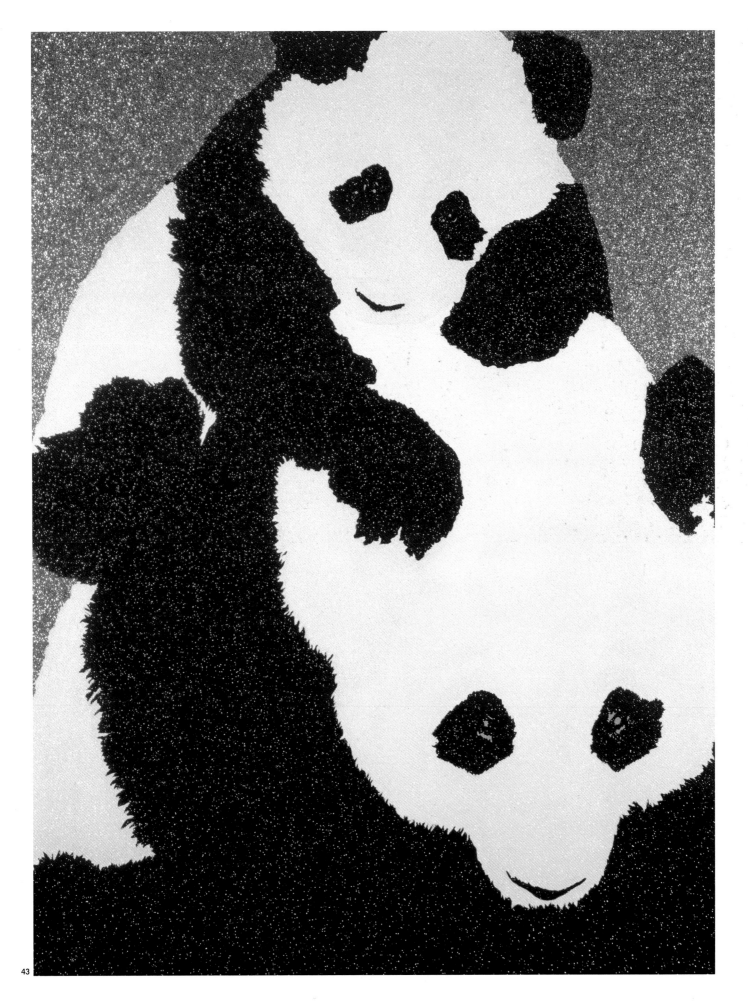

43

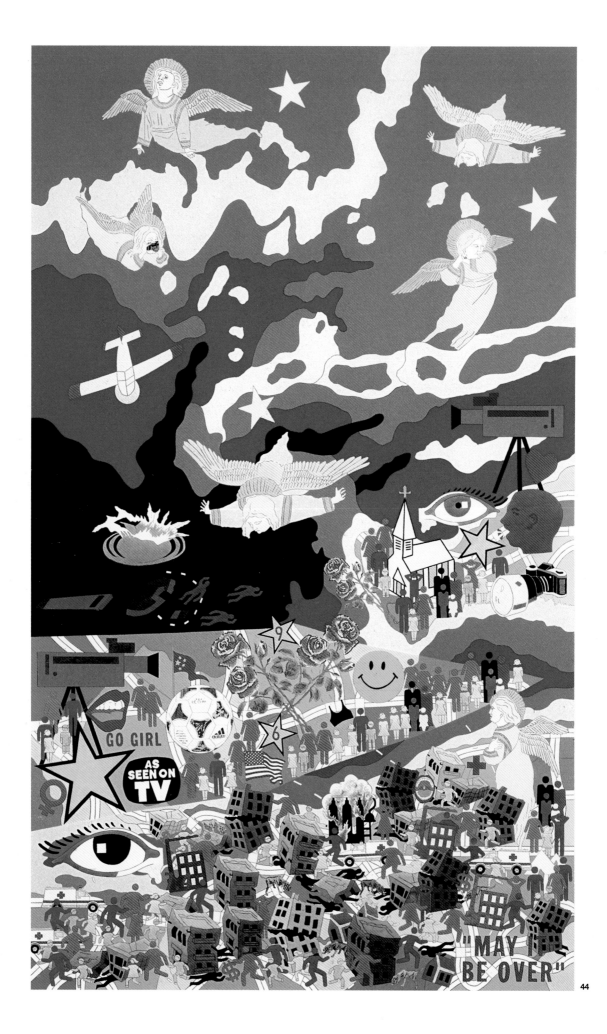

44

the ultimate source seems to be the conventions used in such Disney cartoon films as *Snow White*. It is perhaps worth mentioning here that in 2000 Feinstein was included in an exhibition of work by younger artists held at the Whitney Museum in New York and entitled 'Pastoral Pop'. The phrase neatly encapsulates the contradictory impulses to be found in *Yesterday*. One thing that eluded Pop in its original form was any version of the pastoral.

This heavily sweetened version of Pop has flourished most vigorously in the United States, but is also to be found elsewhere, for example in paintings and sculptures by the British artist Julian Opie (b. 1958). Opie's work encompasses both paintings and three-dimensional objects. *Office Buildings* (1996) is an example of the latter. Opie has said that he 'would rather combine and manipulate existing languages than invent a new one'. He has also compared his own work to 'the simple graphics of computer games'. This suggests that his is an essentially mechanical, industrial art, in tune with high technology. This is not the impression it makes when looked at in isolation. His office blocks belong to a universe that is manageable because it is simplified and toy-like – stripped of its complexities and turned into something completely unthreatening.

In unstable societies – in Russia, for example, or in Israel – Pop innocence is used as a form of defence against the threat of chaos. Valery Katsuba's (b. 1965) photograph of a group of friends in the snow, all of them wearing clown's noses and Mickey Mouse ears (*Morning in the Pinewood*, 2000), is a parody of a painting by the Russian landscapist Ivan Shishkur (1832–1898) that was much used in the Soviet period on chocolate boxes and calendars. The puppet dramas and videos created by the young Israeli duo Zoya and Ruti (Zoya Cherkassky, b. 1976, Kiev; Ruti Nemet, b. 1977, Tel Aviv) seem to be attempts to create a simpler, safer and more charming universe than the one that the artists themselves are forced to inhabit (*Yoavb.*, no. 10, 1997).

A few contemporary artists, notably California-based Mike Kelley (b. 1954), subvert this sweetened innocence by giving it a deliberately nasty twist. At the beginning of the 1990s, Kelley made a considerable reputation with assemblages made from second-hand stuffed toys. At first glance *Arena #11* (Book Bunny) (1990) is a completely innocent assemblage of pre-existing artefacts. It consists of a small crocheted blanket, upon which sit two cans – different varieties – of RAID insect repellent, together with the stuffed rabbit of the title, which is bent over a book. The subtext – that what is suppos-

45

46

44 Nancy Chunn,
All Fall Down, 2001.
Acrylic on canvas, 259 x 152 cm

45 Rachel Feinstein,
Yesterday, 2000.
Wood and enamel,
F: 244 x 244 cm x 4, B: 183 x 153 cm x 4

46 Julian Opie,
You see an office building (3), 1996.
Oil-based paint on wood, 185 x 160 x 45 cm
+ detail, 1996.
Water-based paint on wall

47

47 Valery Katsuba,
Morning in the Pinewood, 2000.
Black and white print on paper, 50 x 60 cm

48 Zoya Cherkassy and Ruti Nemet known as:
Zoya and Ruti,
Yoavb: The Complete Portfolio, 1997.
Portfolio of digital images (variable)

49

50

edly innocent is in fact messy and nasty – was brought out in performances and performance photographs, such as Kelley's *Innocence of Childhood*, dated the same year. In this work we see adult performers simulating the actions of children, and what they are doing with the stuffed toys that surround them verges on the obscene. Kelley's work was controversial as soon as it appeared. The conservative critic Jed Perl, writing in *The New Criterion*, almost immediately launched an attack on it: 'Why the subject matter has slipped in the past few years from the concerns of eighteen-year-olds to (sometimes) the concerns of eighteen-month-olds, I can't say for sure. In part it's probably just the wheel of fashion, turning in response to a shift in demographics: baby-boomers are having their own babies. But childhood may have a particular attraction for the poststructuralists, with kids or without. The late-adolescent persona, with its screaming "I," is harder to deconstruct than the young child, who can be made to look, at least by the adult who wants to present a postmodern indictment of our times, like a totally passive, receptive being. In the current downtown mythology, American suburbia is the factory where people are mass produced. Basically, the new view of youth isn't nostalgic, it's sensationalist.'[1]

Other artists with links to Pop have been careful to avoid this kind of controversy. Will Cot-

ton's (b. 1965) *Love Me* (1999–2000) hovers between Pop Art and Super Realism. It is a luscious Valentine's Day still life, which seems to owe a great deal to Jeff Koons. Like many Pop works, it manages both to have its cake and eat it (a particularly appropriate metaphor in this case). Part of the audience enjoys works of art of this kind without forethought or afterthought. Another, more sophisticated segment perceives the imagery as being essentially ironic.

In fact, almost the only artists who have linked Pop conventions directly to social criticism or ideas about morality have been women – generally women with strong feminist convictions. Barbara Kruger (b. 1946) has long been famous for hard-hitting text pieces based on the conventions of advertising. Her *Untitled: Everything Will be OK/Everything Will Work Out/Everything is Fine* (2000) is an example of this. The satire now extends beyond gender differences and gender inequality to an attack on the bland – and blinkered – optimism that advertisers routinely encourage. Jenny Holzer (b. 1950) uses the light diodes familiar from public announcements of all kinds to deliver disturbing messages. Her installation for the Neue Nationalgalerie in Berlin (2001) is a virtuoso example of this technique. Built in 1968 to a design by Ludwig Mies van der Rohe (1886–1969), the top floor of the building is a rectangle walled with glass, but otherwise open

49 Mike Kelley,
Arena #11: Book Bunny, 1990.
Mixed media on afghan, 196 x 152 cm

50 Mike Kelley,
*Nostalgic Depiction
of the Innocence of Childhood,* 1990.
Sepia-print, 24 x 16 cm

51 Will Cotton,
Love Me, 1999-2000.
Oil on linen, 245 x 305 cm

52 Barbara Kruger,
*Untitled: everything will be okay / everything will
work out / everything is fine,* 2000.
Photographic silkscreen on vinyl, 280 x 205 cm

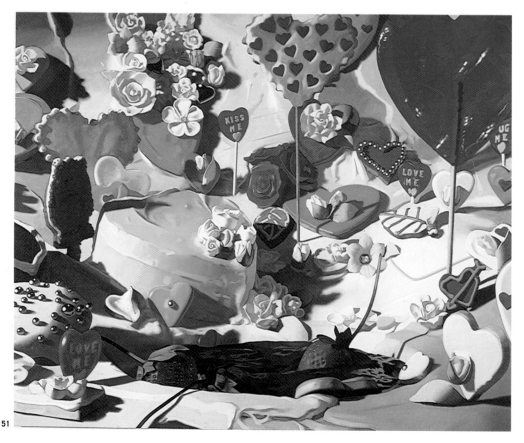

51

to the city. Holzer installed her characteristic scrolling electronic writings on the ceiling and along the thirteen longitudinal ribs that hold it in place. At night the architecture of the museum disappeared and from afar one saw only the writings continuously floating past. At a distance from where it was impossible to make out what they said, they appeared to be simply decorations for some celebration or other. As the spectator drew closer, peremptory phrases, such as 'I Observe You', 'Abuse of Power Comes as no Surprise' and 'Extreme Self-consciousness Leads to Perversion', became visible. These became part of the public space and contrasted with the illuminated advertisements, dense with logos and slogans, that dominate the area in which the museum stands.

It is interesting to contrast these highly industrial and technological works with a recent series by Judy Chicago (b. 1939), the best-known artistic figure in the American feminist movement. Working in collaboration with a team of skilled needleworkers, Chicago produced a series of works with the collective title *Resolutions: A Stitch in Time*. These were embodiments of optimistic proverbial phrases such as 'Do A Good Turn' (2000). This particular item in the series was based on the traditional pattern used for 19th- and early 20th-century 'eye-dazzler' quilts. It refers to a long established tradition of American popular art, but cannot be regarded as generically Pop. And the message, of course, is positive rather than negative.

In European societies, where the division between 'craft' and 'industry' is less rigid, it has sometimes been possible for artists to make works which hover between the world of mass-culture, whose values have been so skilfully exploited by Jeff Koons, and a much older, more artisanal popular tradition. The Italian sculptor Bruno Chersicla (b. 1937) produces delightful figures that look like large, free-standing jigsaw puzzles. The example illustrated is a portrait of a celebrated compatriot, the director Giorgio Strehler (1921–1997), founder of the Piccolo Teatro in Milan. These seem to owe something to the wooden carvings that used to adorn the roundabouts and other rides at old-fashioned fairgrounds. Given Strehler's own commitment to 'popular', democratic theatre, this seems an especially appropriate way in which to depict him.

One significant recent development in the Pop tradition has been the fashion for lightweight, almost throwaway drawings and sequences of drawings. Work of this type is rooted in the underground comics of the late 1960s and 1970s, notably the work of Robert Crumb (b. 1943). However, whereas Crumb sometimes

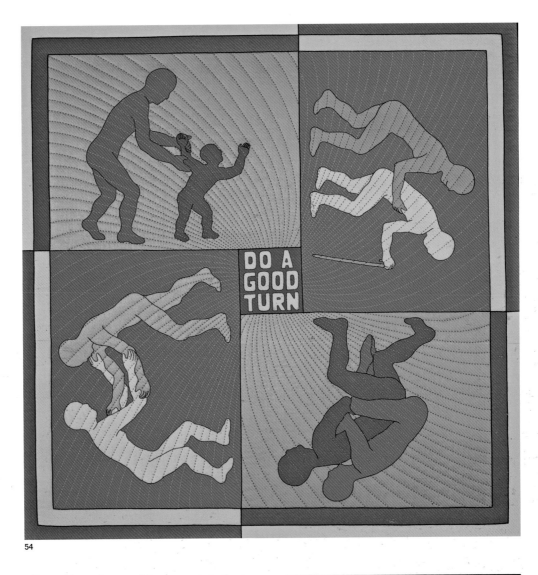

54

offers quite serious social comment, in the tradition of Weimar Republic satirists such as George Grosz (1893–1959), Raymond Pettitbon (b. 1957) and his peers tend to eschew anything so obvious. As the artist once told an interviewer: 'Actually, I really want to disagree with the idea that there is much of an emotional spring to my work. I'm sure there are more distant artists than myself, but I think, for better or worse, that I'm on the outside in a way. My art just doesn't come out of emotion. It doesn't really draw up that much heat, personally. Partly that's a reflection of my personality, I guess'.

Ann Temkin, curator of the retrospective of Pettibon's work shown at the Philadelphia Museum of Art in 1999, was also notably vague when trying to define its effect:

You say, 'OK, I am going to look at this art, I'm going to follow this art and it's going to lead me to its destination that this artist has desired for me.' The thing about Raymond's work is that there is no way to do that. No two people are going to read one of these drawings and connect it with the image in

55

the same way that I would . . . It definitely gets away from the whole masterpiece ideal, getting away from the sort of big expensive artwork mystique of the '80s . . . He came of age in this era when big oil paintings – expensive oil paintings – became the high art thing and their prices went through the roof. You had these collectors fighting over them, and I think for people who were slightly younger, coming of age at that moment it was like, 'Oh, gross. This is so capitalistic, show-offy and ostentatious.' Artists like Raymond were saying to themselves, 'This is not the kind of artist I want to be.' They kind of veered to the other extreme. In other words this is a kind of Pop or at any rate popular art that subverts consumer attitudes and consumer value systems.[3]

Nevertheless, for American spectators Pettibon remains quintessentially American. Ms. Temkin is quite certain of this: 'You certainly get the feeling that he has the pulse of America, There's lots of Elvis, lots of Charles Manson, Joan Crawford and even Ringo Starr. It's really critical of America in a sort of gentle, around-the-bend kind of way.' Criticism, however, is hard to discern in an image like *Mimicked* . . . , with its exuberant celebration of West Coast surfer culture. Though Pettibon began his career as a supplier of album cover designs for punk rock bands, the world evoked here is that of the Beach Boys. Though Pettibon has been much exhibited outside the United States, and has even found imitators in other countries, such as the Franco-German duo Petra Mrzyk (b. 1973) and Jean-François Moriceau (b. 1974), his work remains distanced from European sensibilities in a way that Andy Warhol's, for example, is not.

Another very American manifestation is the work of The Art Guys (Michael Galbreath, b. 1956; Jack Massing, b. 1959). The duo first met at the University of Houston in 1982, and have worked together as a team since 1983. They are now the best-known artists in Houston's lively contemporary art scene. A local journalist has described them succinctly as 'court jesters of the post-modern age'. The Art Guys specialise in manifestations where the line between art and life is deliberately blurred. They also blur the distinction between art and commerce. A typical project, *Sweet and Sour* (2002), was created for a large supermarket. They described the work as follows:

Sweet and Sour consists of five different themes, or shows, all of which use photographic images as their source material. The five themes include: 'Greetings From Hous-

57

ton,' The Art Guys' interpretation of souvenir postcards from our beloved city of Houston. (Wine and Beer section). 'Attention Shoppers' are photographs of details of Central Market itself. These images were enlarged and placed in close proximity to where the original photograph was taken. It's a simple gesture that attempts to shift one's focus just slightly – a sort of Zen for shopping. (Grocery, Frozen Food, and Bulk sections). 'This Week's Special' is a series of works that pushes the medium of photography to its limits. All of the abstract images are photographs that have been greatly manipulated and transformed using a computer. The text is a play on advertising slogans – a nod to the purposes for which the medium of vinyl floor graphics is normally used. (Bakery section). 'Face Value' is a group of stretched, pulled and scattered self-portraits of The Art Guys. (Prepared Meal Counter). 'Short Films' is a series of sequential video stills. (Checkout Lanes). We will also place signage on the floor informing the viewers of what to expect to see on the floors and who we are.

Like Pettibon, but using very different means, The Art Guys' aim is to remove contemporary art from its pedestal, to challenge perceptions that art is somehow a sacred event. Though both they and Pettibon mount shows in museums, there is an implicit challenge in this kind

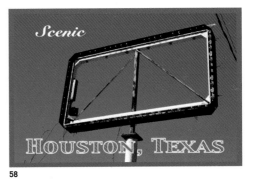

58

56 **Raymond Pettibon,**
No Title: mimicked in its, 2001.
Pen and ink on paper, 190 x 215 cm

57 **Petra Mrzyk and Jean-François Moriceau,**
Untitled, 2001.
Drawing on paper, 29 x 21 cm

58 **The Art Guys, Jack A. Massing and Michael Galbreth**
Greetings From Houston #4, 2002.
Laser jet print on laminated floor vinyl, 40 x 60 cm

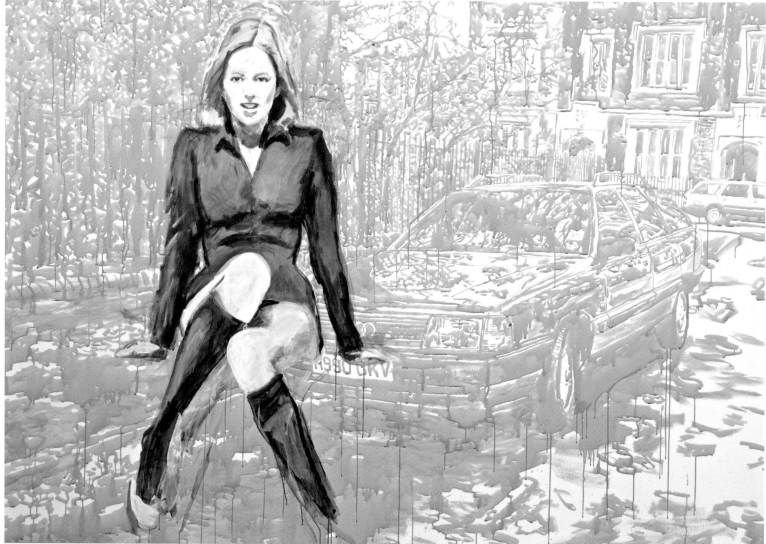

59

59 Merlin Carpenter,
The Estate of Sara Cox, 1999-2000.
Acrylic on canvas, 195 x 360 cm

60 Neo Rauch,
Händler, 1999.
Oil on paper, 116 x 72 cm

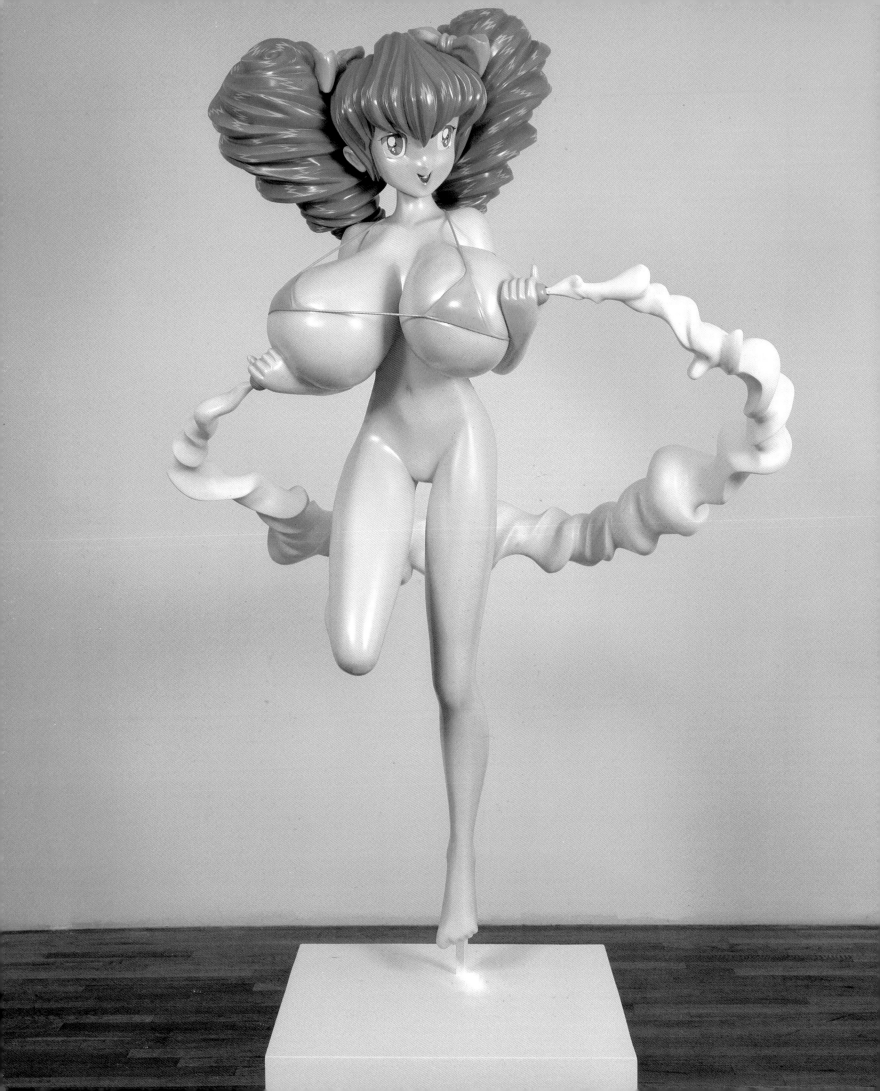

of art to the viability of the museum concept – or at least the concept of the museum as a cathedral for the worship of art.

In recent years, the Pop sensibility has been through some interesting transformations, particularly in Germany and Japan. Merlin Carpenter (b. 1967) is a British painter who divides his time between London and Berlin, and who has perhaps exhibited more often in Germany than he has in his native country. *The Estate of Sara Cox* (1999) is fairly typical of at least one aspect of his work. It shows his preoccupation with aspects of Pop subject-matter – cars and girls – but also an interest in the contrast between areas which are 'finished' and others which are definitely unfinished. In an interview with Isabelle Graw, held at the Vienna Secession on 30 March 2000, Carpenter expressed the Warholian view that he was 'trying to get away from the idea of producing a meaningful image. You'd have to use something that's sort of a cliché because that is the only way you can make an image mean nothing if it's already known. It's a very difficult question; I think it's almost unanswerable.'

His work is nevertheless much more nuanced than that of Andy Warhol. For example, while it makes references to fashion photography, the images tend to be deliberately distanced – the girls wear clothes which belong, not to the 1990s or the 'noughties', but to the mid-1980s. Neo Rauch (b. 1960) is currently one of the most successful of Germany's younger artists. *Händler I* (1999) demonstrates the individuality of his style, which seems to derive from illustrations in old-fashioned children's books. His choice of source material may be due to the fact that he was born in Leipzig and spent his formative years in the DDR, rather than amidst the rabid commercialism of West Germany. He trained under Bernhard Heisig (b. 1925), one of the leading figures in East German art, and still lives and works in the city where he was born. A press release for Rauch's solo exhibition at the Guggenheim Museum in Berlin (March-June 2001) remarked with some shrewdness that 'Neo Rauch's pictures lead the observer into an irritating world of productivity whose purpose has been forgotten.' As any visitor can attest, this sentence precisely sums up the atmosphere of the GDR in the years of its decline.

Takashi Murakami's (b. 1962) *Hiropon* figures (1997) draw on specifically Japanese Pop manifestations, such as *anime* (animated cartoon films) and *manga* (Japanese strip cartoons). The artist describes his work as being, not purely Pop, but as 'poku', a fusion of Pop and Geek (the Japanese for 'geek' is *otaku*). For many Japanese intellectuals, *otaku*, with its

62

emphasis on the technological as well as the popular, is Japan's first unique contemporary cultural movement. The fevered eroticism of the Hiropons is especially provocative within the context of contemporary Japanese urban life, with its curious mixture of the self-consciously childish, the sleazy and the puritanical. Another Japanese artist working in a similar vein is Koji Mizutani (b. 1951). Mizutani's photo project *Merry* (2000) consists of 464 por-

61 Takashi Murakami,
Hiropon, 1997.
Oil, acrylic, fibreglass, iron / ed: 3, 178 x 112 x 99 cm

62 Koji Mizutani,
Merry 1, 2, 3, 2001.
Installation with 200 photos on panels, 146 x 103 cm

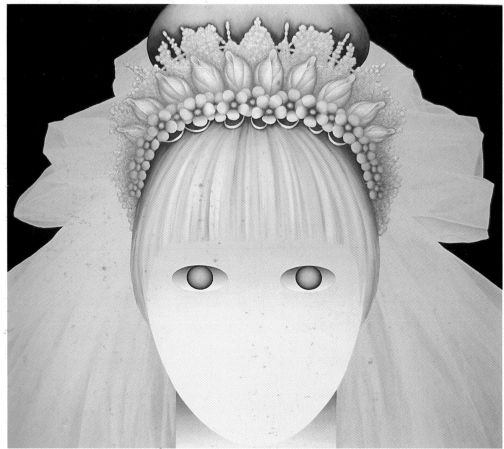

63 Masato Nakamura,
Family Mart, 1996.
Mixed media and light box, 395 x 270 x 25 cm

64 Glauce Cerveira,
I Made It, 2000.
Oil, acrylic and mixed-media on canvas,
120 x 140 cm

traits of female teenagers, taken in the streets of Tokyo's Harajuku quarter, the headquarters of Japanese street fashion. When he took each picture, Mizutani also asked each girl a question, 'How do you express your "merry" state?' He asked them to write down a few words describing what made them happy or what their dreams and hopes for their future were. Each girl's handwritten statement is reproduced at the bottom of each portrait. Superficially optimistic, the *Merry* project is in fact the product of a decade-long economic recession in Japan, and represents the desperate feelings of a generation of young people who wonder what the future has in store for them.

Another Japanese artist, Masato Nakamura (b. 1963), has made abstract works that replicate convenience store signs, but with the lettering removed. A compatriot would, however, immediately recognise the reference to *Family Mart* (1996) from the colour coding and the layout. Works of this kind take the *Brillo Boxes* that Andy Warhol made in the 1960s a step further, and at the same time offer a response to the frenetic glitter of Tokyo's Ginza.

It is not surprising that Japan's vigorous new take on the ideas and values of Pop Art should now be having an impact elsewhere. Glauce Cerveira is a young Brazilian artist who has settled in London. *I Made It* (2000) – the title can be both a declaration of responsibility and a claim to have succeeded (the personnage represented appears to be a bride who has 'made it' into marriage) – has a distinct echo of the *anime* which are now becoming a cult outside Japan.

Pop influences, both oriental and occidental, can of course be inflected in many different ways. Bedri Baykam (b. 1957), probably the best-known Turkish contemporary artist, is fascinated by western pin-ups. *Shiver* (2000) comes from a recent series of such images, collectively entitled *Girly Plots*. There is, however, an additional element here. Turkish secular society, originally created by Kemal Ataturk in the years after World War I, is now under pressure from the Islamic revival that has affected almost all the nations of the Middle East. The *Girly Plots* paintings and collages are a defiant declaration of faith in Ataturk's secularism.

One can also perhaps attach a political meaning to *Leisure* (1999) by the young Lithuanian photographer Vita Zaman. This glamorous but incongruous figure, wearing roller-skates on what looks like a Baltic beach, represents several related but contradictory things: escape from the dreariness of the Soviet past; aspiration towards the richer lifestyle of western Europe; and frustration that the rules which govern this lifestyle still remain in some ways

65 Bedri Baykam, *Shiver,* 2000.
Artificial grass, acrylic, ink-jet print on canvas, 195 x 180 cm

66

66 Vita Zaman,
Leisure: Girl, 1999.
Colour-print, 80 x 120 cm

67 Yasumasa Morimura,
Self-Portrait Actress: after Rita Heyworth A,
1996.
Framed: ilfochrome, acrylic sheet, 50 x 50 cm

67

inaccessibly coded for those who inhabit a post-Soviet society. The young woman seen in *Leisure* might be a performer in a Surrealist film. One of the things that the new Pop Art has inherited from the original Pop of the 1960s is a fascination with the movies. On the whole, however, it is not contemporary movies that inspire art, but the now long-departed golden age of Hollywood. Warhol fixed his attention on Marilyn Monroe, who was his own contemporary. When the Japanese artist Yasumasa Morimura (b. 1951) chose a series of western film stars for his subject-matter, he also portrayed Monroe, but the other actresses who attracted him (Joan Crawford, Rita Hayworth and their peers) belonged to a somewhat earlier generation. An additional twist was supplied by the fact that the artist himself impersonated these long-gone screen goddesses, achieving the necessary transformation through wigs and skilful make up. Morimura himself

says: 'I don't do my painting on a canvas, I do my painting on my face.' When the Actress series was exhibited at the Tokyo Museum of Contemporary Art in 1998, the show included a video in which Morimura demonstrated the application of his elaborate make up. The cultural link is not hard to find: Morimura was suggesting that his subjects were the equivalents of the geishas who figure in Japanese *ukiyoe* prints.

Western artists have also been fascinated by Hollywood's most sumptuous epoch. The American film-maker T. J. Wilcox (b. 1965) made a film entitled *The Funeral of Marlene Dietrich*. Its genesis, as he explained, was Dietrich's habit of describing to friends the grand, baroque obsequies that she envisaged for herself. When the moment came, it was too late – the actress had outlived nearly all her contemporaries, and there were no star players to invite. Wilcox's film was designed to give Marlene the grand farewell she had so often imagined. The British artist Jonathan Monk (b. 1969), who works in a variety of different genres, undertook a somewhat related enterprise when he made a slide-projection installation called *In Search of Gregory Peck* (1997).

Cindy Sherman (b. 1954) originally made her reputation with a series of black-and-white photographs called *Untitled Film Stills*, which she began work on in 1977. These explored the stereotypes used to represent women in the films of the 1950s and 1960s. In every case, the woman enacting the role was Sherman herself. The genesis of these impersonations was Sherman's habit, when she was still an art student in Buffalo, New York, of going out in public dressed up as the comedienne Lucille Ball. Ball's immensely popular television series *I Love Lucy*, first aired in 1951, made her pretty much a 1950s stereotype in her own right. When the show was at its peak, in 1952–53, two-thirds of all American homes with a television set were watching it.

Later, in 1989–90, Sherman did a series based on the Old Masters, followed by other photographs in which the figures were constructed from prostheses found in medical catalogues. More recently she has returned to the subject of women and their status. Though the images are described as *Untitled* (2000), it is clear that they refer to stardom and its burdens. Sherman presents herself as a series of almost recognisable female entertainers, now visibly past their peak. Barbra Streisand seems to have been one source of inspiration. The pictures are funny, sad and a trifle cruel. They offer yet one more exploration of the cult of stardom that lies at the core of so much Pop Art.

69 Jonathan Monk,
In Search of Gregory Peck, 1997.
Installation: slide projection of 80 slides (detail)

70 Cindy Sherman,
Untitled # 205, 2000. Colour photo,
91 x 61 cm

69

70

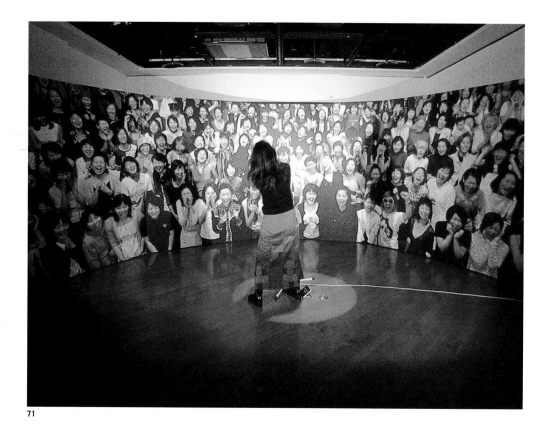

71

A fascination with the idea of the star prompted yet another Japanese artist, Hiroyuki Matsuka-ga (b. 1965), to devise an installation which turned the spectator – or perhaps in this case it would be more accurate to say the participant – into a star in his or her own right, at least for a few moments. *Star* (2000) confronts this partic-ipant with a microphone and a large photomu-ral of an enthusiastically applauding audience. Even apparently traditional forms of artistic expression respond to the allure of the cinema. France possesses perhaps the most enthusiastic and best-informed group of movie aficionados in the world. If Los Angeles remains the world headquarters of film-making, then Paris is the city with the greatest variety of cinematic offer-ings. The listings magazine *ParisScope* offers an incredible variety of possibilities – far more than those available in London, New York or even in Los Angeles itself. It seems natural that recent French art should have responded to this, even when the artist is using comparative-ly conventional forms. Jean-Luc Blanc's (b. 1965) *Sans Titre* (2001) is clearly modelled on a movie close up.

The boundaries that divide the fine arts from the so-called 'entertainment arts' have now in fact become very thin. Matthew Barney's (b. 1967) elaborate *Cremaster* series of videos (*Cremaster 4*, 1994; *Cremaster 1*, 1995; *Cre-master 5*, 1997; *Cremaster 2*, 1999) were some of the most-discussed visual arts events of the 1990s. The fantastic, sexually ambiguous realm that they inhabit is not, however, completely new. There are parallels, for example, with the films made by the Chilean director Alejandro Jodorowsky (b. 1930) in the 1980s and 1990s, and in particular with his masterpiece *El Topo* (1971). Barney stars in the movie with Ursula Andress, famous for her brief but telling role as Honey Ryder in the James Bond film *Dr. No* (1962). Long past her prime as a major movie star, Andress's presence reinforces the grotesque atmosphere of Barney's film. His decision to ask her to perform can be regarded as yet another nostalgic tribute to movie mythology.

Matthew Barney's chief rival in the territory that lies between avant-garde art and popular entertainment is Tony Oursler (b. 1957). Oursler has established his reputation through a wholly original use of video, which freed it from the television screen. Grotesque faces are projected onto the spheres and ovoids that serve as heads for dummies or puppets of vari-ous dimensions, ranging from very small to quite large (*Dedoublement*, 1996). These pup-pets deliver sotto voce monologues that are rambling streams of consciousness. Sometimes a sphere alone is used, and the visage it carries

71 Hiroyuki Matsukage,
Star, 2000.
Installation, 2350 x 900 cm

72 Jean-Luc Blanc,
Untitled, 2001.
Oil on canvas, 150 x 150 cm

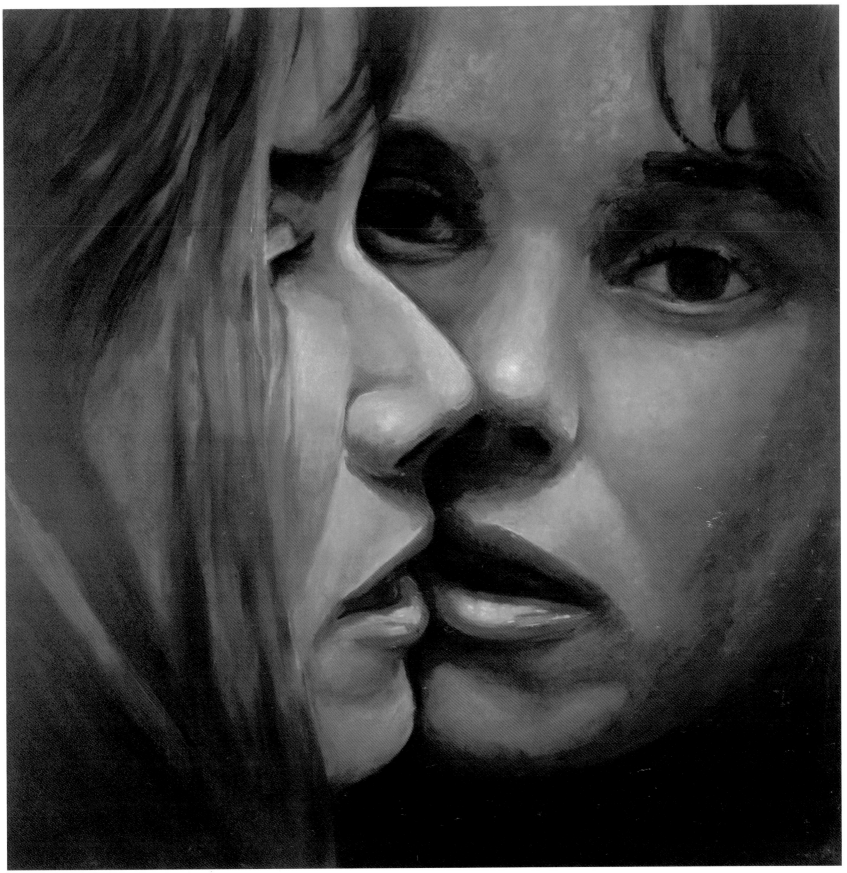

is reduced to a single vast eyeball. More recently Oursler has made large-scale works outdoors. *The Time Machine* (2000) was shown in centrally located spaces in New York and London. Large faces were projected onto trees, building facades and areas of artificial fog. Mysterious voices recited words written by Oursler himself, as well as texts from the history of electronic engineering.

Oursler's constant theme is the impact of the media society and the loss of personal relationships as a consequence of the development of technology. His characters often seem to be in pain. They curse the viewer and implicitly accuse him or her of voyeurism. At the same time, the artificiality of the means used to create them is constantly and brutally revealed. As Carol Rosen has written: 'Ultimately, Oursler is a contemporary voice, a storyteller who deals with alienation, the loss of control, and the anxieties of 20th-century man. To do this he uses the power of the projected image to explore the inner world as it coexists with the outer world, posing his questions about the impact of the media on our lives, ironically, through technology itself.'[4]

In one form or another, Pop images are likely to continue to play an important role in art, especially where they are married to the contemporary technology that forms and modifies urban mass-culture. However, the messages delivered by third and fourth generation Pop works are also likely to be less and less optimistic.

74 **75**

76

1 *The New Criterion*, vol. 9, no. 10, June 1991.

2 *Raymond Pettitbon*, London: Phaidon, 2001.

3 From an interview with Keith Ingersoll, *Princeton Packet*, 7 May 1999.

4 'What Are You Looking At? The Sculpture of Tony Oursler', *Sculpture Magazine*, vol. 19, no. 4, May 2000.

73 Matthew Barney, *Cremaster 5*, 1997.
Production still

74 Tony Oursler, *Dedoublement*, 1996.
Installation: 2 dolls, wooden shelf, steel rods, video projector, 185 x 35 x 50 cm

75 Tony Oursler, *Gag*, 1998.
Ceramic, water, video projection, 89 x 28 x 28 cm

76 Tony Oursler, *The Influence Machine*, 2000.
Video environment

representation of reality

chapter four

One of the keenest debates in 21st-century art is likely to concern something very basic – the way in which the visual arts relate to and represent reality. This debate has been complicated by two factors: the influence exerted by Marcel Duchamp (1887–1968), and in particular by Duchamp's invention of the ready-made; and the relationship between photography as art, and photography as non-artistic representation. One artist who is clearly an heir of Duchamp is the British sculptor Rachel Whiteread (b. 1963). Whiteread's reputation is based on works that are casts of negative spaces – the inside or underneath of architectural spaces, or of common domestic objects such as chairs, stools and bathtubs. A typical example is *Basement, No. 1* (2001), the negative image of a staircase. Commentators have been rather quick to find emotional, even sentimental, meanings in Whiteread's work. A great deal has been written, for instance, about her sculptures and sculptural installations as 'memorials to the human presence'. Essentially this is reading-in. There is nothing in the work itself that directly suggests this kind of emotional connection. It is, I think, more accurate to see what Whiteread does as the product of a sense of paradox. Things we would never think of as having artistic content are transformed by her and become art-objects. Whiteread's proposal for the vacant plinth in Trafalgar Square, London (*Monument*, 1999), was an economical example of this. What she did was to balance another plinth, identical in shape, but made of transparent material and upside down, on top of the existing one.

A somewhat similar conceit, but in this case greatly elaborated, lies at the root of the *Upside Down House* (2001), created by the Turkish Cypriot artist Sumer Erek (b. 1959) for Clissold Park, Stoke Newington, a recreational area on the north-eastern border of London. The aim is to twist the perceptions of the spectators sufficiently to make them experience

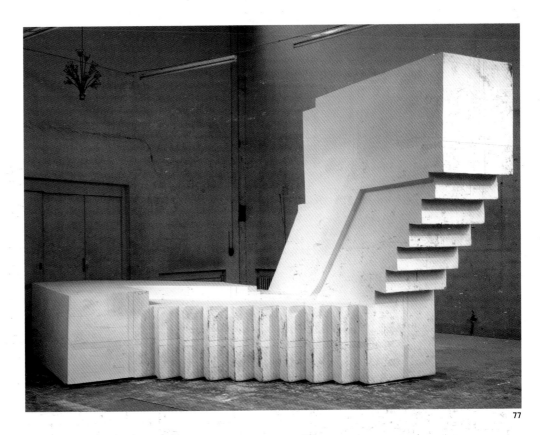

77

sharply something that they would normally take for granted.

Other artists have been quick to follow the same line of thought. An installation made by another British artist, Richard Woods (b. 1966), for the dining room of Tabley House, a splendid Palladian mansion in Cheshire designed by the 18th-century architect John Carr of York, substitutes a painted cloth for the original floorboards. The painted design imitates what is underneath, but changes the colour to a virulent green. This intervention makes a striking contrast with the paintings on the walls, which form part of a large collection of British art brought together soon after 1800 by the first Lord de Tabley. It provokes thought about the nature of painted simulacra, and their relationship to reality.

76 Rachel Whiteread,
Monument, 2001.
Resin and granite, 900 x 510 x 240 cm

77 Rachel Whiteread,
Untitled: Basement, 2001.
Installation: mixed media, 325 x 658 x 367 cm

78

78 Sumer Erek,
Upside Down House, 2001. Installation,
400 x 500 x 500 cm

79 Richard Woods,
Tabley House, 2000.

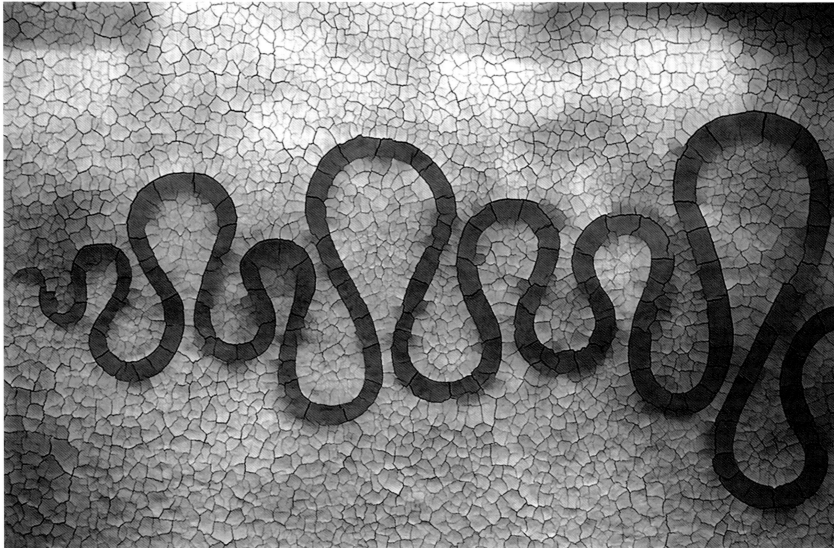

80 Andy Goldsworthy,
À la mémoire des arbres, 2001.

81 Ahmad Nadalian,
Riverart, 2001.
Colour-print on paper

81

Installations of this kind can be compared with others by contemporary artists that look in a completely different direction, and put great emphasis on the idea of nature and the natural. A leading exponent of art of this kind is Andy Goldsworthy (b. 1956). Goldsworthy works with material found at a particular spot, and his work is often deliberately ephemeral. Even when what he does is moved indoors to a gallery setting (*À la mémoire des arbres*, 2000), the stress is always on the idea of oneness with nature. In predominantly urban societies, of the kind that most lovers of contemporary art inhabit, art of this sort has great appeal. It has found a home in many different cultures. The New Zealand sculptor Chris Booth (b. 1948), for example, often works in close cooperation with the Maori community. His Cave (1994–97) forms the entrance to the Kati Kura *marae*, or Maori meeting place, at Kaikoura, on the rugged coast of New Zealand's South Island. It consists of 5,000 white limestone pebbles, collected from the coast with the assistance of the local community. The *marae* is both a ceremonial centre and a focus for Maori political life.

In Iran, Ahmad Nadalian (b. 1963) is in the process of creating an immense *River Art* installation along the banks and amidst the waters of the Haraz River, near Mount Damavend. Various symbols are incised on boulders – chiefly fish, which for the artist are 'emblems of the human soul, thirsty to experience life', but also human figures, emblems of hands and feet, and images of birds, goats, snakes and crabs. While some of these engravings are on a large scale, others are carved on small pebbles, and are left for casual visitors to find. Nadalian regards the discoveries these visitors make as acts of collaboration with the artist.

The tension between what is natural and what is deliberately, and indeed polemically, artificial is very much part of the story of current art. One of the ways in which contemporary society approaches the work of Land artists such as Goldsworthy, Booth and Nadalian is through the camera. It would not be an exaggeration to say that without photography art of this kind would be largely unknown, not only because of the remote locations the artists often choose, but also because of the ephemeral nature of the interventions which the artists make.

Photography occupies a central but ambiguous place in today's art, and is likely to continue to do so for some time to come. For contemporary society, it is the vision of the camera, but not necessarily the vision of the camera placed in the hands of an artist, which continues to dominate the way in which things and events are perceived.

At its beginnings, photography was thought of as a completely neutral and objective way of recording the substance of the world. In 1844 one the great photographic pioneers, William Henry Fox-Talbot (1800–1877), inventor of the negative-to-positive process, published the first book to be illustrated with photographs. He entitled it *The Pencil of Nature*, the implication being that God, or nature, could now, thanks to this new and wonderful technique, dispense with the services of the traditional fine artist. Later, at the beginning of the 20th century, Alfred Stieglitz (1864–1946) organised the Photo Secession, which lasted from 1902 until 1917. Stieglitz's aim, and that of his collaborators, was to raise photography to the level of a fine art, separate from but on a par with painting and sculpture. It was an essential part of their doctrine that photographs were subjective expressions of the sensibility of the person who made them.

83

82 Chris Booth,
Cave, Takahanga Marae, Kaikoura, New Zealand, 1994-1997.
Mixed media entranceway: stones, stainless steel, cable, wire, 300 x 300 x 500 cm

83 Vic Muniz,
Empire State, 2001.
Image from a public art project using a sky-writer

84

84 Nan Goldin,
Valerie on the stairs in yellow light, Paris, 2001.
Cibachrome print, 76 x 102 cm

85 Peter Fischli and Davis Weiss known as:
Fischli and Weiss,
London: British Air, 1997-2000.
Colour-print / ed:6, 4 x (124 x 190 cm)

85

86

Approaches to photography as an art form have continued to oscillate between these opposing points of view. For most of the time, the idea that photography is subjective has held the upper hand. Or, rather, it has held the upper hand whenever photographic images were considered as things with an independent existence as objects of art, and not as mere documentation.

Stieglitz's late series of *Equivalents* (begun in 1922) – photographs of cloud formations which the photographer aimed to raise to the status of abstract painting, find an ironic modern parallel in the 'Clouds' series (2001) by the Brazilian photographer Vik Muniz (b. 1961). The artist employed a sky-writing airplane to create primitive images of clouds, of the kind one might see in children's drawings, in the sky above New York. Muniz has also been responsible for the ironic questioning of other photographic modes. For example, there are the stereoptic images from his portfolio 'Principia' (1997). These use the vocabulary employed for scientific photography. But what looks like an extreme magnification of facial hair protruding from the skin turns out to be simply strands of black rubber pulled through the holes in a colander. The stereoptic lins that accompanies the works, and which enables the viewer to see them in 3-D, offers a false guarantee of scientific authenticity.

However, a new twist was given to the story when photographic documents began to be thought of as near relations to the Duchampian readymade. *Light Switch* (1992) by the British artist Ceal Floyer (b. 1968) is a case in point. It consists of an image of a light switch projected onto a wall, on precisely the same scale as the original object, and in the position where one might expect a real light switch to be. In other words, the artist plays a rather simple-minded game with the visual perceptions of the spectator, presenting him with an object that both is, and is not, present.

Obviously there is a big difference between this kind of photographic reality and the kind that is offered by the work of Nan Goldin (b. 1953). Goldin's *Valerie on the stairs in yellow night, Paris* (2001) belongs to a huge series of images made by Goldin during the course of thirty years of photographic activity. These pictures document her life in a peculiarly intimate, raw-edged fashion. Goldin herself once wrote, 'I believe one should create from what one knows and speak about one's tribe . . . You can only speak with true understanding and empathy about what you've experienced.' While it is

86 Bruno Serralongue,
Firework, Sérandon, 14 July 2000 #9,
2000.
Cibachrome on aluminium, frame in wood and glass, 161 x 127 cm

87 Ceal Floyer,
Light Switch, 1992.
Slide projector, 35 mm slide, plinth

87

possible to trace other, subsidiary influences, such as fashion photography, the basic metaphor Goldin uses in her work is that of the apparently artless amateur snapshot. 'This,' she seems to say, 'is my life as I have lived it, presented without concealment.' Where Floyer shuts any kind of emotion out of her images, Goldin's version of 'truth' as the camera presents it is primarily an emotional one.

Photography as a means of cataloguing the everyday is used in an entirely different fashion in the photographic sequences put together by the Swiss duo Fischli and Weiss (Peter Fischli, b. 1952; David Weiss, b. 1946). Their basic aim is, as they put it, to 'slow time down' by forcing the spectator to focus on the banal. Their *Airports series* (1997) is an example of this, consisting of a series of images of large international airports, represented as thousands of travellers see them, without emphasis, and seemingly without point. Fischli and Weiss do not confine themselves to photography – they also make videos and sculptures that dwell on the banal – some of their sculptural installations, for example, are painstaking reconstructions of rooms apparently filled with litter.

A similar approach has been used by the French photographer Bruno Serralongue (b. 1968), albeit without the ironic overtones present in the work of Fischli and Weiss. An example is Serralongue's beautiful sequence of images in *Fireworks, Sérandon*, made on 14 July 2000. To commemorate both the new millennium and the day (the French national holiday commemorating the fall of the Bastille), a group of leading French photographers were commissioned to record the picnics held throughout France. Serralongue's pictures were a by-product of this – his own private celebration.

His sequential approach owes a great deal to the work of Bernd (b. 1931) and Hilla (b. 1934) Becher, two German photographers who became famous in the 1960s for their painstaking documentation of industrial facilities, such as water towers and blast furnaces, which they presented in generic groups. Bernd Becher was appointed Professor of Photography at the Kunstakademie in Düsseldorf in 1976, and his teaching there has influenced several generations of German photographers. Examples are the sumptuous photographs of museum interiors and other art-connected spaces (San Zaccaria, Venice, 1995) made by Thomas Struth (b. 1954), and the work of Andreas Gursky (b. 1955).

Gursky was, like Struth, a student at the Kunstakademie, and his work, certainly at first sight, seems to have been strongly affected by the Bechers' 'objectivism'. In an interview with the French newspaper *Le Monde* (22 February

88

89

88 Thomas Struth,
San Zaccaria, Venice, 1995.
Colour print, 235 x 187 cm

89 Andreas Gursky,
Singapore - Symex, 1997.
Colour print, 176 x 276 cm

90 Matthiew Dalziel and Louise Scullion
known as: **Dalziel and Scullion,**
'Drift', (detail) 2001.
Freestanding photographic prints on digital
canvas stretched over timber frames clad at
rear with dressed birch ply, 300 x 400 x 50 cm
to 20 x 400 x 175 cm

91

2002), Gursky pointed out that he is in fact both the son and grandson of commercial photographers, and did not originally think of himself as an artist. He also noted that one of the things that freed him to work in the way that he now does is the availability of digital techniques, which enable him to pull the image apart and then recompose it. 'From 1991, I have used the computer as a means of altering the image, sometimes making big changes and sometimes only small ones.' 'But,' he added, 'this process should not be visible, or modify the spectator's perception of the work.' The image is thus in Gursky's case no longer purely objective, in that objectivity itself becomes a kind of fiction. There is also another aspect of digitisation: it makes it much easier to create pictures of considerable size, able to compete, in terms of scale, with the very large paintings we are now accustomed to seeing on the walls of museums. Many of Gursky's most striking images are about collective activity (*Singapore-Symex,* 1997). It is this, in addition to their imposing scale, that makes them so very different from the works of Nan Goldin.

A slightly different line was taken in work created by the Scottish duo Dalziel and Scullion (Matthew Dalziel, b. 1957; Louise Scullion, b. 1966). Their exhibition 'Drift' (2001), first shown at the Fruitmarket Gallery in Edinburgh, incorporated sculpture and video as well as photography, but the most striking element in it was digitised photographic imagery of landscapes presented on an immense scale. The title of the exhibition referred to the theory, first put forward by the German meteorologist Alfred Wegener (1880–1930) in 1912, that there originally existed one vast supercontinent, which scientists have named Pangea. The artists saw the enterprise as a suitable way of marking the millennium, but their photographs have a surprising resemblance to the kind of panoramic landscapes created by the American landscape painters of the late 19th century, notably Frederic Edwin Church (1826–1900), whose subject-matter was sometimes strikingly similar to some of the images included in 'Drift'. One thinks, for example, of his vast picture of *Icebergs,* now in the Dallas Museum of Art.

In this kind of photography, the quirky is only occasionally allowed a place. This quality appears, for instance, in some of the photographs made by Erwin Wurm (b. 1955). Wurm's *Melons, Taipei* (2000) embodies a Dadaist sense of the absurd more often found in current performance art, as illustrated by the work of Francis Alys (b. 1959 in Belgium, lives and works in Mexico City). Alys's compulsive wanderings within the urban environment and

92 Erwin Wurm,
Taipei Outdoor Sculpture, 2000.
Colour print on paper / ed: 5, 127 x 159 cm

93 Boris Mikhailov,
Untitled from 'Case History', 1997-1998.
Colour print on paper, 127 x 187 cm

94 Reineke Dijkstra,
Abigail: Herzliya Air Force Base: April 1999,
+ *Abigail: Palmahim Air Force Base:*
December 2000.
Diptych: Colour prints / ed:10,
2 x (126 x 107 cm)

94

95

95 Shimon Attie,
Almstadtstraße 43 (formerly *Grenadierstraße 7)*
Slide projection of former hebrew bookstore, 1930
Berlin, 1992.
On-location installation and chromogenic print

the way in which he interacts with it are examples of the way in which the absurdist spirit lives on. In one piece, for example, he carried a gun in plain view in the street (illegal in Mexico) and waited to see how long it took before he got arrested; he later repeated the action in staged form, with police complicity.

The images made by many of these objectivist photographers are, as Gursky's comments on his own work suggests, very often of a sort which, only a few years ago, would have been regarded as lying outside the sphere of art. Struth's image of the interior of the church of San Zaccaria in Venice, for instance, would not have looked out of place in a 1950s or 1960s issue of *National Geographic* magazine. Fischli and Weiss's views of airports would quite likely have been rejected by the picture editors of this and similar publications as being of insufficient visual interest to claim a place in their pages.

Related to this inherited documentary style, but in a more potent and interesting way, is the work of the Russian photographer Boris Mikhailov (b. 1938) and that of Rineke Dijkstra (b. 1959) from the Netherlands. Mikhailov comes from Kharkov in what is now the independent Ukraine. In his series *Case History*, he focuses on post-Soviet Russia, and in particular on the plight of a new class of *bomzhes* (homeless people without any form of social support). His photographs often seem crude and shocking, and have quite frequently been attacked as exploitative, but Mikhailov justifies them in these terms: 'The people didn't have a choice: either you pose or you vanish. They were not scared of any boss. They didn't do it under compulsion' (Boris Mikhailov, *Case History*, Zurich, London and New York: Scalo, 1999, p. 8). What he does is to represent both a society and some of its members in a state of transition that is also a state of extreme tension.

Dijkstra has enjoyed a better press. Her photographs of young people at turning points in their lives (adolescents who are on the verge of adulthood, women who have just given birth) have been some of the best-liked images of our time. Nevertheless, a recent series featuring young Israeli recruits – both male and female – makes it plain that she has much in common with Mikhailov. Both are interested in rites of passage, both voluntary and involuntary. Both, by implication, mirror a social context. And both seek to penetrate an ambiguous or deceptive surface. Dijkstra, for example, likes to get her subjects to pose immediately after some bout of intense physical exertion. She believes this enables her to capture them in a less self-conscious, more completely natural state.

96

96 Hai Bo, *Middle School,* 1999-2000.
Colour prints on paper 2 x (60 x 90 cm)

97

97 Anthony Goicolea,
Blizzard, 2001.
Colour print / ed:6, 102 x 107 cm

98 Keith Cottingham,
Fictitious Portrait: Double, 1993.
Digital photo, 117 x 97 cm

for memory. It is perhaps repositories of this sort that both Mikhailov and Dijkstra are endeavouring to produce.

The Chinese artist Hai Bo (b. 1962) certainly thinks of photographs in this way. In a series of diptychs made in 1999, he examines the changes that have taken place in China during the past quarter of a century. In each case, the left-hand image is a group photograph taken in 1974, at a time when the Cultural Revolution controlled Chinese society. In the right-hand image the photographer has posed the same people, with each person occupying his or her previous position. The alterations in dress and demeanour make a point about the vast changes that have overtaken China during the period since Mao Zedong's death. There is also, however, a strong sense of nostalgia for a time when those who posed were still young and full of hope.

It is interesting to compare this approach, which relies heavily on our absolute faith in the veracity of the photographic image, with the direction taken by Keith Cottingham (b. 1965) in his *Fictitious Portrait* Series. 'In this series,' Cottingham says, 'I use the computer as a tool to draw upon traditional sculptures, models, photography, and drawings, and through the use of digital painting and montage, ideas materialize into finished photographic prints. The realism in my work serves as a revealing mirror of ourselves and our inventions, both beautiful and horrific. The images themselves are portraits of a youth. By combining myself with others, these imaginary portraits expose the movement and development of the "Self". The soul is not seen as a solidified being, but is exposed as multiple personalities, each expressing a different view of the "Self".' In other words, what seems to be photographic truth is in fact an elaborate fiction.

Much the same thing can be said about a recent series of digital images featuring young boys made by Anthony Goicolea (b. 1971). All the figures in Goicolea's *Blizzard* (2001) are in fact versions of the artist himself, and the Russia they inhabit, signalled by the presence of an Orthodox church in the background, is a fictional realm. Like the Martinchiks and the Chapman brothers, whose work I have discussed, Goicolea is one of a number of artists, not all of them involved with photography, who have already recently shown an interest in constructing fictional worlds.

Among the most interesting of these makers of fictions is the Israeli artist Roee Rosen (b. 1963). Rosen is one a number of contemporary artists who have started to re-imagine and re-examine the Holocaust. They also include the American David Levinthal

It is interesting to compare Dijkstra's work in Israel with that of Shimon Attie (b. 1957). Attie, American-born but resident in Rome at the time of writing, is best known not for pure photography, but for a series of installations featuring on-location slide projections in the former Jewish quarter of Berlin. *Almstadt-straße 43* (formerly *Grenadierstrasse 7*) (1992) projects the image of a Hebrew bookstore made in 1930, just before the Nazis took power, onto the building where it was formerly housed. Attie describes works of this type as 'a kind of peeling back of the wallpaper of today to reveal the histories buried underneath'. In doing so, he also reveals the way in which photographs function, not simply as representations of immediate reality, but as repositories

99 Roee Rosen,
Justine Frank's 'The Stained Portfolio' of 1927,
1998-2002.
Gouache on paper / 100 works on paper

(b. 1949), who has re-created the events of 1940–45 by photographing toy figures, often basing himself on concentration camp and ghetto photographs taken by the Nazis themselves. Similarly, the Pole Zbigniew Libera (b. 1959) has created a number of boxed sets based on standard Lego construction kits that enable one to build one's own miniature concentration camp. Rosen himself has proposed a 'virtual reality scenario' called *Live and Die as Eva Braun* (1997), which was shown at the Israel Museum, Jersusalem, where it caused a predictable uproar. The illustrations to his text were cut paper silhouettes of a deliberately sentimental sort – the kind of thing one might find in an old-fashioned children's book.

Rosen's most recent narrative invention is the story of Justine Frank. Frank is an alter ego for Rosen himself, and also for Anne Frank, author of the justly famous Holocaust diary. Her forename also suggests a hidden connection with the eponymous victim/heroine of a notorious 18th-century erotic novel (1791) written by the Marquis de Sade. The fictional Justine Frank is an artist who settles in Israel/Palestine during the inter-war period, and thus escapes the Nazi terror. Leaves from her sketchbooks, which Rosen entitles *Stained Folios* (1998), illustrate her gradual absorption of Jewish culture, and at the same time her loss of European values and European sophistication.

Rosen's *Stained Folios* are 'realist' only in the paradoxical sense that they are elaborate fakes – documents intended to convince the spectator of the existence of something (a whole life story) that in fact never took place. A more conventional realist art has, nevertheless, continued to exist side by side with the photographic experiments described in this chapter. As numerous failed attempts to define the nature of realism in painting and sculpture demonstrate, the concept is an extremely slippery one. Successful realism in art simultaneously attempts and denies total verisimilitude. As regards work in three dimensions, an example was set by the Pop sculptures of George Segal (1924–2000), which were moulded from the bodies of the artist's friends. This technique was further elaborated by the Super Realist Duane Hanson (1925–1996), whose astonishingly life-like figures, dressed in real clothes and accompanied by appropriate props, resemble those to be found in traditional waxworks museums, though they are made of polyester resin rather than wax. In fact, the only things that distinguish them from such waxwork effigies are slight exaggerations of pose and demeanour, which turn them into representatives of a particular group or class.

100

101

100 Ron Mueck,
Mother and Child, 2001.
Mixed media,
24 x 89 x 38 cm

101 Sean Henry,
Sic Transit Gloria Mundi, 1999.
Bronze and oil paint /
ed:5, 205 x 130 x 65 cm

102

103

102 Josep Santilari, *Envasats,* 2000.
Oil on canvas, 55 x 55 cm

103 Pere Santilari, *Pa i Formatge,* 2001.
Oil on canvas, 35 x 45 cm

104 William Beckman,
Studio II, 2000-2001.
Oil on panel, 200 x 170 cm

Contemporary sculptors have drawn back a step or two from Hanson's deceptive versions of real life. His nearest successor is the Australian-born sculptor Ron Mueck (b. 1958), who now lives in London. Mueck did not start his career as a fine artist, but rather as a model-maker for film and television, collaborating with Jim Henson (1936–1990), creator of the *Muppets*, on the fantasy movie *Labyrinth* (1986), starring David Bowie, and on *The Storyteller* television series (1987). He also worked on the science fiction film *Alien 3* (1992), directed by David Fincher (b. 1963). Not surprisingly, Mueck possesses both an extraordinary degree of skill and an acute sense of what is expressive and dramatic. One of his chief devices is to play with scale. Although his work is extremely realistic, his sculptures are usually either much larger or somewhat smaller than we expect them to be. When they are larger, they threaten to overwhelm us; when smaller, we feel we are looking through the wrong end of a telescope at the event or implied narrative that they embody.

Another British realist sculptor who often works on a scale smaller than life is Sean Henry (b. 1965). For the most part, Henry portrays members of the working class, particularly labourers on building sites. Originally his figures were made of painted terracotta, but now they are more often executed in painted bronze. Sometimes two figures are brought together to imply a narrative. This is the case with *Sic Transit Gloria Mundi* (1999), where one figure – the better dressed of the two – gazes from the top of a flight of steps at another man who is seemingly oblivious to the fact that he is being observed. A number of different narratives can be constructed to fit this grouping. For example, is the interest of the man who stands on the upper level sexual? Or is it predatory in some other fashion? Or is it to do with class and position in the world – the richer man envying the freedom of the poorer? The Latin words of the title (meaning 'Thus departs the glory of the world') are those spoken as part of the ritual when a newly elected pope enters St Peter's Basilica in Rome. As with Mueck, the thing that moves Henry's work out of the category of the purely veristic is the sense that the sculptures must be regarded as events in time, the visible parts of a sequence of happenings that existed before the moment the sculptor has elected to represent and that will continue to evolve after it.

Realistic painting, when compared with realistic sculpture, occupies a more conventional and much more easily definable position. It is one of the paradoxes of recent art history, for

105 Nazario Luque Vera,
El sueño de Endymion
or *Vanitas III*, 1997.
Watercolour on paper, 70 x 100 cm

example, that the United States has been, for the past fifty years, both an environment that supports the most radical possible experiments in art, and the home of one of the chief schools of contemporary realism. William Beckman (b. 1942) belongs to an unbroken tradition of American realist painting that can be traced back to late 19th-century masters such as Thomas Eakins (1844–1916) and Winslow Homer (1836–1910). There is, as we shall see in the next chapter, a big difference between art of this type, with its concentration on minute particulars, and what is generally, though sometimes rather loosely, described as 'classicism'.

In Spain, another country with a strong, deep-rooted tradition of realist art, the modernist experiments that blossomed in the later years of the Franco regime – not always welcomed by the Spanish government of the day – and even more freely in the period immediately after, are being challenged by a strong school of realist painters. Catalan twin brothers Josep and Pere Santilari (b. 1959) make paintings that they work on together, though these are sometimes signed separately (Josep Santilari, *Envasats*, 2000; Pere Santilari, *Pa i Formaige*, 2001). The paintings belong to a tradition that can be traced back to the beginning of the 17th century in Spain, to the work of masters such as Juan Sanchez Cotàn (1560–1627). One of Spain's most celebrated artistic rebels, Nazario (Nazario Luque Vera, b. 1944), father of the underground comic in Spain, and the local equivalent and rival of his exact contemporary, the American underground cartoonist Robert Crumb (b. 1944), has been unable to resist the allure of the traditional Spanish still life, and his oeuvre includes a number of elaborate examples of the genre. Even Miguel Barcelo (b. 1957), an artist generally associated with the Europe-wide Neo-Expressionist movement of the 1980s, shows an occasional attachment to aspects of realist art. His *Rebozo* (2001) is a paraphrase of a famous canvas by Gustave Courbet (1819–1877), leader of the mid-19th-century Realist movement in France. As the title indicates, however, the image may also possess an allegorical significance. A *rebozo* is a traditional Mexican shawl,

106 Miquel Barcelo,
Rebozo, 2001.

107 Diarmuid Kelley,
Housewife's Choice, 1999.
Oil on canvas, 107 x 86 cm

108 Liliane Tomasko,
Pillow, 2000.
Oil on canvas, 60 x 80 cm

often used by mothers to carry their babies, and the sea itself is sometimes thought of as an emblem of motherhood or birth.

What is perhaps most conspicuously missing from the figurative paintings being produced today is the sense of transformation, the sense that what is seen by the painter is mysteriously transmuted, becoming a different substance. Two younger artists who can manage this quasi-magical process are the Irish-born Diarmuid Kelley (b. 1972) and the Swiss-Hungarian Liliane Tomasko. Kelley's paintings of the human figure often make play with the notion of the fragmentary, the apparently unfinished. In *Housewife's Choice* (2001), the image still seems to be evolving, to the point where a large area of canvas is left unpainted. Tomasko's *Beds* series (*Pillow*, 2000) deliberately confines itself to a group of small visual incidents. Tomasko says that she works not directly from the thing itself, but from the photo library that she has built up over the years. This collection of images provides a store of visual ideas, some of which have proved to be central to her work. Paradoxically, one's mind turns not to a painter, but to some of the late work of the great early 20th-century photographer Alfred Stieglitz, whose cloud studies (which he entitled *Equivalents*) are one of the central achievements of his oeuvre. For Stieglitz, the challenge was to take material that seemed essentially formless, and use the camera to give it form. The images that resulted were 'equivalent' in his mind to various moods or states of mind.

What one is dealing with here is the link between art and feeling. Tomasko's paintings, like those of Diarmuid Kelley, self-evidently reflect what has been felt, as well as presenting a report on something that has been seen. There can be no doubt, however, that in both cases the act of seeing is both focused and intense. Tomasko describes how, before actually beginning to paint, she transcribes the image in pencil. 'This,' she says, 'is a very important part of the process for me; the continual making and erasing of marks is like a ritual attempt to enter the photographic reality. In the space between the promise of the finished painting and the faintly described image on the canvas, the picture belongs entirely to me. Once paint is engaged, a fair amount of control has to be given up in order for the painting to appear.' It is a pity that this attitude now seems increasingly rare.

107

108

looking at the past

chapter five

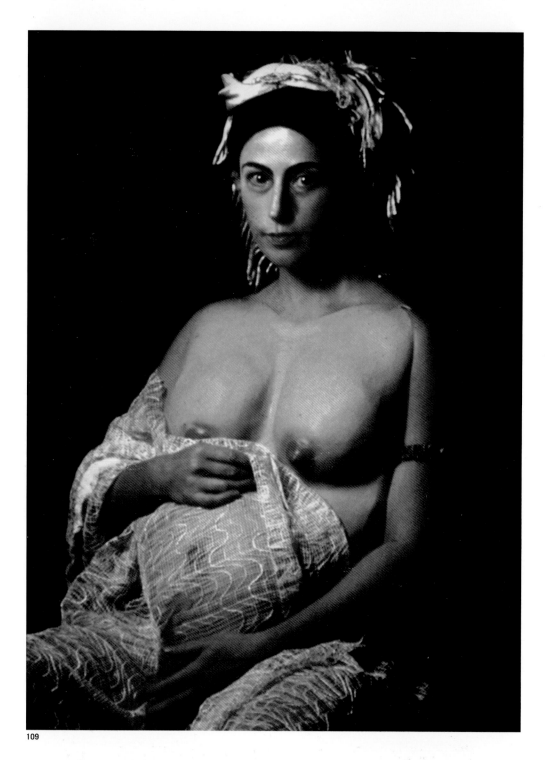

109

109 Cindy Sherman,
Untitled #205, 1989.
Colour print, 90 x 60 cm

So-called 'classical revivals' are not exactly new. Quite apart from long absorbed and accepted historic phenomena, such as the Italian Renaissance and the Europe-wide triumph of Neoclassicism in the late 18th and early 19th century, revivals of this type were in fact a specific feature of 20th-century art from the 1920s onwards. These more recent revivalist impulses took a number of forms. These included the conservative recoil from the supposed excesses of Modernism – the so-called rappel à l'ordre, or 'return to order', inspired by the horrors of World War I – and, a little later, the attempts by various dictatorships (Fascist, Nazi and Soviet) to provide themselves with an imperial identity.

In the concluding decades of the 20th century, classicism took on a surprising number of apparently contradictory guises. In the eyes of architectural historians such as Charles Jencks (b. 1939), whose book *The Language of Post-Modern Architecture* (1977) first popularised the use of the term 'postmodern' with reference to the visual arts, the revival of classical forms and ornaments meant the rejection of the International Modern style of architecture, till then triumphant in the hands of architects such as Le Corbusier (1887–1969) and Mies van der Rohe (1886–1969). Revived classicism thus became, in terms of architectural discourse, almost synonymous with Postmodernism.

Nevertheless, this late 20th–century classicism did not seem to be deep rooted. It was usually perceived as a mode of disrupting or contradicting the existing Modernist discourse, and very often, in the hands of artists such as Jeff Koons or the French duo Pierre et Gilles (who first assumed a joint artistic identity in 1976), it became identified with kitsch. Some examples of this tendency survive, and can be amusing in themselves. The *Wedgwood Concrete Mixer* (1993) devised by the Belgian provocateur Wim Delvoye (b. 1965) is an example. By no stretch of the imagination, however, is this a genuinely classical object. All it does is to set up a rather shallow conflict of expectation between the job a particular object does or the

way it functions, and they way we think it ought to look.

Disruption of expectations certainly continues to play its part where artists choose to re-inhabit traditional forms. An example of this is the series of self-portrait photographs in which Cindy Sherman, with the aid of various rather crude prostheses, presented herself as a surrogate for various celebrated masterpieces – in this case (*Untitled no. 205*, 1989) in the guise of Raphael's (1483–1520) erotic portrait of *La Fornarina* (c. 1518–19). Several different kinds of cultural game were being enacted here. The fact, for example, that the work is untitled challenges the spectator to identify Sherman's source. The deliberate crudity of the re-enactment at the same time implies sarcasm, so that this new version becomes a feminist critique of the original image.

Critical impulses of a similar but more complex sort seem to have inspired Yinka Shonibare's (b. 1962) *Diary of a Victorian Dandy: 11:00 hours* (1998) and Delmas Howe's (b. 1935) *Sketch for an Expulsion* (2001). *Diary of a Victorian Dandy* is one of a series of elaborately staged fantasy photographs depicting the life of the same protagonist. They are modelled on the 19th-century narrative paintings produced by English artists such as William Powell Frith (1819–1909) and Augustus Egg (1816–1863), and offer an ironic commentary on the artist's own experiences as a black man from Africa finding his way in British society.

Delmas Howe's work is a painting, not a photograph, and also forms part of a series, which is entitled *Stations of the Cross*. However, the subject-matter, as in this case, often strays quite far from that of the traditional Stations seen in churches illustrating Christ's journey to Calvary. Howe's theme is the discrimination and persecution of homosexuals. The background is a crumbling fresco depicting the god Pan, seen here as an emblem of sexual freedom. Pan seems to be fleeing from what is being enacted in the foreground, where two naked figures, based on those of Adam and Eve in the famous *Expulsion* (c. 1425) by Masaccio (1401–1428) in the Brancacci Chapel of S. Maria del Carmine in Florence, but in this case both male, are being driven out of this pagan setting by a burly man brandishing two whips. This muscular version of the traditional avenging angel wears fantasy leather gear – vest, harness, chaps and metal-studded belt and codpiece – of a kind featured in gay SM videos and adopted by the patrons of homosexual fetishist clubs. The suggestion is that gay men are to some extent at least the architects of their own misfortunes.

110 Wim Delvoye,
Wedgewood Concrete Mixer, 1993.
Enamel paint on teak wood, 130 x 175 x 110 cm

111 Yinka Shonibare,
Diary of a Victorian Dandy: 11:00 hours, 1998.
Colour-type print / ed.3, 183 x 229 cm

110

111

112

112 Delmas Howe,
Study for an Expulsion, 2001.
Oil on canvas, 122 x 132 cm

There are now signs, however, that revived classicism had deeper roots and a more profound significance for the future than commentators were originally prepared to allow. In some contexts, its meanings were intellectually specific and had little to do with Jencks's commentary on architecture. In Italy, for instance, there was a link between the use of classical forms and references and the Conceptual Art and Arte Povera that dominated the 1970s. Carlo-Maria Mariani (b. 1931), one of the most celebrated recent users of classical forms, remains insistent that the whole of his artistic enterprise is rooted in Conceptual thinking. He does not like to be seen as simply the leader of a classical revival. It is important to him that his paintings are vehicles for ideas, often ironic comments on the history of art and modern society. One way of viewing his work is to recognise that the Neoclassical style of the late 18th and early 19th century, from which Mariani borrowed many ideas in the 1970s, was itself an intellectual construct. Artistic theory came first, and artists were required to illustrate it. Mariani, of course, now creates his own theories, reinventing classicism to suit himself. An example of his ironic humour, and a very specific illustration of his sense of his own relationship to the history of Modernism and Postmodernism, is his startlingly effective painting *Headrack* (1990), which shows classical heads and fragments impaled on the spikes of one of the most celebrated Marcel Duchamp readymades, *Bottlerack* (1914).

Most Italian artists who now practice a kind of classicism, and particularly the artists connected with the Pittura Colta movement, have links to the late work of Giorgio de Chirico (1888–1978). Throughout the later stages of his career, from the mid-1920s onwards, de Chirico was in rebellion against the Modern Movement, which he had spent his youth helping to create. It was not, however, a rebellion of a simple kind. Mingled with de Chirico's often proclaimed ambition to rival the Old Masters there remained a spirit of provocation peculiar to himself. He was – and Francis Picabia (1879–1953) is his only rival in this respect – the first Postmodern painter. His mixture of impulses produced a kind of art that was undervalued and misunderstood almost everywhere. However, de Chirico's long residence in Rome and his powerful personality had their effect. When his reputation began to revive towards the end of his life, it was in that city that the reassessment began.

It was this line of development that led to the Pittura Colta movement of the 1980s, founded by the critics Italo Mussa and Arnaldo Romani

113

113 **Carlo Maria Mariani,**
Head Rack, 1990.
Oil on canvas, 180 x 125 cm

114 Ubaldo Bartolini,
Portatrice d'acqua, 1997.
Oil on canvas, 50 x 70 cm

114

115

Brizzi. Essentially Pittura Colta undertook a new enterprise: to reintegrate traditional figurative art with many of the basic intellectual ideas that had been thrown up by the Modern Movement. In so doing, it also had to look at the way in which Italian Old Master painting in particular had been integrated with contemporary systems of thought. The influence of the late 16th-century art theorist Giovanni Lomazzo (1538–1600) is a case in point.

In particular, the Neoclassical preoccupation with the expression of aesthetic values was revived by Pittura Colta, as was the Neoclassical search for the beautiful, as opposed to the merely expressive. Beauty was once again seen as the product of harmony – a concept familiar not merely to the protagonists of the Neoclassical movement, notably Winckelmann (1717–1768), but also to Leon Battista Alberti (1406–1472) in the mid-15th century.

However, de Chirico's influence is the one that remained paramount, and it is still felt strongly today. The nature of his art is still widely misunderstood. His strange ability to combine experimental and conservative elements, com-

116

bined with the ambiguity of his attitudes towards the nature of his own gift, have made him extremely difficult to grasp. He is now often described as a 'premature Postmodernist'. This is mildly helpful, but does not go far enough. From his early Metaphysical period onwards, de Chirico's work evinces a unique gift for fantasy. Even when he is most determined to present himself as the direct heir of

Raphael, the Pompeian fresco painters or the Roman masters of the Baroque (stylistic inconsistency was, for him, a way of being true to himself), these deliberately anachronistic ventures were linked by a poetic sense of irony that was unique and instantly recognisable.

Traces of a similar irony will be found in the work of a number of leading Italian artists illustrated here, most notably perhaps in the work of Ubaldo Bartolini (b. 1944). Bartolini's landscapes refer not to the work of Claude (1604–1682) and Poussin (1594–1655), the usual reference points for classical landscape painting, but to a period when the depiction of landscape was beginning to emerge as an independent genre. He has some of the fantasy of 16th-century Mannerist artists such as Niccolo dell'Abbate (c. 1509–1571), and there also seem to be references to the work of northerners working in Italy during the early 17th century, among them Adam Elsheimer (1578–1610) and Paul Brill (1554–1626). Bartolini is therefore not 'classical' in the sense that Poussin and Claude are classical. He invites the imagination into a different, more dynamic sphere. This dynamism is linked to the restless, experimental nature of his talent. He does not, for example, confine himself to conventional formats: a recent speciality has been superb painted furniture. He is an artist who constantly subverts his sources, reminding the spectator that the dreamlike landscapes he creates must always be read as the products of a modern sensibility. Comparable impulses are also at work in the Romantic landscapes painted by Silvano d'Ambrosio (b. 1951).

Stylistically very different, the work of Alberto Abate (b. 1946) shares some of the same fundamental qualities. Though Abate makes frequent references to classical legend, his attitudes to this source material are filtered through a fascination with late 19th-century Symbolism. One of his masters is clearly Gustave Moreau (1826–1898), and there are also references in his paintings to the work of the English Pre-Raphaelites, and in particular to Dante Gabriel Rossetti (1828–1882), born in London of an Italian father. The legacy of Symbolism, denounced by the Italian Futurists at the beginning of the last century (the Futurists hated Symbolism far more than they hated the academic art of the same epoch), has been extremely durable. An exhibition devoted to the artistic sources of Alfred Hitchcock, shown in 2001 at the Centre Pompidou in Paris, demonstrated how much the great director owed to Symbolist source material – much more, in fact, than he owed to Surrealist artists such as Salvador Dalí, with whom he actually collaborated.

117 Stefano di Stasio,
A sud del tempo, 1999.
Oil on canvas, 180 x 200 cm

118

119

Abate's construction of the ideal allows quite a large space for sinister and ambiguous elements. Like Bartolini, he invites the viewer into a world of dreams, and stresses the chasm been the idealising impulse and the world of harsh reality. When we look at Abate's paintings, we are conscious of the extreme complexity of cultural history, since his paintings refer not only to classical mythology – itself a transmutation of much earlier myths – but to the Symbolist movement of the 1880s and 1890s. Abate's work, with its density of cultural reference, is recognisably Postmodernist, using classicism in a self-conscious, profoundly ironic way.

One of the artists who comes closest to de Chirico is Stefano di Stasio (b. 1948). *A sud del tempo* (1999) is an ambitious composition, which conjures up the atmosphere of the traditional Italian *commedia de l'arte*. In the foreground, a pair of lovers reclines – he is clothed, but she is naked. Behind them, flames symbolise the force of their passion. Beyond the barrier of flames is a long pier stretching towards a mysterious structure of wooden laths draped with crimson curtains, which may perhaps be a kind of theatre. Dancing along this pier is a

punchinello, a character from the traditional Italian *commedia dell'arte*, playing a guitar (similar figures appear in the work of G. D. Tiepolo, 1727–1776, and later in the post-Futurist compositions of Gino Severini, 1883–1966,). Following the punchinello towards the theatre are a group of handsome young people, one of whom is already starting to strip off his shirt. One has the feeling that soon all three of them will be naked, just like the woman in the foreground. The composition is a denial of human constraints, and a celebration of life and liberty.

Like much of the work produced by de Chirico himself, both during and after his 'metaphysical' period, di Stasio's paintings often contain Surrealist elements without being definably Surrealist. In particular, di Stasio lacks the characteristic harshness of true Surrealism – the sense that the libido is out of control. There is in many respects a closer affinity to the work of artists who belonged to the Symbolist movement. In addition, di Stasio uses many of the allegorical and symbolic devices that were familiar to the masters of the Renaissance, Mannerist and Baroque periods in Italy. Far from renouncing the Italian past, he wants to attach himself to aspects of it, but in a much less self-conscious way than de Chirico himself. This is partly an accident of timing. Because he belongs to a much younger generation, di Stasio has not had to fight nearly as hard against the more tyrannous aspects of the Modern Movement.

Carlo Bertocci (b. 1946) is another Italian artist of this generation who has a comfortable relationship with the art of the past. Bertocci gives apparently ordinary domestic scenes, often featuring children or adolescents, a poetic, metaphysical twist. Often, there is a subsidiary element in the composition that 'rhymes' with the main event. A particularly complex example is *Il Barchetta* (2000). In this work, the play of forms is enhanced by intense, saturated colour, and the picture, an apparently straightforward depiction of a child playing with a paper boat, is arranged so that symbolic meanings are conveyed quite simply and apparently naturally. Note the way, for example, in which the full moon shines through the window behind the boy, and is reflected in the mirror that serves as the lake on which the ship voyages.

Younger Italian figurative artists have continued to follow much the same line. They are increasingly comfortable in their response to the demands of 'traditional' patronage, for example that of the Church, though they often respond in non-traditional ways. Stefania Fabrizi's installation *La Veronica* (2000) is a case in point, with its reference to the legend of St

120

121

122

122 Antonio Violetta,
L'aurora (Dawn), 2000.
Terracotta, 80 x 50 x 35 cm

123 Paolo Borghi,
L'ombra del tempo, 2001. Painted terracotta,
205 x 80 x 35 cm

Veronica's veil, which took the imprint of Christ's face when the saint succoured him on the road to Calvary. Lithian Ricci's *Hacker* (2001), on the other hand, is a reference to the new world of electronic communication, and the role of young people in it, expressed in allegorical terms that the masters of the Italian Baroque would have understood. One of the most gifted painters of this new generation is Elvio Chiricozzi (b. 1965), whose monumental near-monochrome figures have an obvious relationship to the work of Mario Sironi (1885–1961) the leader of the Novecento group of the inter-war period.

There is also a considerable output of figurative sculpture in Italy, following in the footsteps of artists such as Marino Marini (1901–1980) and Giacomo Manzù (1908–1991). Sculptors such as Paolo Borghi (b. 1942) and Antonio Violetta (b. 1966) have made use of painted terracotta, following traditions established first by the Etruscans and the Greeks of southern Italy, and later by leading Renaissance workshops, such as that of the della Robbias (Luca della Robbia, d. 1485; Andrea della Robbia, 1435–1525; Giovanni della Robbia, 1469–1529). Borghi is especially skilful in his use of scale – often less than life-size – and in the way in which he integrates figure and plinth. The manner in which he unites the figure and its support often seems to owe something to Art Nouveau. Violetta's half-length figures borrow certain ideas from Roman imperial portrait sculpture, as well as from the portrait busts of the Italian Renaissance.

The nearest thing to a coherent classical movement in the mould of Pittura Colta has been the Novia Akademia, which has established itself in post-Soviet St Petersburg under the leadership of the artist and theorist Timur Novikov (1958–2002). The art of the Novia Akademia has even more complex cultural origins than the figurative art that has appeared during the last decade in Italy. The artists of St Petersburg, like artists now working in Rome, see their city as being itself a dictionary of classical forms – though Peter the Great's foundation is, of course, much less ancient than the Rome of Augustus or Romulus. They also look back, beyond Gorbachev's *perestroika*, which reintroduced Modernism to Russia, to the classical elements in Stalinist art. They admire both satirical versions of this classicism – for example *The Wings Will Grow* (1997), painted by the Russian dissidents Vitalii Komar (b. 1943) and Aleksandr Melamid (b. 1945) from the early 1980s onwards – and also some of the genuine, non-satirical products of the high tide of Stalin's regime. They even go so far as to admire the

124 Timur Novikov,
Grand Duchess Elizabeth of Russia before
becoming a Nun (detail), 1999.
Mixed media on textile, 145 x 115 cm

products of other dictatorships – Novikov spoke highly of the work of Arno Breker (1900–1991), who supplied sculptures of nude warriors for Hitler's Chancellery in Berlin.

In his own work, Novikov in addition sometimes celebrated aspects of the Romanov regime as it existed in the years immediately before the Bolshevik Revolution. The work illustrated (1999) features a photograph of the Grand Duchess Elizabeth Fyodorovna of Russia (1864–1918), sister of the Empress Alexandra. After her husband the Grand Duke Serge was killed by an anarchist bomb in 1884, the Grand Duchess, shown here in elaborate fancy dress based on Russian peasant costume, became a nun and founded a convent in Moscow. Murdered by the Bolsheviks in 1918, she was canonised by the Russian Orthodox Church in 1992. It is this event that Novikov wanted to commemorate. The fabric used as background, with its pattern of crosses, evokes Orthodox priestly vestments.

Attempting to describe Novikov's attitudes, in an essay celebrating the tenth anniversary of the foundation of the Novia Akademia, the St Petersburg critic and curator Ekaterina Andreeva wrote as follows:

In the late 1980s, the radicalism of his artistic views was unexpectedly manifested in a peculiar conservative revolution. An expressionist painter in the early '80s and an initiator of a 'new wave' having mainly to do with rock music, Novikov saw modernism in all its glory only in 1988, when he travelled abroad for the first time. Contemporary art museums made a huge impression on him. Giving the heroism of those who participated in the aesthetic revolution of modernism its due (Novikov dedicated early works to Beuys and Warhol), he came to understand, nevertheless, that the avant-garde movement, having disembodied the object in the minimalism and conceptualism of the 1970s, had reached an impasse. He likewise recognised the efforts of postmodernism in returning art to culture and to life, to representation and thematicity. As a result . . . the Empire-style architectural ensembles of Leningrad, which he had perceived earlier as something self-evident, for the first time attracted his attention as a possible road to the future and a source of new images.

While they see the remnants of the academic system of art training set up by the Soviets as a precious legacy which ought to be preserved rather than dismantled in the name of a new era of political freedom, members of the Novia

125

125 Vitalii Komar and Aleksandr Melamid
known as: **Komar and Melamid,**
The Wings Will Grow, 1997.
Tempera and oil on canvas, 183 x 122 cm

Akademia such as Olga Tobreluts and Genia Chef (b. 1954) also experiment boldly with new techniques, such as computer digitisation and alteration of photographic images. In general, members of the group accord a more important role to photography than their counterparts in Rome. Novikov even went so far as to say that it had become the last refuge of the cult of the beauty that had been rigorously suppressed in other forms of Modernist image-making. He cited not only numerous Russian photographers, but also the work of Robert Mapplethorpe (1946–1989) and the advertisements produced for firms such as Versace.

The real reference point for the Novia Akademia is, however, not the Stalinist era but the period just before the fall of the tsars, and in particular the artists in the entourage of Serge Diaghilev (1872–1929) during the earliest part of his career, before he became the impresario of the Ballets Russes. From 1899 to 1904 Diaghilev edited the luxurious magazine *Mir Iskusstva* (World of Art). This periodical is generally seen as one of the organs of the Symbolist movement, an equivalent of the *Yellow Book* in London. But the Diaghilev circle at this time also had a strong bias towards classicism. The impresario later discarded most of these associates in favour of out-and-out Modernists, some drawn from avant-garde circles in Moscow, like Mikhail Larionov (1881–1964) and Natalia Goncharova (1881–1962), together with others discovered after he had begun to base himself in Western Europe. Nevertheless, the impact made by the magazine on cultivated circles in St Petersburg continues to resonate nearly a century after its demise.

Novikov was troubled by health problems in recent years, but continued to make collages with the help of his wife, in addition to issuing a stream of pamphlets and theoretical essays. His adherents divide into two groups, though with some overlap between the two. There are those who are primarily painters, such as Georgy Gurjanov (b. 1961) and the duo Oleg Maslov and Viktor Kuznetsov (both b. 1965), and those who experiment with new media. Gurjanov's work is heavily influenced by official Soviet painting, and particularly by its celebration of athletes and the military. He gives these representations a slight satirical edge, which marks the difference between his version of these themes and the original Communist version. In this respect he is a direct successor of Komar and Melamid, but with a touch of nostalgia absent from their work. Maslov and Kuznetsov produce new versions of the Russian classicism of the early years of the 19th century, a time when Russian art was gradually feeling its way

127

towards the creation of a new national style. The ambitious canvas *The Shipwreck* (1997) is a re-creation of the kind of work that might have scored a success in a 19th-century Salon. Chef and Tobreluts use the computer to create works which have an eerie resemblance to the art of the past, but which yet, in many respects, remain visibly and substantially different. *Diana and Victoria* (2001) is a monochrome panorama incorporating a number of very familiar

126 Olga Tobreluts,
Sacred Figures: Naymi (Naomi), 1998.
Digital print on canvas, 160 x 120 cm

127 Georgy Gurjanov, *Sailors,* 2000.
Acrylic on canvas, 190 x 200 cm

128 Oleg Maslov and Victor Kuznetsov
known as: **Maslov and Kuznetsov,**
After the Shipwreck, 1997. Oil on canvas, 95 x 125 cm

128

129

129 + 130 Genia Chef,
Diana and Victoria, 2001.
2 computer prints on canvas, 2 x (100 x 180 cm)

130

131

132

131 Per Wizèn,
Untitled: Figure Undressing by Piero della Francesca, Reclining Body after Carel Fabritius, Bed and Background by Caravaggio, Vermeer, Ingres and Giorgione, 2001.
Collage and lamda print on paper, 80 x 105 cm

132 Noam Holdengreber,
The Masters: Untitled, 2001.
Series of prints

classical sculptures (the Nike of Samothrace, the reclining figure of the Nile from the Louvre and the Hellenistic *Sleeping Faun* from Munich). At the extreme right of the composition there is a group of nymphs bathing which may have been borrowed from Cornelius Polenburgh (c. 1586–1667). Tobreluts also likes combining disparate elements. For example, one series combines those she sees as the true heroes and heroines of our time with images borrowed from Old Master paintings. The super model, Naomi Campbell, for example, is grafted onto an elegant female portrait by the Italian Mannerist Parmigianino (1503–1540). The work belongs to a series called *Sacred Figures.*
This procedure has also attracted artists outside Russia. The Swede Per Wizèn (b. 1966) creates elaborate new compositions by piecing together elements borrowed from Old Master paintings. In *Francesca and Fabritius* (2001), a mysterious erotic scene with sadomasochistic overtones has been created from a wide variety of sources. Wizèn lists them as follows: 'The man in the background is from the baptism scene of Piero della Francesca hanging in the National Gallery in London. The man lying in front of him with hands tied up is from a scene of the beheading of John the Baptist, by Karel Fabritius hanging in the Rijksmuseum in Amsterdam. The cloth in the bed and the background features details from Vermeer, Ingres, Giorgione and Caravaggio.'

The Israeli artist Noam Holdengreber (b. 1965) uses a similar technique. He combines gay erotic photographs borrowed from pornographic magazines with Old Master images. In *Untitled* (2001) an image of Saint Vincent Ferrer by the Italian Renaissance master Francesco del Cossa (c. 1435–c. 1477) coexists with a raunchy homosexual scene. These combinations disturb our complacent attitudes to the art of the past and refresh our perceptions of it. At the same time, they open up new realms of subject-matter that had become inaccessible to orthodox Modernists.
An artist who tackles Old Master subject-matter in a slightly different way is the British digital photographer Paul Hodgson (b. 1972). His carefully staged images are not borrowings, but actual re-creations based on famous Old Master paintings. They invariably subvert their source material in some way. For example, *Rehearsal* (2001) is a paraphrase of the celebrated *Dead Christ* (c. 1490) by Andrea Mantegna (1431?–1506), in the Pinacoteca di Brera in Milan. Hodgson has deliberately removed the Romantic or heroic elements found in the original, and turned the subject into an entirely contemporary event.
It is not surprising that some of the most interesting work making use of Old Master sources, or in some way alluding to them, is currently to be found in Spain. *El Arbol Hermano* (2001) by Alberto Galvez (b. 1963) is a subtly altered version of an early composition by Raphael, *The Knight's Dream* (c. 1501). In the original, the sleeping knight is being asked to choose between Virtue, a female figure holding a sword and a book, who stands to the left, and Pleasure, another female figure holding flowers, who stands to the right. In Galvez's version the sleeping figure wears a simple T-shirt rather than armour, and the figure to the left has no attributes. The one to the right holds a spray of olive, a symbol of peace, which seems to have been broken from the tree that stands in the middle (a similar tree figures in Raphael's painting). The composition is no longer admonitory: no stern choices have to be made and the dreamer is at one with nature.
Guillermo Pérez Villalta (b. 1948) is a fascinating painter who has been so successful with Spanish collectors that he has had little opportunity to become known outside his own country. His work covers a range of subjects, some erotic and some religious. The religious paintings, often deliberately schematic, like *Via Crucis* (1996), frequently owe a good deal to Spanish artists of the transitional period when art in Spain was moving from the Late Gothic towards Renaissance forms imported from

133 Paul Hodgson,
Rehearsal, 2001.
Pigment print on paper, 121 x 183 cm

135

Italy. Pérez Villata makes use of elements that in the original works seem naïve, and even in the paintings with sacred subjects there is often, as here, an erotic subtext. In an early 16th-century work, Christ would never have been shown completely nude, as he is here.

Another Spanish artist who favours erotic subtexts is Dino Valls (b. 1959). *Earth and Heaven* (1999) demonstrates his extraordinary level of painterly skill and the way in which he makes use of classical archetypes while at the same time contradicting or subverting them. The figure on the extreme right is a heroic male nude of a kind that might have figured in a large Renaissance painting of the Resurrection. The other figures, such as the strange group second from the left, where two upper torsos grow out of one body, are not classical at all. Some elements perhaps refer to compositions by Dalí, and maybe also to the early 16th–century Flemish master Hieronymous Bosch, whose work had so much appeal for

Spanish collectors, notably the greatest of them all, Philip II of Spain.

It is at first sight not surprising to discover that certain Latin American artists also favour classical forms. An example is the Argentinian painter Ricardo Cinalli (b. 1948). Cinalli's immense fresco *Homage* (2000), for an arts centre in Punta del Este, Uruguay, has clearly been influenced by Italian Renaissance art, perhaps most specifically by the Florentine Mannerist Jacopo Pontormo (1494–1557). In the early 19th century, Latin America was transformed both culturally and politically by the impact of Enlightenment ideas, which led to its liberation from Spanish colonial rule. Where the visual arts were concerned, this meant that painting and sculpture went through a belated Neoclassical phase. However, this academic Neoclassicism was in its turn overthrown by Modernism during the 1920s and 1930s. With the exception of the impact made by Italian Novecento painting in Argentina (the result of

134 Alberto Galvez,
Hacia el arbol hermano con las dies contadas, 2001.
Tempera and oil on canvas, 160 x 145 cm

135 Guillermo Pérez Villalta,
Via Crucis, 1996.

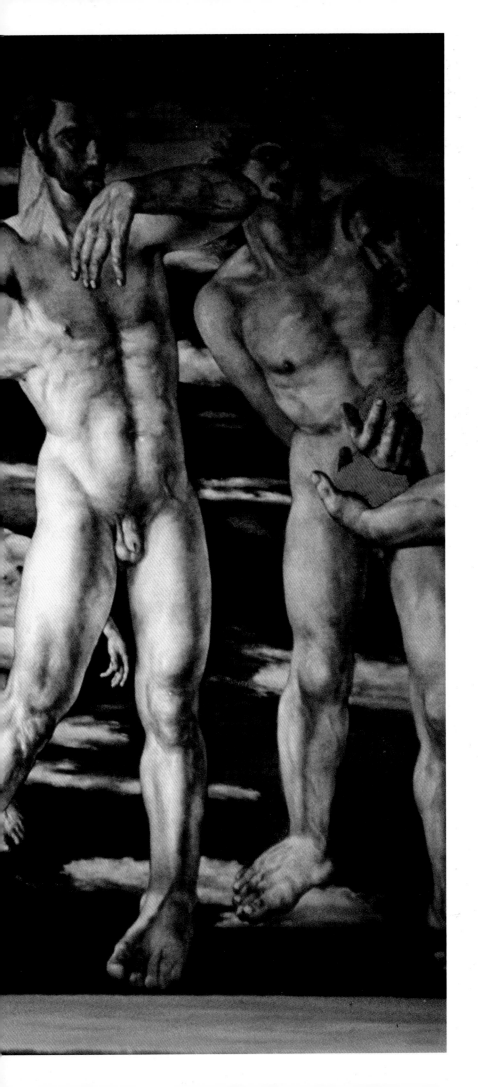

136 Ricardo Cinalli,
*Homenaje Humanista para el Nuevo Milenio
(Humanistic Homage for the New
Millennium),* 1999-2002.
Installation: oil on plaster, 1600m²

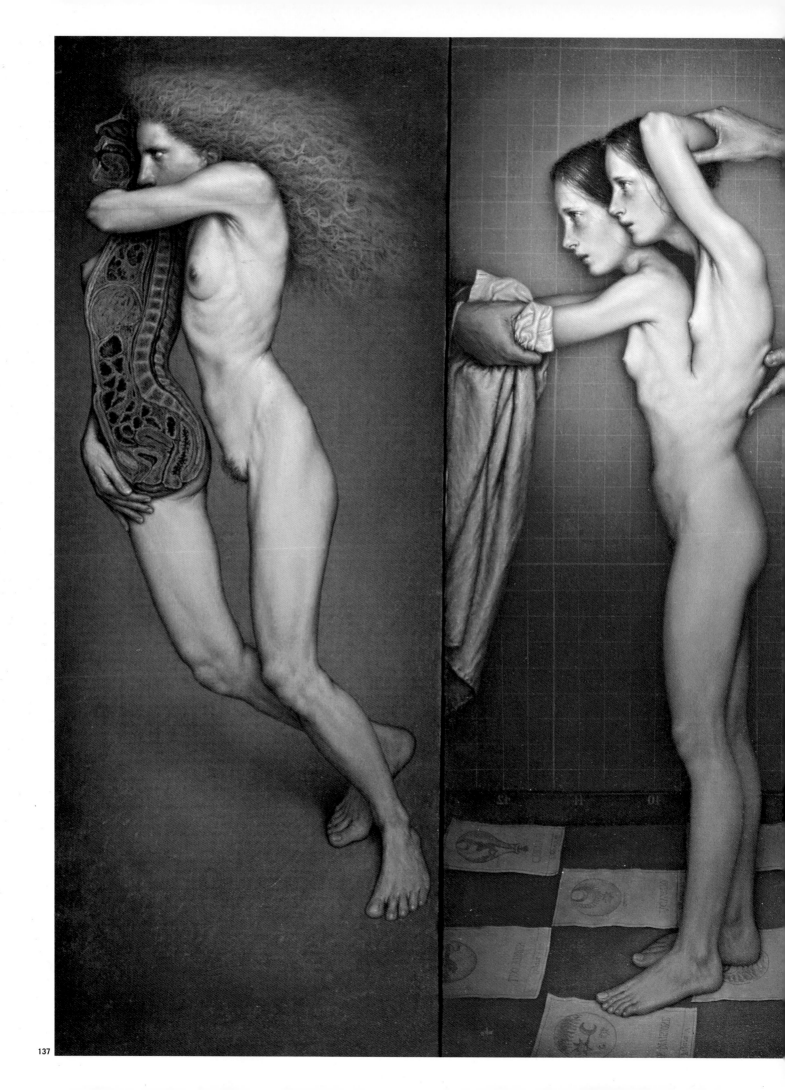

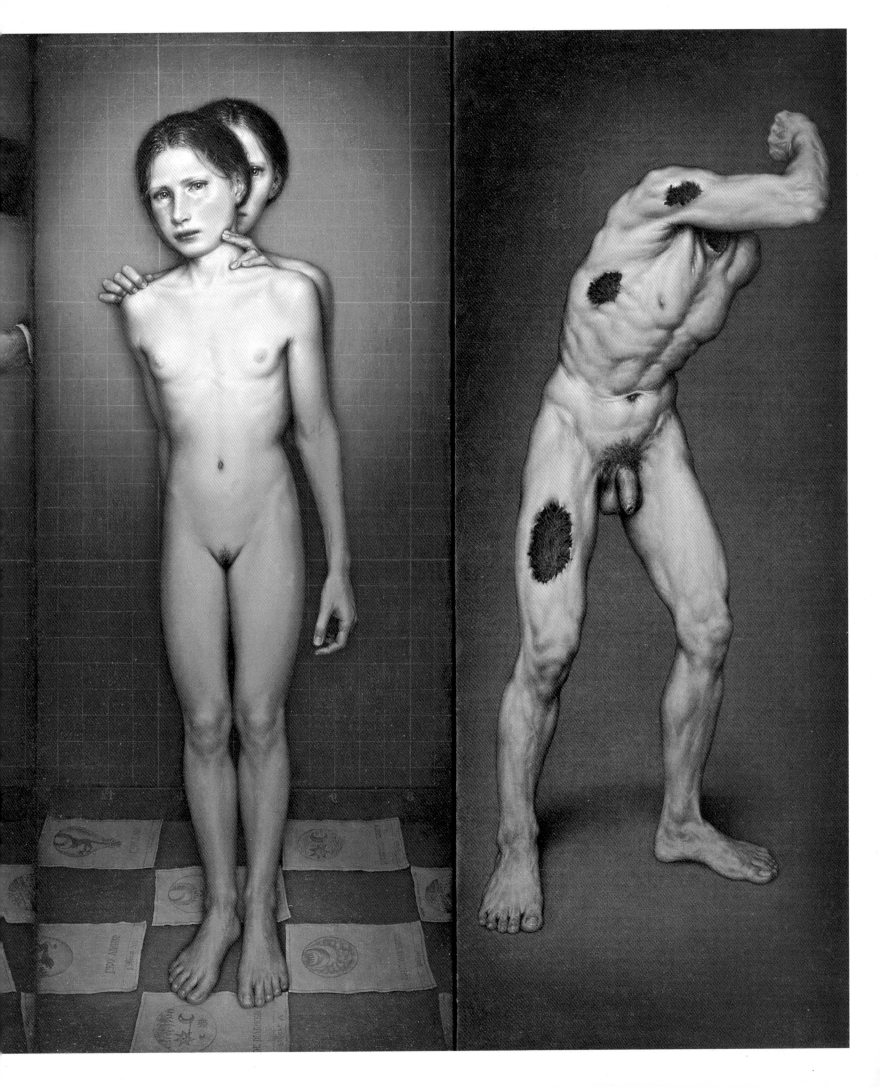

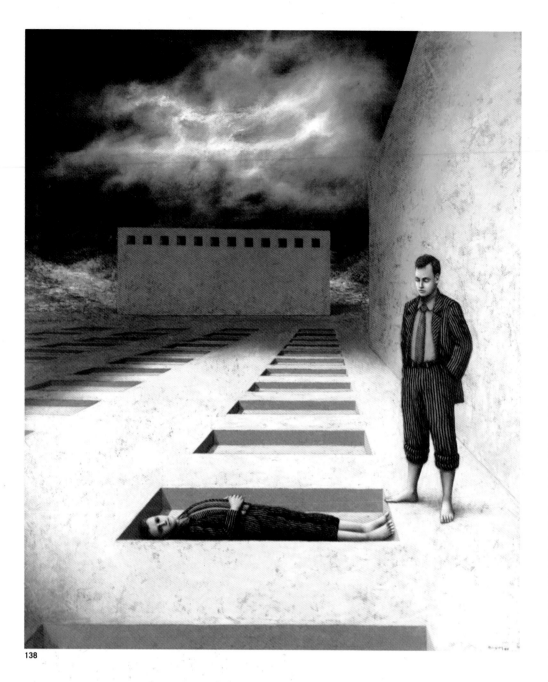

138

He began by taking sculpture classes at the Escuela de Artes Plásticas in Guadalajara. He then studied architecture, while simultaneously attending a literary workshop and making illustrations. He also studied poetry for two years at the Taller de Literatura Elias Nandino. His first participation in a group show was with the members of this literary group.

At a time when artists have often been at some pains to hide their possession of a complex culture, Marquez has been happy to offer evidence of it. His work refers not only to great writers such as Wallace Stevens, Jorge Luis Borges, Fernando Pessoa and, most recently, Dante, but also to architects such as Aldo Rossi (1931–1997), composers ranging from Thomas Tallis to Franz Schubert, and to other painters, both famous and comparatively obscure. *El Doble* (1999) is an example of the complexity of reference to be found in his work. It reflects the old superstition that to encounter one's double is a premonition of death (Dante Gabriel Rossetti used the same theme in one of his best-known drawings, *How They Met Themselves*, 1860). The setting, with its boldly simplified geometric forms shows the attraction that Aldo Rossi's architecture has long had for Marquez. Marquez spent some time in the south-western United States, and it is interesting to note that a number of American painters who are interested in classical forms have chosen to make their careers in this region. One, Delmas Howe, has already been mentioned. Others are Paul Pletka (b. 1946) and Elias Rivera (b. 1937). Pletka first made his reputation with paintings on Native American themes. Later, at the beginning of the 1980s, he became fascinated with the secretive New Mexican cult of the Penitentes, whose members aim to take upon their own shoulders the sins of the world. More recent paintings, such as *Looking for Heaven* (2001), speak of the artist's fascination with religious experience in general. Four monumental figures are seen three-quarter length, very close to the picture plane. Three are tribal shamans, one of which, second from right, wears the shamanic regalia of the Northwest Coast Indians. The fourth figure is a priest of the Greek Orthodox Church. What impresses is not only the extraordinary detail, but also the solidity with which each figure is constructed. Strip them of their costumes, and they would conform perfectly to classical norms.

Elias Rivera is Puerto Rican by descent but American by nationality. He has long been fascinated by the peasant life and costumes of Guatemala, though he maintains a studio in Santa Fe, New Mexico, which is where he lives and paints. Because of his subject-matter,

(Previous page)
137 Dino Valls,
Between Earth and Heaven: Per Luctam / Criptodidimo / Per Luctum, 1999.
Triptych: oil on canvas, 120 x 50 / 120 x 100 / 120 x 50 cm

138 Roberto Marquez,
El doble, 1999.
Oil on canvas, 180 x 150 cm

139 Paul Pletka,
Looking for Heaven, 2001. Acrylic on canvas, 183 x 274 cm

140 Elias Rivera,
In the Heart of the Crowd, 2001.
Oil on canvas, 152 x 127 cm

close cultural links between the two countries during the first half of the 20th century), recent Latin American art has not favoured classicism. Its impulses have been Expressionist, Surrealist and, more recently, Conceptual.

Cinalli himself is at least partly an expatriate, commuting between London, Buenos Aires and Punta del Este. Other Latin American artists with 'classical' inclinations – using the adjective in a very loose sense – are almost invariably expatriates. Roberto Marquez (b. 1959) was born in Mexico, but has passed the greater part of his career in the United States, first in Arizona and more recently in New Jersey. Marquez is unusual because he has always been an unashamedly literary painter. His early studies were as closely connected with literature as they were with the visual arts.

139

Rivera invites comparison with the late 19th- and early 20th-century *costumbrista* painters of Latin America, who recorded local life and customs. The impact made by his work is in reality very different from anything this comparison might suggest. The classical solidity with which each figure is constructed in fact evokes the art of Jacques-Louis David (1748–1825). David's great history paintings, such as *The Oath of the Horatii* (1784), display an immaculate sense of rhythm and interval. Rivera's paintings are much less agitated and rhetorical than the majority of David's, but his work reveals a similar approach.

Though there is no 'classical' group or movement in the United States, or nothing comparable to what is happening in St Petersburg or in Rome, there are nevertheless numerous artists who have opted out of the official avant-garde, some of whom are consciously classicist. One of the most prominent of these is David Ligare (b. 1945). Ligare lives and works in California, and his paintings are suffused with brilliant Mediterranean light. Ligare, however, is also

140

BUT FOR ALL THINGS THERE IS A MEASURE SET: TO KNOW THE DUE TIME, THEREIN LIES TRUE SKILL. OLYMPIANS 13 PINDAR

141

141 David Ligare,
Areta: Black Figure on White Horse, 2000.
Oil on canvas, 244 x 295 cm

142 Alan Feltus,
Alone Together, 1998.
Oil on linen, 110 x 80 cm

142

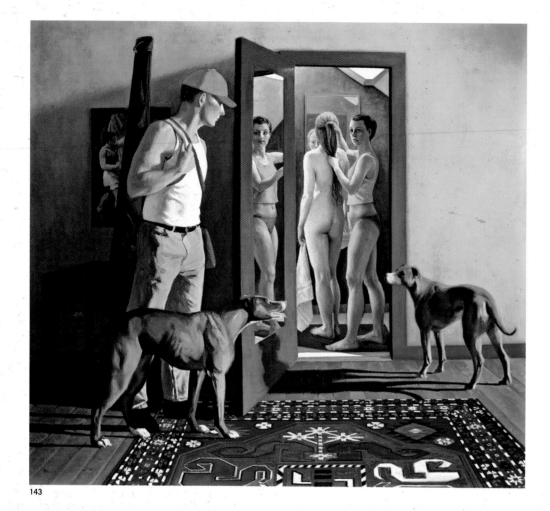

143

143 Katherine Doyle,
Diana and Actaeon, 2001.
Oil on linen, 90 x 100 cm

144 John Paul Evans,
Miners' Memorial, 2001.
Black and white print on paper, 24 x 19 cm

strongly Conceptual, in the sense that his paintings, whatever their subject-matter, are essentially about proportion and measure. About his painting Areta – *Black Figure on a White Horse* (2000), Ligare has written:

I began making studies for a horse and rider painting over twenty years ago. The horse and rider was a familiar theme in ancient Greek Art, as it was in many subsequent periods. The monumental marriage of a human and a beast well represents the essence of classical thought; the Unity of opposing forces. In this case, man represents culture and the horse, nature.

My painting was inspired by black figure vase painting which flourished in Greece throughout the seventh and sixth centuries, BC. It involved the painting of black silhouettes on red clay and incising the details so that the pale clay shows through the lines.

The inscription at the bottom of my painting is from the Greek poet Pindar, (c. 518–438 BC) who wrote many poetic celebrations of human excellence and achievement. According to the scholar Jerome Pollitt, 'Areta' is a particularly Pindaric term which means 'the innate excellence of noble

natures which gives them proficiency and pride in their human endeavors, but humility before the gods.'

Pindar's text (at the bottom margin of the painting) is from the Olympian Odes and it reads, 'But for all things there is a measure set: To know the due time, therein lies true skill.' It was written in praise of Xenophon for his success in the Olympic footrace and Pentathlon in 464 BC, but it could also apply to the art of the poet or indeed, many other endeavours requiring timing and skill.

Some American artists are so attached to the classical ethos that they now work in Italy. This is the case with Alan Feltus (b. 1943). The two languid beauties in *Alone Together* (1998) have a lot in common with Italian art of the inter-war years, in particular with some of the compositions of Felice Casorati (1883–1963). Casorati's personages often have an air of distinguished melancholy, and the same mood pervades many of Feltus's compositions.

Another American, Katherine Doyle (b. 1952), lives and works in New Hampshire, but makes frequent visits to Europe. She might just as easily have been included in the previous chapter, as her work combines classical and domestic themes in a way that looks back to the two leading American artists of the late 19th century, Thomas Eakins and Winslow Homer. She is a representative of a developing tradition of realism, often underpinned by recognisably classical values, that survived in American art throughout the 20th century, though frequently overshadowed by more fashionable non-realist styles. The situation in British art is less clear-cut. The growing fascination with classical ideas and values has recently made itself felt there just as it has done elsewhere, as can be seen in the photograph *Miners' Memorial* (2001) by John Paul Evans (b. 1965). The subject is a detail of a sculpture by the academic artist Albert Hodge (1875–1917) on the east façade of the mid-Glamorgan County Hall in Cardiff's civic centre. Evans writes: 'This particular detail . . . is of the back of an ageing miner pushing a coal truck. I was drawn to the miner's back in relation to the low-relief figures [beside it]. As there was something strangely real about the figure retreating from the shot. At the same time I made connections between this and my doll portraits in my desire to make the inanimate real . . . Also I like the way a matter-of-fact, almost documentary title works in relation to an ambiguous detail of a sculptural form which seems to have a homoerotic quality.'

Paul John Reid (b. 1975), a young Scottish painter, opts for full-blown classicism in his

146

147

The Heliades, 2002.
Oil on canvas, 120 x 120 cm

147 Marc Quinn,
Jamie Gillespie, 1999.
Marble, 180 x 60 x 50 cm
and plinth, 20 x 60 x 50 cm

ambitious painting *The Heliades* (2002), the retelling of a classical legend about the daughters of Apollo who mourned so long over their brother Phaethon's death that they were turned into larch trees. It is so close in style to the cooler sort of 17th-century Baroque painting that at first glance it looks as if it might be a work by Orazio Gentileschi (1563–1639) in his late, English phase, or perhaps even by Simon Vouet (1590–1649).

It is perhaps significant that these two artists, in British terms, work away from the centre. The artistic climate in London is not friendly to classical or realist impulses, or to a combination of the two. There are, however, some exceptions to this rule, such as Marc Quinn (b. 1964). Quinn is a restlessly inventive artist generally identified with the YBA (Younger British Artists) group, which was glorified by its connection with the enterprising collector Charles Saatchi and with the controversial but popular 'Sensation!' exhibition (1997) based on his collection. Quinn has produced statues of amputees and of people born without limbs that challenge comparison with fragmentary antique statues. These figures are not truly classical – they lack any impulse towards the ideal, since they are in fact moulded from life – yet they do, nonetheless, toy with our inherited ideas about what classicism is like.

Michael Leonard (b. 1933) produces paintings that have puzzled critics because, in their eyes, their style hovers uneasily between the photographic and the classical. Leonard's nudes, his most characteristic productions, are indeed based on photographs that he makes himself. The photographs, however, are always in black-and-white. Leonard uses them because he wants his models to assume the sort of pose that no model in the studio could sustain for long. The reason for choosing poses of this type is that they enable the artist to use the human body to create a quasi-abstract pattern of solids and voids that fills and activates the surface of the picture. Leonard's 'realism' is thus very much qualified by an idealising impulse.

Yet another, and very different approach can be found in the work of Christopher Le Brun (b. 1951), who, like Roberto Marquez, has recently shown a fascination with the work of Dante. 'Dante and Virgil – The Embarkation' (1999–2000) is uncannily close in style to the work of Sir Edward Burne-Jones (1833–1898), whose career formed the main bridge between English Pre-Raphaelitism and the pan-European Symbolist Movement. In some ways, Le Brun offers a British equivalent to the work of Alberto Abate in Italy.

Classical imagery now manifests itself in unexpected places, such as China, the Balkans,

148 Christopher Le Brun,
Dante and Virgil - The Embarkation, 1999-2000.
Oil on canvas, 191 x 181 cm

149

149 Sui Jianguo,
Clothed Discobolus, 1998.
Painted fibreglass, 172 x 112 x 70 cm

150 Liu Dahong,
Sacrificial Altar, (detail)
Mao as God the Father, 2000.
Multi-panel construction: oil on canvas (20 panels)

Israel and Iran. In China, Sui Jianguo (b. 1956) has made a startling series of sculptures called *Creases in Clothes.* Icons of western classical art, such as the *Discobolus* of Myron or Michelangelo's *Dying Slave,* are presented fully clothed, in ill-fitting modern western clothes. These seem to take a derisive look at the survival of the western academic tradition within the Socialist Realist style that was de rigueur in Chinese official art during the years of the Cultural Revolution (1966–76). The supposition is reinforced by the fact that the same artist has also made a parallel series of sculptures that consists simply of gigantic hollow Mao jackets. Using western prototypes in this way has become one of the standard strategies now employed by contemporary Chinese artists when attempting to deal with the Cultural Revolution and its aftermath. The Shanghai-based painter Liu Dahong (b. 1962) produced perhaps the most ambitious of all the works of this type. His *Sacrificial Altar* (2000) is an elaborate parody of the Ghent altarpiece (completed 1432) by the brothers Hubert (c. 1366–1426) and Jan van Eyck (1385–1441). His version faithfully follows the iconographic pattern of the original. For example, Mao Zedong duly occupies the central place given by the van Eycks to the figure of God the Father. In true medieval fashion, Mao is supplied with numerous symbolic attributes, such as a seal engraved with his slogan 'Serve the People' and, round his right arm, the red armband worn by the Red Guards. At his feet is an evergreen plant, a traditional Chinese symbol of longevity.

Mersad Berber (b. 1949) uses classical imagery in a nostalgic rather than satirical fashion. Born in Bosnia, he now lives and works in Zagreb, with another studio in Dubrovnik. His paintings, often complex multi-panel compositions like the one shown here, make complex allusions to classical mythology or to local Balkan history. *Alegorija* (2000) is typical of his work in its use of overlapping images, and in the way it suggests that the surface of the painting has already been degraded a little by time. The figure of Mercury in the centre of the composition derives from a statuette by the French 18th-century sculptor Jean-Baptiste Pigalle (1714–1785). This can also be seen in a still life entitled *The Attributes of the Arts* (1766) by Pigalle's contemporary and friend Jean-Baptiste-Siméon Chardin (1699–1779), which is now in the collection of the Minneapolis Institute of Arts. In the ancient world, Mercury was the patron of commerce and quick thought, in addition to being the god of thieves. His presence in Berber's painting is a defiant tribute to the value of artistic sleight of hand – in other

151

151 Mersad Berber,
Velika Alegorija IZ Bosne, 2000.
Oil and crayons on canvas, 160 x 240 cm

words, the kind of unrepentant virtuosity towards which the post-Duchampian avant-garde has been most hostile.

Israeli visual culture is often perceived to be essentially Expressionist, but this situation, if it was ever in fact the case, has long ago dissolved. The Israeli art world now offers room for a multitude of different initiatives. The young sculptor Elie Gur-Arie (b. 1964) uses forms borrowed from nature to create sculptures that blend classicism with Surrealism. The somewhat older Michael Rapoport (b. 1948), originally from Kazakhstan, makes painted constructions featuring images with an affinity to the work of Caravaggio and Zurbarán.

The most unexpected place to show traces of classical influence is Iran. To outsiders, since the

Islamic world, creates digital compositions with strong classical overtones, sometimes with reference to the ancient world (*The Men Who Built the Pyramids*, 2001). Khosrojerdi overcomes Islamic prohibitions concerning the display of the nude body by wrapping his models in bandages soaked in mud before photographing them. At the same time, this process helps to generalise the bodily forms, to make them more idealised and less specific and particular.

Fereydoun Ave (b. 1945) takes a different route by focusing on the ancient Persian legend of Sohrab and Rustum. Rustum is the Iranian warrior-hero who kills his own son Sohrab in battle without realising who he is. Ave's works are digitally altered photographs and photographic collages. The images are based on the

152

153

154

Islamic Revolution of 1979 Iran has seemed like a closed society, deliberately shutting itself away from outside influences. The Iranian artists who have made reputations in the west have invariably been, like Shirin Neshat, expatriates, making careers in London, Paris or New York. One form of artistic expression has been an exception to this: Iranian film-making. Not surprisingly, therefore, many of the new artists now emerging from Iran itself are concerned with some version or other of the photographic arts. Many of these artists are not particularly young: they are simply newcomers on the world stage because of the political history of their country. Hossein Khosrojerdi (b. 1957), the grand prizewinner at the Sharjah Biennial of 2001, perhaps the most important biennial in the

local passion for wrestling and wrestlers' clubs, the traditional *zurkhanes*, or 'houses of strength'. In addition to providing a venue for a form of wrestling closely related to the oil-wrestling popular in Turkey, the *zurkhane* is a place where men do callisthenics and perform feats of strength to the accompaniment of rhythmic chanting, exercises that are believed to confer spiritual as well as physical benefits. Because they are rooted in traditional aspects of Iranian culture, Ave's images of *pehlivans*, or champion wrestlers, do not attract condemnation. The subject itself is, of course, also very much part of the classical heritage. In fact, physical contests of this kind were one of the things that, centuries ago, linked ancient Greek to ancient Iranian culture.

152 Elie Gur-Arie,
Untitled, 2001-2002.
Mixed media, 220 x 195 x 40 cm

153 Michael Rapoport,
Untitled #7, 1998.
Mixed media, 160 x 136 x 6 cm

154 Hossein Khosrojerdi,
The Pyramids Began Here, 2001.
Digital print on MDF, 185 x 90 cm

155 Fereydoun Ave,
Pehlivans: Sohrab and Rustum, 1998.
Digital photograph, size variable

156

157

(1582/3–1666). Hals's group paintings of the *Regents* and *Regentesses* (both 1644), now in the Frans Hals Museum in Haarlem, offer an obvious precedent for Rustin's *Étude d'après les six pensionnaires* (2001), with its row of decrepit figures swathed in a rich penumbra. The Norwegian Odd Nerdrum (b. 1944) offers another example of a contemporary artist who has a complex relationship to the pre-Modern tradition. *Summit* (2000), with the swaddled, pupa-like baby that recurs in many of his canvases, is an example of his characteristic style. Nerdrum is often compared to Rembrandt, but in this case a more direct model for the composition is the great German Romantic painter Caspar David Friedrich (1774–1840). There is a close compositional relationship to Friedrich's *The Wanderer Above a Sea of Fog* (1818) in the Hamburg Kunsthalle, which has a single figure with its back turned to us, poised on the crest of a hill, looking towards a mysterious immensity. Nerdrum has for many years been a violently controversial figure both in his native Norway and in the United States. In both countries, he is sometimes portrayed by critics as the arch-betrayer of Modernism. Nerdrum's reaction has been to proclaim himself 'the king of kitsch'. As his defender, the Norwegian critic Jan Åke Peterson, explains: 'Nerdrum sees the concepts of art and kitsch as having reversed their roles since the end of the nineteenth century. Starting with Cézanne, the modernists transformed art into an exercise in pure design and became the "timekeepers of science" in Nerdrum's words. Kitsch came to mean everything else that had still dealt with sensuality and emotion, as the art of the past had once done'.[1]

Nerdrum is perfectly correct in asserting that overt emotional statements – at least those conveyed by traditional painterly means – are now rare. They are not, however, unknown. There is an unexpected link, for example, between the work of Nerdrum and that of the British painter John Kirby (b. 1949). Both artists are autobiographical and often appear as protagonists in their own work, as Kirby does, for example, in *Jeremiah Lamenting the Fall of Jerusalem* (1992), a painting that also contains an unmistakable reference to the Holocaust.

There has also been an increasing tendency amongst painters searching for a new beginning to look at precedents within what could be called the 'modern age' that are not generically modern. The British painter David Remfry (b. 1942) makes large watercolours of dancers that are certainly not idealised. They represent ordinary people enjoying themselves within a specific social context. Because of their subject-matter, they bring to mind the

Among western artists, even those who are not classicists by temperament, there is also an increasing tendency to refer to the work of the great pre-Modern masters. The figurative paintings of the French artist Jean Rustin (b. 1928) refer to an 'abject' world that is in many ways much more frightening than that created by his slightly older contemporary Francis Bacon (1909–1992). But they also make very obvious references to the work of artists such as the 17th-century Dutchman Frans Hals

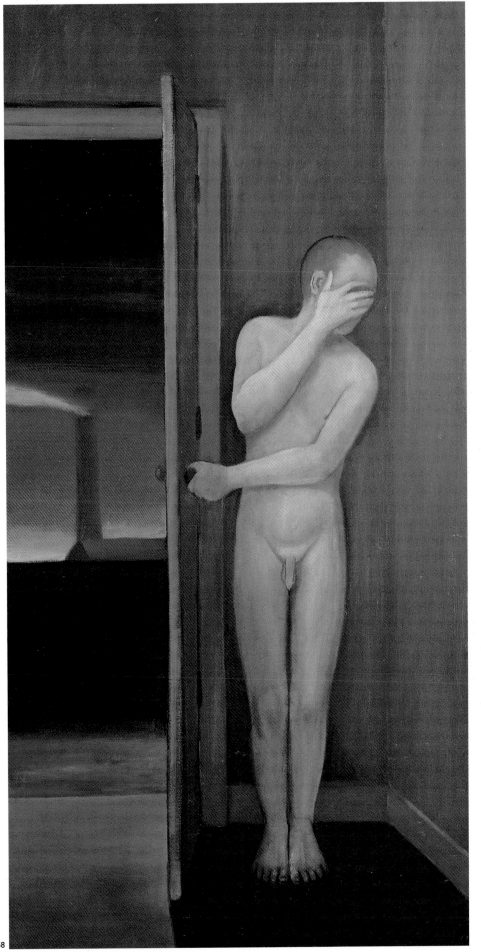

159

159 David Remfry,
Untitled, 2002.
Watercolour on Arches paper, 100 x 255 cm

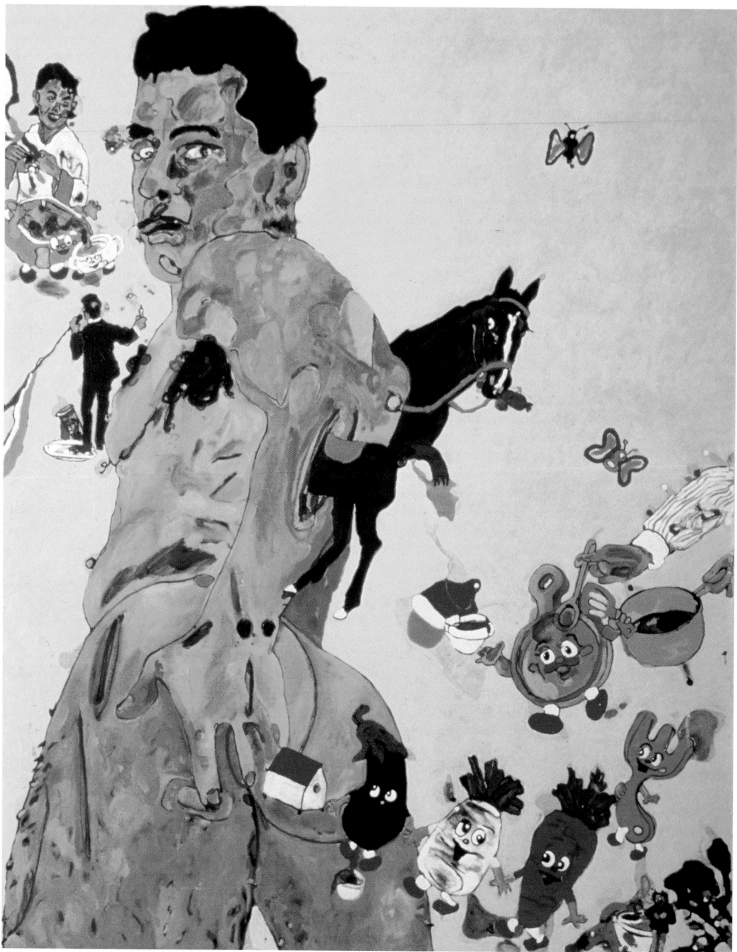

work of the American inter-war artist and illustrator Reginald Marsh (1898–1954), a connection reinforced by the fact that Remfry is an expatriate who lives in the United States. However, his real affinities, as he says himself, are with the German artists of the Neue Sachlichkeit (New Objectivity), notably with Otto Dix (1891–1969).

In France, Philippe Perrot (b. 1967) has devised a curious new version of the work of Egon Schiele (1890–1918), the short-lived genius who was one of the leading figures in the Vienna Secession. Secessionist and Neue Sachlichkeit influences are also visible in the work of the Italian painter and draughtsman Andrea Martinelli (b. 1965). Martinelli owes something not only to Schiele, but also to the German Weimar period master Christian Schad (1894–1982), whose talent for incisive characterisation he shares. One aspect of Martinelli's art, which looks back beyond the Vienna Secession to Symbolism, is his interest in doubles or doppelgängers. The personages he depicts are frequently accompanied by an alter ego (*La donna nella città*, 2000).

The legend of the doppelgänger ('double-goer' or 'co-walker'), which has also attracted Roberto Marquez (see above), is rooted in European folk tales, but it first acquired intellectual importance in the Romantic period, coming to prominence for the first time in Jean-Paul Richter's novel *Siebenkas* (1796–97). Other celebrated uses of the idea occur in E. T. A. Hoffmann's short story *The Doubles* (1821), Dostoevsky's *The Double* (1864) and Robert Louis Stevenson's famous novella *The Strange Case of Dr Jekyll and Mr Hyde* (1886). Stevenson said of this book, in his essay 'A Chapter on Dreams' (1888), that he 'had long been trying to write a story . . . to find a body, a vehicle, for that strong sense of man's double being which must at times come in upon and overwhelm the mind of every thinking creature'. In the note he leaves before he kills himself, Dr Jekyll states: 'Man is not truly one, but truly two. I say two, because the state of my own knowledge does not pass beyond that point . . . I learned to recognise the thorough and primitive duality of man.' This is yet another example of the way in which today's art is returning to pre-Modern roots.

Contemporary photographers, as can be seen from the work of Paul Hodgson (see above), have also begun to look with some fascination at the work of the Old Masters. The photographs of the Japanese Hiroshi Sugimoto (b. 1948), for example, which are made in wax museums, re-create the atmosphere of traditional painting. Sugimoto's depiction of *Henry*

161

162

163

VIII (1999) depends for its effect on the spectator's recollection of the painting by Hans Holbein (1497?–1543). Of course, there is a curious kind of double-bind situation involved here, since Holbein's portrait of the Tudor monarch is also, and obviously, the prime source for the waxwork itself.

Elger Esser (b. 1967), who like so many leading German photographers was a student of Bernd and Hilla Becher, cites 19th-century literature as part of his source material, such as the letters exchanged between two great French writers, Gustave Flaubert and Guy de Maupassant. He even travelled extensively in France and Italy in search of the places the two authors mention in their correspondence. It is also clear, however, that he has made a close study of European landscape painting, from the 17th century onwards. An image such as Elger's *Cap d'Antifer* (2000) owes a fairly obvious debt to the coastal scenes painted by Claude Monet (1840–1926). One finds similar reconstructions of 19th-century art in the work of British

164

162 Hiroshi Sugimoto,
Henry VIII, 1999.
Gelatin-silver print / ed:5, 150 x 120 cm

163 Elger Esser,
Cap d'Antifer, Etretat, 2000.
Chromogenic print on DiaSec face / ed:7,
130 x 185 cm

164 Matt Collishaw,
The Awakening of Conscience Kateline, 1997.
Nova print, wood, glass, sr:3 (261 x 261 cm)

165

166

165 Michal Chelbin,
Untitled #9, 2002.
Colour print on paper, 140 x 100 cm

166 Sam Taylor-Wood,
Pietà, 2001.
35mm film / ed:3, 1.57m

167 Bill Viola,
The Quintet of the Astonished, 2000.
Video installation, 825 x 877 x 410 cm

artist Matt Collishaw (b. 1966), though his
Awakening Conscience has in fact little in com-
mon with the painting by Holman Hunt
(1827–1910) after which it is named. Michal
Chelbin (b. 1974), who, like Adi Nes, is a
young Israeli photographer, sometimes uses
Christian archetypes as part of her imagery.
The Pietà, which is one of the archetypes select-
ed by Chelbin, reappears in a video by the
British artist Sam Taylor-Wood (b. 1967),
another member of the YBA group. In this
work, she shows herself holding the semi-nude
body of the American actor Robert Downey Jr.
The message here is a complex one. Taylor-
Wood is herself very much part of the celebrity
culture that coloured the reception of British
avant-garde art in the 1990s. Downey is at
least as well known for his drug addiction and
imprisonment for drugs-related offences as he
is for his talent as an actor, though his reputa-

167

tion as a movie star is considerable (in 1992 he was Oscar-nominated for his performance in the title role of the film biography of Charlie Chaplin). Summing up Downey's public persona, Charles Taylor said: 'There is an image at the beginning of Mike Figgis' 1997 film *One Night Stand* that seems to sum up the public's perception of Robert Downey Jr. He stands on a stage, dressed in jeans and black tank top, looking gaunt and haunted, his arms outstretched at his sides while magnesium flares go off around him. It's the image of a hipster Christ crucified for his art.'[2] The role assigned to him in Taylor-Wood's video is therefore a familiar one. She does, however, give it an additional twist. As the video shows her physically straining to support Downey's weight, the spectator automatically tends to think of the two protagonists as being in some mysterious fashion martyrs to their own fame.

The seamless integration of high culture and the essentially popular medium of video reappears in even more complex forms in the work of Bill Viola (b. 1951). An example of this is his work *The Quintet of the Astonished* (1999) made in response to *The Mocking of Christ* (c. 1490) by Hieronymus Bosch. This reflects not on the main subject of the painting, but on the reactions of the spectators, here portrayed by actors and filmed in extreme slow motion – so slow that it is at first easy to miss the fact that this is a moving image. The technique somehow focuses acute attention on the emotions portrayed. Viola's video was shown side by side with the Bosch original in an exhibition entitled 'Encounters: New Art from Old' (2000) organised by the National Gallery in London. Twenty-four leading contemporary artists were invited to participate, and Viola's work was one of the very few which sustained the demanding comparison.

Viola's success was a proof not only of his own considerable talent but also of the way in which art is now returning to essential sources of nourishment, despite continuing critical and theoretical hostility.

1. Jan Åke Petersen, *Odd Nerdrum: Storyteller and Self-Revealer*, Oslo, n.d. (1998), p. 230.

2. Piece written for the Internet magazine *Salon.com*, 10 April 2001.

the politics of shock

More than any other form of creative expression, the contemporary visual arts have a symbiotic relationship with scandal, and therefore, inevitably, with attempts at suppression. In the 1970s, matters appeared to be relatively simple. Large tracts of the world were still dominated by the Soviet Union and by satellite regimes allied to it. In these regions, Socialist Realism remained the only officially sanctioned form of art. Nevertheless, things were beginning to change. In fact, they had begun to change more than a decade earlier. This gradual thaw was abruptly checked when, in 1962, Nikita Khrushchev visited an exhibition held at the Manege in Moscow, to mark the thirtieth anniversary of MOSKH (Moscow Section of the Artist's Union). This featured the work of a number of only marginally official Russian artists. Khrushchev was outraged with what he saw and had a noisy public exchange of views with the sculptor Ernst Neizvestny (b. 1925) who, only three years previously, had won a competition for a national memorial commemorating the Russian victory over the Nazis. The thaw nevertheless cautiously resumed and by 1974 matters had progressed so far that Neizvestny was actually asked to design the now fallen Khrushchev's tombstone at Novodevechiy Monastery. That year, however, witnessed another, less positive event, the so-called 'Bulldozer Exhibition' held by a large group of 'dissident' artists in the Izmailovsky Park in Moscow, where the work on view in the open air was swept away and crushed by official clean up crews. This piece of savagery, much publicised in the west, confirmed European and American perceptions that the censorship of art was primarily political, and was a feature of Communist societies, not of democratic ones.

At the same time, however, practitioners of the contemporary arts have often been very ready to cry censorship – especially in the prosperous western democracies, where they are fairly certain that their cries will be heard. The tradition is such, especially in the visual arts, that to have suffered some degree of censorship, or some attempt at censorship, is both a guarantee of authenticity and, to a certain degree, a badge of honour. In any case, attempts at suppression generate publicity. It is therefore not surprising that contemporary artists often seem to invite it, rather than making efforts to avoid it.

An early example of this kind of manipulation was the debut organised by Marcel Duchamp (1887–1968) for his *Fountain*, the most famous of his readymades. This is a men's urinal, selected by Duchamp from a supplier of sanitary fittings, signed by him with the pseudonym 'R. Mutt' and submitted for exhibition at a nonjuried show held at the New York Armory in 1917. As Duchamp had anticipated, even though the exhibition had no jury or selection committee, the object was thrown out. This enabled him to make a number of points. The first, and most obvious, was that the organisers of the exhibition were not, after all, free of all prejudice – their treatment of the unknown R. Mutt was proof of their hypocrisy in proclaiming complete openness of mind. The second point was that artworks, to ensure their status as art, to some extent rely not on their own innate qualities, but rather on the context in which they are presented. In a store selling sanitary porcelain, the urinal was just that – a uri-

169

nal. Selected by Duchamp and transferred to a gallery setting, it became a bona fide sculpture. This has something to tell us about the nature of censorship itself, since we often find that what seems unexceptionable in one context, attracts attempts at suppression when placed in another. Censorship has a lot to do with what people in authority think is decorous, or appropriate to a particular set of circumstances. In the United States, the 1980s and 1990s saw a series of running battles between artists and the American art world in general and conservative politicians, often allied to the Christian right. Mostly these battles were to do with sex and representations of sexuality, but religion also played a part. One of the first of these controversies was aroused by Judy Chicago's ambitious feminist installation *The Dinner Party* (1979). The piece, a triple Eucharist, with places provided for thirty-nine celebrated women at a vast triangular table, was first shown at the San Francisco Museum of Modern Art, where it was an immense success, attracting huge crowds. Later, other museums

refused to exhibit it, apparently for fear of losing funding, and alternative non-museum spaces had to be found. When the artist tried to negotiate a permanent home for the installation at the University of the District of Columbia, the project foundered when the United States Congress threatened an audit and a reduction of federal funding.

The problem was not simply Chicago's feminist viewpoint but the sexual imagery she employed. The vagina-like design of the plate provided for each guest aroused sharp controversy. During a heated Congressional debate, Representative Dana Rohrbacher described *The Dinner Party* as 'weird sexual art', while Representative Stan Parris condemned it as 'clearly pornographic'. Though *The Dinner Party* is now perhaps the most celebrated artwork of its period, and is routinely illustrated in college textbooks about 20th-century art, it has only recently acheved a permanent home, with the Brooklyn Museum.

Another major American controversy of the final decades of the 20th century surrounded

168 + 169 **Barbara Nahmad,**
Untitled: Couple of Women, 2000.
Oil and enamel on canvas, 110 x 200 cm
Untitled: Couple of Men, 2000.
Oil and enamel on canvas, 90 x 135 cm

170

170 Nobuyoshi Araki,
Tokyo Alice: In the Box, 2001
Black and white print on paper

171 Andres Serrano,
A History of Sex: Antonio and Ulrike, 1995.
Cibachrome, silicone, plexiglass, wood frame
ed:3, 153 x 126 cm

the Robert Mapplethorpe (1946–1989) photography exhibition 'The Perfect Moment'. This was organised by the Philadelphia Museum of Contemporary Art just prior to the artist's death, and was due to be shown at the Corcoran Museum in Washington, DC. News of its forthright sexual content reached members of Congress, among them the veteran conservative senator Jesse Helms. In the face of their protests, the director of the Corcoran, Christina Orr-Cahill, lost her nerve and cancelled the event. When, in 1990, 'The Perfect Moment' continued its tour, going to the Contemporary Arts Center in Cincinnati, the local authorities shut it down and arrested the CAC's director, Dennis Barrie, on charges of obscenity. The event became a rallying point for opponents of racism and homophobia. Barrie was

eventually acquitted, and the show reopened. The exhibition itself was recently restaged, more than ten years after the original tour, at the Santa Monica Museum of Art, demonstrating its now iconic status.

More recent censorship controversies in the western democracies have often seemed factitious – deliberately stirred up for the sake of publicity. The 'Sensation!' exhibition of new British art from the collection of the advertising tycoon Charles Saatchi, which was seen first in London (1997), then in Berlin and finally at the Brooklyn Museum in New York, offered striking examples of this kind. In London, the item that caused most offence was a large portrait of Myra Hindley, who was serving life imprisonment for her part in the so-called Moors Murder case, which involved the sexual molestation,

torture and death of very young children. Though the trial took place as long ago as 1966, Hindley and her partner Ian Brady retain an especially dark place in the British popular imagination. The sullen police photograph made of Hindley after she was arrested has become iconic, and it was this that the artist, Marcus Harvey (b. 1963), used as the basis for his painting. The paint was applied using a model of a child's hand. When news of the painting's inclusion in the show leaked out before it opened at the Royal Academy of Arts in London, the British tabloid press lashed itself into a fury, organising public protests from the victims' relatives. The work was later vandalised and had to be temporarily withdrawn from the show. This incident offers a perfect example of the symbiosis between Postmodern avant-garde art and the popular press. Supposedly at odds, they are to some extent co-dependent. The howl of protest about Harvey's painting played a large part in generating the publicity that made the exhibition an enormous success.

When the show reopened sometime later at the Brooklyn Museum, protests centred not on the painting of Hindley (the story of the Moors Murders had little meaning in America), but on a painting of the Madonna by a British artist of African origin, Chris Ofili (b. 1968). Ofili's artistic trademark is the fact that he incorporates balls of dried elephant dung into his painting. In this case, one of the Madonna's breasts was a collaged-on lump of dung. Instead of the traditional cherubs, she was surrounded by photographic representations of sexual parts, cut from pornographic magazines. The latter, however, caused relatively little offence. It was the dung that generated the uproar. The painting was described by its opponents, most of whom had never seen it, as being 'smeared with excrement'. The chief opponent of the exhibition was the mayor of New York, Rudolph Giuliani. Giuliani was at that time thinking of running for the American Senate, and needed the support of the strong Catholic community in his city. He seemed to think that threatening to withdraw city funding from the Brooklyn Museum if it showed Ofili's picture would be a popular electoral ploy. The tactic backfired and once more the exhibition, benefiting from the publicity generated by the controversy, drew very large crowds.

These two incidents illustrate the kind of dialogue that now often takes place between avant-garde art on the one hand and television and newspapers on the other, with various forms of political and legal authority making up the third side of the triangle. Only rarely do the censors triumph. Rather, their feeble efforts

171

to suppress tend in the long run to validate artistic enterprises that sometimes do not deserve the glory thus conferred upon them. The only occasions when suppression comes near to succeeding is when the artist strays into a few areas that currently make western liberal society feel especially nervous. Harvey's painting, not at all experimental in itself, toyed with the panic about paedophilia, which has risen to new heights in both Britain and the United States. If he had made an image of a naked child, he would have been in much greater danger of suppression. There are images that seemed perfectly acceptable to the hippie culture of the 1970s – bearded naked daddies dandling their equally naked prepubescent daughters – which are now unexhibitable and unpublishable.

One artist who has had particular trouble with this is the American photographer Sally Mann (b. 1951), who has from time to time run into trouble with candid pictures of her children. Here, for instance, is an opinion from a lecture delivered by Christopher H. Pyle, Professor of Politics at Mount Holyoke, an American women's college well known for its openness to radical ideas: 'It is not just the artfulness of Mann's images that shields her from condemnation; it is the artful way she excuses her transgressions. We look at the picture of the all-too-aware girl with the cigarette and fear she is headed for trouble. Then we read the caption and discover that the cigarette is made of candy. Similarly, those scabrous legs are not diseased; flour and water just made them look that way. The red liquid on the boy's abdomen

172

is not really blood; it is raspberry juice. The children look wild, shameless, and out of control, but the captions tell us otherwise.' A more conservative opinion was expressed by Dane L. Peters, headmaster of a school in Connecticut: 'In this electronic era can we afford the subtleties and nuances projected in Sally Mann's art? Sally Mann exploits youth's innocence, and while I am not in favor of censorship, I do take exception to art that uses children to pose in questionable situations, and the fact that Sally Mann used her own children should not legitimize her work. At what point does child art become pornographic?' Mr Peters's protestation that he is 'not in favor of censorship' clearly has to be taken with a pinch of salt.[1]

In western democratic societies efforts at suppression almost invariably centre on sexual issues. There is one exception to this: imagery to do with the Holocaust. An example of the kind of emotion this can stir up was the forced

withdrawal of the Polish artist Zbigniew Libera's (b. 1959) *Lego Concentration Camp* from the Venice Biennale of 1997. It is not altogether easy to understand why Libera's work aroused so much negative emotion in a society where Art Spiegelman's (b. 1948) *Maus* (*Maus I*, 1986; *Maus II*, 1991) – the story of the Holocaust presented as a comic strip – enjoyed such a colossal success. Both works make use of deliberately trivial popular imagery. The different reactions they aroused seem to be almost entirely a matter of nuance, combined with the fact that Spiegelman is indisputably Jewish, and a child of concentration camp survivors. His book is in fact the story of his father, Vladek, who was imprisoned at Auschwitz. Spiegelman won the Pulitzer Prize in 1992 and his book was hailed by the *Wall Street Journal* as 'the most affecting and successful narrative done about the Holocaust'. Libera has not attained this level of secure celebrity, but he

was, nevertheless, one of the artists featured in the exhibition 'Mirroring Evil: Nazi Imagery/ Recent Art' held at the Jewish Museum, New York, in 2002 (as was Roee Rosen, whose work has already been discussed).

When we look at contemporary art that seems intended to shock, it is seldom truly avant-garde in the sense of being technically experimental. Two paintings by the Italian artist Barbara Nahmad (b. 1967), *Couple of Men* (2000) and *Couple of Women* (2000), both seem to be based on photographs found in pornographic magazines. The Super Realist technique emphasises the anonymity of the bodies portrayed, reinforced by the cropping of the heads. Interestingly enough, it is the painting of the male couple that will probably seem more disturbing to the majority of spectators. Though contemporary feminist theory makes much of the 'male gaze', of the way that men seem to control and dominate women by simply looking at their unclothed

173

bodies, it is the unclothed male body that has the greater power to make people feel uneasy.

The theory of the male gaze comes not from art criticism but from film criticism. The classic statement of the feminist position can be found in Laura Mulvey's essay 'Visual Pleasure and Narrative Cinema', first published in the magazine *Screen* in 1975, and many times reprinted. Mulvey highlights the role of gender in the spectator's viewing of the female body on screen. Originating as they do in film, her ideas often seem to work better when applied to photography than when feminists try to relate them to other aspects of contemporary art. For example, the photographs of Nobuyoshi Araki (b. 1940), the pre-eminent Japanese photographer of his generation, do often seem to combine voyeurism and sadomasochism in a way that very precisely mirrors some of the things that Mulvey has to say. The following quotation from Mulvey needs little adaptation if we apply it to the image illustrated here: 'Woman then stands in patriarchal culture as a signifier for the male other, bound by a symbolic order in which man can live out his fantasies and obsessions through linguistic command by imposing them on the silent image of woman still tied to her place as bearer, not maker, of meaning.' In fact, the parallel seems almost too neat.

The really crucial element here is not the male gaze as such but the fact of photography. Virtually everything that now has the power to shock, at least in the west, seems to be dependent, in one way or another, on the camera. The majority of the artistic controversies of the final two decades of the 20th century were linked to work which was either directly photographic or in some fashion or other linked to photography (as in Marcus Harvey's portrait of Myra Hindley discussed above). The reason is self-evident. Though we are becoming more and more keenly aware of the way in which photographic

172 Michelle Williams,
Sunday Afternoon, 2000.
Video, 6.13m

173 Oleg Kulik,
Deep into Russia, 1993.
Silver-print on paper, 30 x 40 cm

images can be digitally manipulated, the photographic image, as opposed to the painted one, seems to offer a guarantee of authenticity. Our gut feeling still is that 'this really took place, and someone was there to witness it'.

The artistic controversy of the late 1980s and early 1990s which, in the United States at least, rivalled the row over Mapplethorpe's work, focused on a single image by another American photographer, Andres Serrano (b. 1950). Serrano's *Piss Christ* purported to show a small plastic crucifix plunged in a vat of urine. Senator Alfonse d'Amato attacked the work in Congress, using terms even more violent than those previously applied to Judy Chicago's *Dinner Party*: 'Well, if this is what contemporary art has sunk to, this level, this outrage, this indignity – some may want to sanction that, and that is fine. But not with the use of taxpayers' money. This is not a question of free speech. This is a question of abuse of taxpayers' money. If we allow this group of so-called art experts to get away with this, to defame us and to use our money, well, then we do not deserve to be in office.'[2]

Piss Christ retained its power to disturb well into the 1990s. In 1997 Serrano had an exhibition in Australia, at the National Gallery of Victoria. The Roman Catholic Archbishop of Melbourne tried to take out an injunction, on the grounds that the image was blasphemous. The Supreme Court of Victoria rejected this. Visitors to the show then physically attacked the piece on two separate occasions. After the second attack, Dr. Timothy Potts, director of the gallery, closed the exhibition on the grounds that the gallery could no longer guarantee the security of the visitors and staff or of the works of art. The irony is that the camera does not in fact represent liquids such as urine very well. For all the evidence the photograph itself provides, the offending liquid might as well be lemonade.

Serrano has continued to explore the frontiers of the unacceptable. His *History of Sex* (1995–96) offers images that evoke various forms of erotic perversion. The series also features unlikely physical conjunctions and, sometimes, maimed participants like those who feature in some of the sculptures of Marc Quinn. Nevertheless, many of the compositions Serrano uses are often extremely familiar to anyone with a knowledge of Old Master painting. *Antonio and Ulrike* (1995), for instance,

resembles what art historians would call a 'Roman Charity'. The Roman historian Valerius Maximus relates that when the Athenian general Cimon was condemned to starve to death in prison, his daughter Pero secretly visited him in order to nourish him with milk from her own breast. The story, regarded as offering a paradigm of filial devotion, was illustrated by Sir Peter Paul Rubens (1577–1640) among others. Modern commentators have often noted the erotic overtones of Rubens's treatment of the theme, which dates from c. 1625.

Sexual shock has also been a weapon employed by a number of other celebrated contemporary artists, such as Jeff Koons in his *Made in Heaven* series (1989–91). A number of very large cibachrome photographs, plus sculptures in various materials, show the artist engaged in various sexual acts with his then wife, the Italian porn star Ilona Staller, nicknamed 'La Cicciolina' ('the little cuddly one'). The images are nothing if not explicit: one shows Koons having anal intercourse with his partner. They are heavily indebted to the imagery of the purely commercial erotic films previously made by Staller. Since his divorce in 1992, Koons no longer allows these images to be reproduced, but they were widely circulated at the time when they were made. In fact, where very similar photographs in hard-core pornographic magazines might have attracted the attention of the law, these, much larger and more public, escaped censorship almost entirely.

The Russian performance and video artist Oleg Kulik (b. 1961) is perhaps best known for his parody of Joseph Beuys's 'action' *Coyote: I like America and America Likes Me* (1974). In *I Bite America and America Bites Me* (1997), he impersonated a savage dog twenty-four hours a day, shut up naked in a cage in a New York Gallery. Kulik has also made a series of challenging photographs called *Deep into Russia* (1993). In these he commits, or seems to commit, acts of bestiality with various farm animals. His wife, the critic Mila Bredikhina, provides a justificatory text to support what he does: 'Kulik's activities simultaneously reveal two vectors in contrast with one another, both equally topical in today's Russia. His aggressive external unpredictability today coexists with the deep, tormented contemplation of one's obscure, stifling unmetaphysical profundities. The madly energetic explorer of the profundities of the cow reveals the two coexisting codes of two Russian realities: anxiety and aggressiveness.'[3] The series is actually part of a broader project named *Zoophrenia* on the theme of 'Animals as the alter egos of human beings', or 'The animal as anthropomorphic Alien'. In oth-

er words, Kulik believes that sexual intercourse with animals is OK, because all species are equal.

A rather similar enterprise was undertaken by the British artist Michelle Williams, whose video *Sunday Afternoon* (2000) shows a young woman (the artist herself) trying to seduce a dog, which remains indifferent to her advances. The video was shot in close-up, so that only parts of their bodies are visible at any one time, and it is thus impossible for the spectator to make out exactly what is going on. The viewer becomes a voyeur, staring at something that may, or on the other hand may not, be completely innocent – although the intensity with which the scene is filmed suggests that the former is the more likely of the two interpretations. A video from a very different source takes a completely opposite tack. The Serbian artist Zoran Naskovski (b. 1960) has made a confrontational animation (1997) of Gustave Courbet's famous – or notorious – painting *L'Origine du monde* (1866), commissioned by Khalil Bey, a Turkish diplomat and collector, once Ottoman ambassador in St Petersburg, who also owned Ingres's (1780–1867) *Le Bain turc* (1862). The painting shows the torso and pubic area of a woman in extreme close-up, and was for long time considered so scandalous that various owners, among them the celebrated French psychoanalyst Jacques Lacan (1901–1981), always kept it concealed behind a shutter or curtain. In Naskovski's version the woman comes to life, masturbates herself to orgasm to the strains of the Andante from Mozart's Piano Concerto No. 21 (the 'Elivira Madigan' concerto) and then sinks back into stillness again. The Serbian critic Branislav Dimitrijevic has noted the widely differing contexts that produced the two works: the suppression of overt sexuality in the 19th century and the way society has been saturated with pornography in recent years.

In fact Naskovski's video, like Kulik's suite of photographs, poses a whole series of questions about contemporary society, contemporary art and our current attitudes to eroticism. It is worth noting, for instance, that both Kulik and Naskovski are natives of former Eastern bloc countries, where erotic manifestations were often fiercely suppressed by the ruling Communist regimes. Post-Communist regimes have been far more lax in their attitudes, even when they were not democratic. Naskovski's video was made when Slobodan Milosevic was still in power. When I saw it in Belgrade, in late 1999, I asked if there had been any difficulties with the local censorship. The answer was: 'No, none at all, though we did experience some

175 Thomas Ruff,
Nudes lac15, 2000.
Laserchrome and diasec, 150 x 110 cm

176

176 Ghada Amer,
The Yellow, 1999.
Acrylic, embroidery, gel medium
on canvas, 180 x 200 cm

177 Marlene Dumas,
Miss Pompadour, 1999.
Oil on canvas, 46 x 50 cm

177

178 Gilbert and George,
Pissed, 1996.
Handcoloured photos on paper, 338 x 710 cm

PIS SED

1996

Gilbert & George

179 Tracey Emin,
My Bed, 1998.
Mattress, linens, pillows, rope, suitcases,
various memorabilia

when we wanted to show it in Germany.' One explanation may have been that the Milosevic regime, pursuing an oppressive political agenda, saw no reason to irritate the population, intellectual in particular, by imposing irrelevant restrictions elsewhere.

Another point worth noting is Naskovski's selection of musical accompaniment. The choice of one of Mozart's best-known works defiantly puts forward a claim that the video with which it is associated must be regarded as high art, and at the same time undermines this claim through further association with a notoriously melodramatic and sentimental film. *Elvira Madigan* (1967) is a story of doomed love between a young army officer and a circus acrobat with a period setting, directed by Bo Widerberg (1930–1997).

In fact Naskovski's work, like that of Koons, Kulik, Serrano and a multitude of others, now exists in a context where erotic and indeed pornographic images are pretty much universally available. This is largely due to the rapid growth of the Internet. For technical reasons – in broad terms, because of the fact that it exists both everywhere and nowhere – the Internet has proved itself extremely resistant to censorship, far more so than its predecessors radio and television. For the first time since the invention of printing, the means of mass communication have apparently slipped from the grasp of those who seek to control them.

Not surprisingly, certain artists have actually begun to use Internet pornography as source material. An example is the German photographer Thomas Ruff (b. 1958), yet another pupil of Bernd and Hilla Becher, has made a series of images based on pornographic scans found on the Web. Despite the cleverness of Ruff's technique, the banality of the source material tends to undermine what he does. The result is too refined and sophisticated for its own good.

The same comment can perhaps legitimately be made about a very different artist, using a totally different technique. Ghada Amer (b. 1963) is an Egyptian-born artist who now lives and works in New York. Her best-known works are canvases with brightly coloured grounds – one critic called them 'Popsicle-coloured'– adorned with delicate threadwork. When these stitched paintings are looked at closely, these threads resolve themselves into depictions of provocatively posed female nudes, of a type familiar from western 'nudie' magazines and now also from numerous Internet sites. Ghada Amer, thanks both to her technique and her subject-matter, has been co-opted by American feminists, but her real dialogue is with traditional Islamic culture, with its profound suspicion of

the body. As Dishad D. Ali commented in Islam Online, a website devoted to Islamic culture and society, 'Orthodox Muslims consider displaying the human image in any form unacceptable; painting or drawing a nude figure, of course, is forbidden. The display of the human image is deemed sacrilegious because it attempts to glorify the human figure when it is only Allah that should be glorified. And since Allah cannot be presented in form, appropriate Islamic art instead typically delves into abstraction and calligraphy. The suggestive content of most of Amer's work goes against the very nature of proper Islamic art.' Amer is, however, interesting because she has initiated a dialogue between opposing cultures, a dialogue of a subtler and more perturbing sort than that associated with the better-known Shirin Neshat.

In general, women artists have understandably had a more difficult time of it making a place for themselves in the new erotic culture, whose imagery can often be perceived as being innately hostile to women. There is also the fact that men find erotic representations made by women more threatening than similar images made by members of their own gender. The controversy over Judy Chicago's *Dinner Party* was a case in point.

One artist who has successfully leapt most of the barriers is Marlene Dumas (b. 1953), who was born in South Africa but now lives in Amsterdam. Dumas is typically upfront about her motivations. In a self-interview she wrote: 'I paint because I'm a woman. (It's a logical necessity.) If Painting is female and insanity is a female malady then all female painters are mad and all male painters are women.' Some paintings by Dumas, for instance *Miss Pompadour* (1999), come remarkably close to works by Jean Rustin, who shows female figures in similar poses, although the resemblance is probably coincidental. Dumas's paintings of this type seem motivated not so much by a desire to shock as by a desire to assert the right to make use of all types of subject-matter.

Autobiographical artists play a prominent role in today's avant-garde, and it is fairly commonplace for them to stress the more scabrous aspects of their private lives. This is the case, for example, with the British duo Gilbert and George (Gilbert Proesch, b. 1943; George Passmore, b. 1942), who in recent large-scale photo-works such as *Pissed* (1996) have tackled topics such as their own inebriation. The duo have long been fascinated by excrement and excretory functions, and the word 'shit' appears quite frequently in their titles. A whole series of *Naked Shit Pictures* showing the nude artists surrounded by enlarged representations

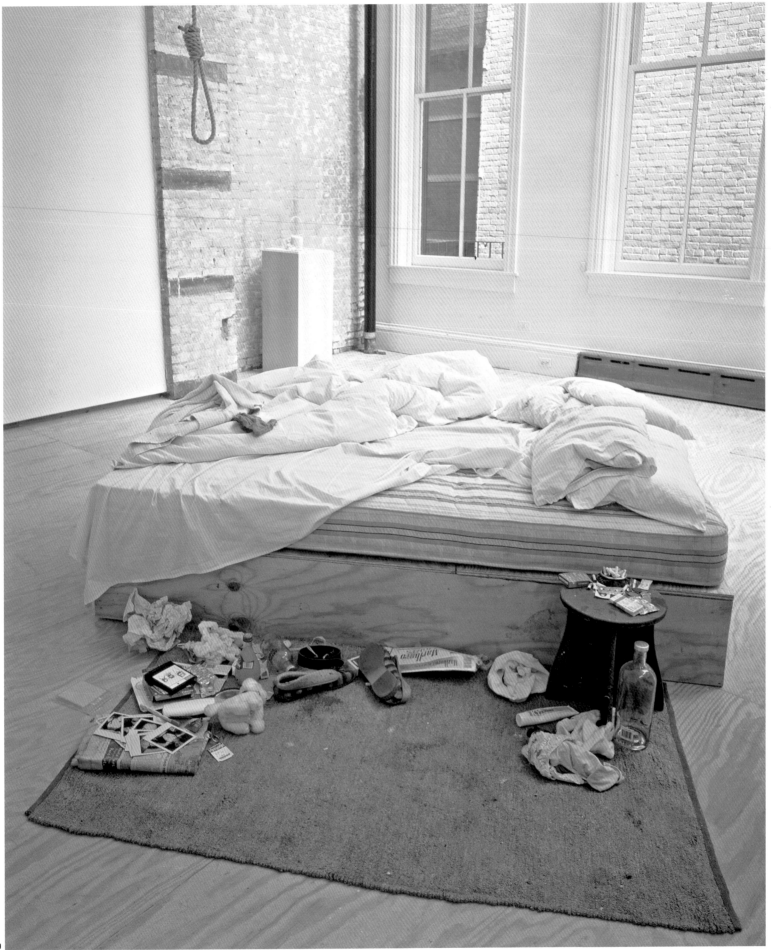

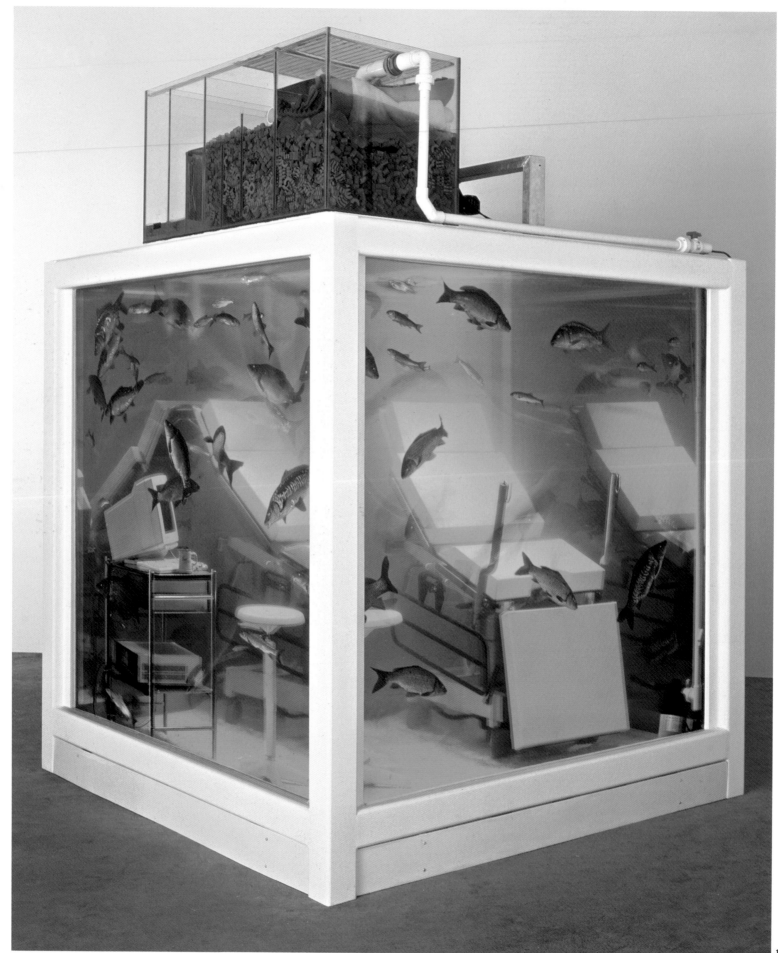

of their own excrement debuted at the South London Art Gallery in 1995, and was subsequently shown in a variety of other prestigious locations, both in Britain and abroad. It was only when the work reached the Ormeau Baths Gallery in Belfast in 1999 that it aroused some sort of protest. This came from the fundamentalist Protestant clergyman and politician the Reverend Ian Paisley, who declared that the artists had 'tainted Ulster with their filth'. Since Paisley protests about many aspects of contemporary life, and is adept at getting publicity for his views, his opposition did the artists more good than harm. Gilbert and George are avowed populists, who once said: 'We want our Art to speak across the barriers of knowledge directly to People about their life and not about their knowledge of art.'

Another artist who has become famous for her exposure of the more intimate aspects of her private life is Tracey Emin (b. 1963). Already quite well known as a leading member of the much publicised YBA group, Emin achieved national notoriety in Britain with her installation piece *My Bed* (1999), which was entered for, but did not win, the Turner Prize in the year of its creation. *My Bed* is a faithful reconstruction of the artist's bedroom, after a bout of illness, depression and – it is implied – sex. In fact, as *The Guardian* newspaper pointed out at the time, *Bed* was hardly world-shaking in terms of its context: '*My Bed* is not a particularly shocking work of art. It is, as a previous Turner nominee points out, "muted" compared to other things Emin has done. The stains, contraceptives, vodka bottles, KY jelly, etc. are just inert objects; slightly icky imagery, as a Turner judge says. Everyone denies being shocked themselves, but they have still gone on about "urine-stained sheets", "heavily soiled knickers" and "used condoms". *The Daily Telegraph* reported that "several journalists at the press view described the exhibit as stomach-churning". No one will quite admit it wasn't all that filthy except Matthew Collings in *The Observer*, who described it as "elegant". In fact, the clear glass of the vodka bottles and the white bed linen are more noticeable than the stains. The transgressive quality of the work is not to do with content at all but its claim to be "art".'[4] This latter claim had, of course, been made long ago, in precisely the same terms, by Marcel Duchamp's Fountain. If the argument still has not been settled more than eighty years later, then perhaps it ought to be.

The truth is that the tactics of shock, so long an identifying mark of avant-garde activity, have gradually been losing their potency over a period of time. This is especially true of societies where the making of art of an identifiably 'advanced'

contemporary type has come to be regarded as something that occupies a central place in cultural consciousness. One of the striking aspects of contemporary art, already noted in the first chapter, is that it is now also official art. Outbursts like that of Paisley can be accommodated within the existing official framework – indeed, they play their part as a kind of validation of the authenticity of the work that is being condemned. Mapplethorpe's reputation, and later that of Andres Serrano, were in fact reinforced by the controversy aroused. It is because of the controversy, not despite it, that we now regard them as important.

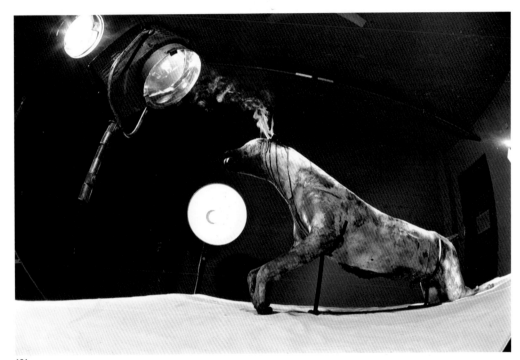

181

The only time that people are genuinely shocked by contemporary artworks is when there is some kind of cultural mismatch. Examples of this are some recent installation pieces by the young Chinese duo Sun Yuan (b. 1972) and Pen Yu (b. 1974), though Sun Yuan believes that 'there is no explicit border between Chinese and western culture'.[5] The installations they make often cross boundaries that are still maintained in the west. For example, a number make use of foetuses – children carried nearly to full term or else born dead. Asked where he obtains these, Sun Yuan says that he purchases them, quite legitimately, from hospitals.[6] The little corpses are evidently a product of the one-child, one-family policy in China. The action/installation *Soul Killing* (2000) is only marginally less disturbing. Its main feature is a

180 Damien Hirst,
Love Lost, 2000.
Aquatic tank, filtration unit, couch trolley, gynaecological stool, surgical instruments, computer, jewellery, cup, river fish, 275 x 215 x 215 cm

181 Sun Yuan & Pen Yu,
Soul Killing, 2000.
Installation

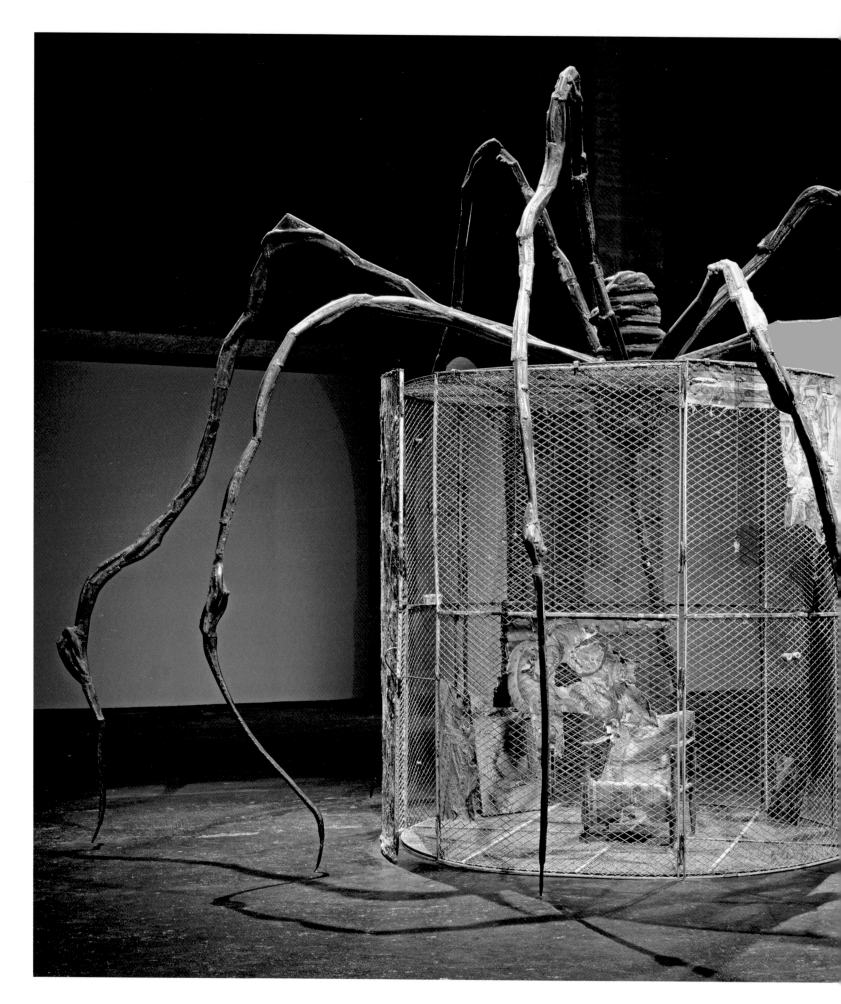

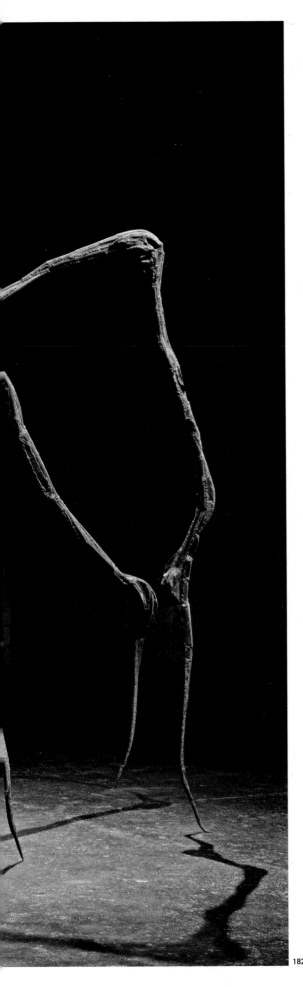

dead, skinned dog, perhaps purchased in a Beijing food market. It is propped up on a metal stand, as if still alive, and a powerful light projector has been directed at its head, to burn away the brain. The reference is to a Chinese folk belief that the spirit may linger in a mischief-making fashion within or close to a dead body, and needs to be driven out by violent means. With the much more empathetic western attitude towards animals, particularly dogs, it is scarcely possible to think of an installation of this sort being mounted in a western museum or *Kunsthalle*.

There is, nevertheless, only a fairly narrow margin separating an installation of this type from some of the more characteristic works of one of the greatest art stars of the 1990s, the Briton Damien Hirst (b. 1965). Hirst often makes use of dead animals. In fact, he first became famous for a piece entitled *The Physical Impossibility of Death in the Mind of Someone Living* (1991), which features a dead tiger shark floating in a tank, balanced there to look as if it was still alive. *Love Lost* (2000) is a tank filled with live fish, swimming round a submerged obstetricians chair and various other pieces of medical paraphernalia. However, Hirst's piece has a metaphoric force that somehow seems to mark it off from *Soul Killing*. Unlike the work of the two Chinese artists, it does not permit any kind of straightforward explanation. It seems, instead, to be a disturbing metaphor, in elaborate three-dimensional form, for aspects of the human condition.

In this respect, it is comparable to certain works by Louise Bourgeois (b. 1911), such as *Spider* (1997). Bourgeois made her reputation very late, partly because of emigration to America from her native France, partly because of family responsibilities in her new, American life as the wife of a well-known art historian, but also in large part because of her gender. Paradoxically, however, her work is, as she has said quite openly, the product of childhood traumas, in particular the product of emotional conflicts with her father, who made Louise's English governess his mistress. Her father's business was a workshop that repaired antique tapestries, and Bourgeois, perhaps in reaction to this, has made the spider one of her preferred symbols, seeing it both as a creature that labours tirelessly at its own domestic tasks and as something which stealthily entangles its prey, just as domestic obligations entangle human beings. Bourgeois is really a belated Surrealist and her installations are direct descendants of some of those seen in the major International Surrealist exhibitions held during the inter-war period. There is a resemblance,

for instance, to Salvador Dalí's *Rainy Taxi*, which was installed in the entrance courtyard of the 'International Exhibition of Surrealism' held in Paris in 1938. With its internal sprinkler system and population of snails, this has, in addition, an obvious kinship to Hirst's *Love Lost* and similar works that seems to have escaped commentators on Hirst's career.

The search for the shocking has in fact been going on for a very long time. It was 18th- and 19th-century Romantics, such as Henry Fuseli (1741–1825) with his painting *The Nightmare* (1781), who initiated the politics of shock in art; and Symbolists, such as the Italian sculptor Adolfo Wildt (1868–1931), who codified them. Later, the members of the Surrealist movement turned the whole idea of shock and outrage into an acceptable form of public spectacle. Every artistic generation since then has thrown up artists who feel it is their duty to outrage the bourgeois public. Today, while the bourgeoisie are still with us, it looks as if the options are running out. It would be difficult for any artist working now to outdo some of the performances put on by the Vienna Actionists in the 1960s. In one of these, staged in 1968, Gunter Brus (b. 1938), a leading member of the group, undressed, cut himself with a razor, urinated in a glass, smeared his body with faeces, then sang the Austrian national anthem while masturbating. He was arrested for degrading state symbols and sentenced to six months in jail. Today, if he submitted a script for an action of this kind to the appropriate bureaucratic organisation, someone would probably offer him a grant.

1 Quotations from Professor Christopher H. Pyle and Dane L. Peters are taken from the Internet.

2 Congressional Record, 18 May 1989.

3 Mila Bredhikina in 'Flesh and Fell/Tout Cru/Met Huid en Haar', portfolio issued by ArtKiosk, Brussels, n.d. (c. 1997), no pagination.

4 Jonathan Jones, *The Guardian*, 26 October 1999.

5 Statement on the website *Artscene China*.

6 Interview in Beijing with the author, August 2000.

182 Louise Bourgeois,
Spider, 1997.
Mixed media and steel, 445 x 666 x 518 cm

the body and identity

chapter seven ••••

183

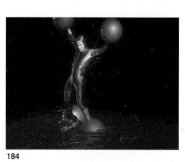

184

185

183, 184 + 185 Lars Siltberg,
Man on Ice, 1998.
Man on Water, 1999.
Man on Air, 2001.
3 production stills from the video series
Man with Balls on Hands and Feet, 1998-
s2001

It both is and is not surprising that the human body now occupies a central position in contemporary art. At the beginning of the 20th century, the Modern Movement challenged the supremacy traditionally assigned to it in post-Renaissance painting and sculpture. The birth of abstraction seemed to push the human figure to one side. Though its presence in art was never entirely abolished, abstract art became identified with the idea of true uncompromising modernity – a preconception that lingered at least as late as the early 1960s, when Abstract Expressionism was challenged by the rise of Pop Art. Even after that point, the Minimalists continued to push the idea that the only truly radical and experimental art was entirely non-representational.

The human figure re-emerged in avant-garde art thanks to the rise of Performance Art from the 1960s onwards. Real bodies – rather than bodies represented in painting and sculpture – began to be perceived as the animated, or at any rate animate, equivalents of Duchamp's ready-mades. Throughout its long history in the west, art has always had strong links to theatrical presentation. The medieval mystery plays, for example, were book illuminations and stained-glass windows brought to life. The influence was reciprocal: there is a miniature by Jean Fouquet (c. 1420–1481) in the *Hours of Etienne Chevalier* (c. 1435) that shows the *Martyrdom of Saint Apollonia* as if it were an episode in a contemporary mystery cycle. The genre painters of the 18th and 19th centuries were strongly influenced by the stage, which occupied the central place in the culture of the time that is

today held by film and television. William Hogarth's (1697–1764) *Rake's Progress* cycle (1732–34), for instance, is a series of episodes from an unwritten play, closely related to the same painter's record of an actual performance of John Gay's *Beggar's Opera* (1728).

Performance works are still plentiful today, and their appeal has been strengthened because they can now be married to video. The subject of some of these works is the human body itself. A recent example is the elaborate video-installation *Man with Balls on Hands and Feet* (1998–2001) by the Swedish artist Lars Siltberg (b. 1968). A lone performer is seen in different situations, attempting to deal with ice, water and air. The imagery is curiously touching: the human being is reduced to total helplessness in the face of what the world does to him; he cannot cope with the hostility of natural forces.

The *Bread-Men* series (1999) by the Japanese artist Tatsumi Orimoto (b. 1946) is more difficult to explain. Here a group of performers, with baguettes of bread tied to their heads so as to form a kind of mask, paraded in the streets of Cologne. Orimoto has also made a series of Performance pieces that deal with the Alzheimer's disease that afflicted his mother, and these figures too may offer a comment on the essential absurdity of human existence.

One of the best-known creators of Performance Art today is the Italian American Vanessa Beecroft (b. 1969). Her serried ranks of female nudes have made her enormously popular, but also highly controversial. As an article printed in the magazine *Parkett* noted, 'The drama of Vanessa Beecroft's work derives from . . . transposition. In inspiration her work is essentially classical. Nude and semi-nude females, shorn of any trappings that might express their individuality, contractually obliged to remain as silent and immobile as possible, posed vertically and arranged in a group composition on a horizontal plane. The sum effect is something like a painting by Poussin except for this one crucial difference: Beecroft's subjects are not made of paint but of living flesh. To abstract from the life model in order to paint a timeless figure is one thing, but to abstract the life model herself is another. What appears as classicism in the first case becomes depersonalization and suppression of individuality in the second.'[1]

Most of Beecroft's Performance pieces involve females, but she has also created others that make the military metaphor in her work explicit. *VB 42 Intrepid: The Silent Service*, included in the Whitney Biennial of 2000, involved the participation of US Navy SEALs in full uniform. The piece aroused the violent indignation

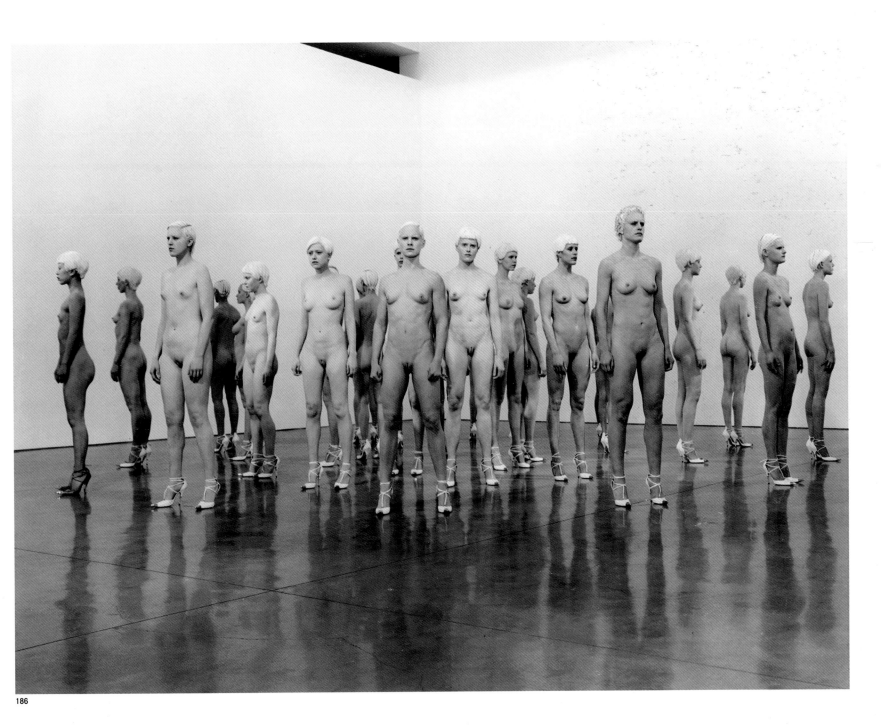

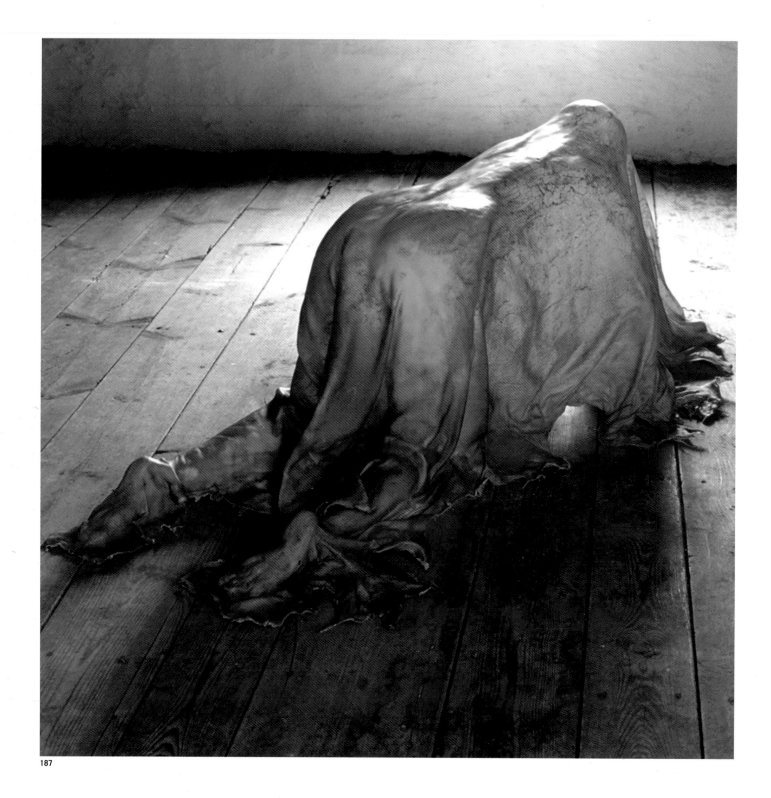

187

187 Janine Antoni,
Saddle, 2000.
Full raw hide, 66 x 83 x 200 cm

of at least one spectator. In a parody of Allen Ginsberg's poem 'Howl' (1956), the radical critic Charlie Finch noted that the performance took place on an aircraft carrier that had played a prominent role in the war in Vietnam, and wrote:

Where is the sense of loss,
the humility of Maya Lin's
Vietnam monument?
It is not here,
in Beecroft's wham bam four star blowjob.
As Picasso genuflected to the commies,
or Ezra Pound broadcast
his hateful screeds,
so Beecroft thinks her genius
justifies her slavish craving
for order–
What a joke,
and it's on you and me,
artvölk.[2]

Beecroft's Performance work is in fact unusual for its lack of political content. Many of the most prominent Performance artists, especially in the United States, have been women, and their work has usually made reference to feminism. This is also the case with sculptures that are obviously related to Performance, like Janine Antoni's (b. 1962) *Saddle*, which essentially represents females as anonymous beasts of burden.

Perhaps the most celebrated art work of recent years to take the female body as its subject is Mona Hatoum's (b. 1956) *Corps étranger* (1994). This is not exactly a Performance piece, though it is related to Performance. It consists of a small enclosure containing, projected on to the floor, a video produced when the artist introduced a camera into the orifices of her own body, using procedures such as endoscopy and colonoscopy. The resulting images, accompanied by sound of the artist's own heartbeat, offer an intensely intimate yet at the same time alienated self-portrait. Observing herself in this way, the artist, as the title of the work suggests, becomes a stranger to herself. Part of the resonance of *Corps étranger* springs from the fact that Hatoum is doubly exiled. Born in Beirut of Palestinian parents, she was stranded in Britain when the Lebanese civil work broke out in 1975, and has now become identified with the British art scene.

It is not surprising to find Hatoum's example being followed by other women artists from the Islamic world. Two of the most interesting are Iranian. Afshan Ketabchi, an artist living and working in Tehran, presented her *What I Have in Common with Aurelia and Rudabeh* at the First Iranian Festival of Contemporary Art

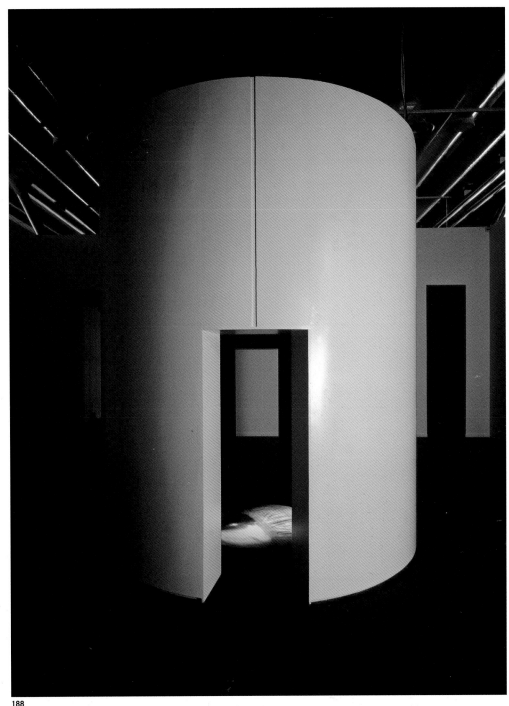

188

188 Mona Hatoum,
Corps étranger, 1994.
Video installation: cylindrical wooden structure, video projector, amplifier, 4 speakers, 350 x 300 x 300 cm

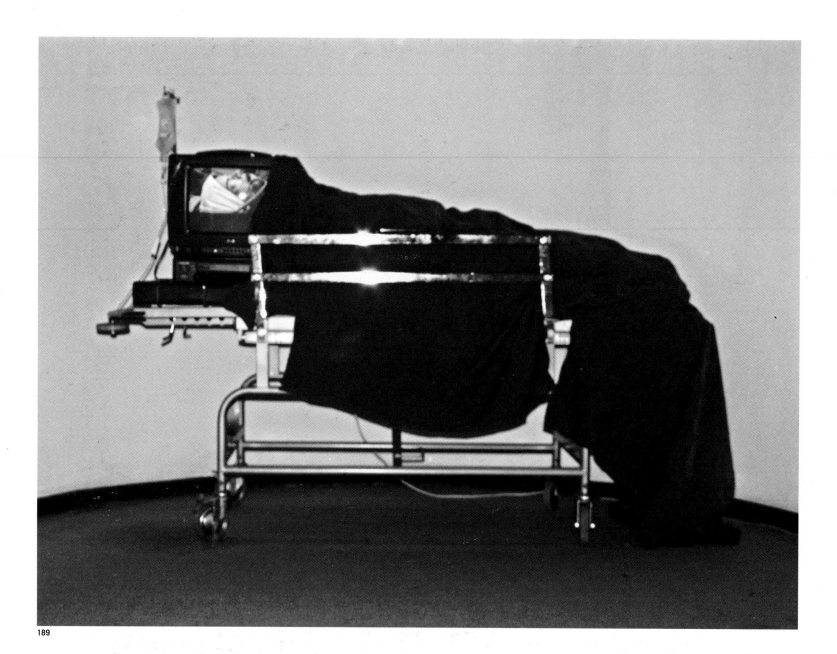

189

189 Afshan Ketabchi,
*What I Have in Common with Rudabeh
and Aurelia,* 2001.
Video installation

190 Ghazel,
*Me: being 'cool'" was showing-off with
your two wheels when we were teenagers,*
1997-2000.
Video still

(2001). The title refers to the mother of Julius Caesar and the mother of the legendary Iranian hero Rustam. Both were reputed to have given birth through an incision in the belly (hence the modern medical term 'Caesarean section'). As part of a more elaborate installation, Ketabchi offered a video showing the birth of her own daughter by this procedure. Another video showed various stages of her daughter's life, together with a hospital bed and glass cases displaying paraphernalia connected with birth.

Ghazel is an Iranian artist now living and working mostly in France. She has made a remarkably funny series of 42 short videos called *Me* (1997–2001), that show in various 'scenes of life' – waterskiing, getting executed, sunbathing, moonwalking, emerging out of the sea as a Botticelli Venus, making a Molotov cocktail, exercising with Jane Fonda exercise tapes – while wearing a veil, which is obliga-

tion in Iran. She says: 'My work is about the foreigner's position in the west and the foreigner's position in Iran. My films are like a home video, through images I document my life, my reflections, impressions, thoughts, fears, remembrances, wishes, experiences, my present, past and future, my emotions, hopes and desires, my energy and complexes, paradoxes, my personality and my dreams, my recollections and my memory. They are my parallel life.'[5]

Artists working in difficult Third World situations are often forced to be political activists as well. This has been the case with the Indonesian artist Arahmaiani (b. 1961), who has gained a substantial reputation through participation in various international exhibitions, such as the Havana Biennial. Arahmaiani is in fact as much an activist as she is an artist. Her earliest art activity took place in the early 1980s and took the form of a protest against

being 'cool' was showing-off
with your two-wheels
when we were teenagers

191

the rising toll of street accidents. She wrapped the electric poles along Bandung's Dago Street with bandages smeared with fake blood, and distributed a pamphlet with accident statistics. This led to her suspension from a university art education course. Following this she travelled widely outside her native country, going to Australia, Thailand, the Netherlands and even as far as Kazakhstan. However, it is only since the fall of the Suharto government in 1998 that she has been able to work freely in her own country. *Offering from A-Z* (1996), a performance in the Padang Cemetery in Thailand, offered a typically feisty combination of images, sex confronting death.

Arahmaiani is political because circumstances force her to be so. As she once remarked: 'I live in a country of full of paradoxes. People seem to be friendly and warm like the tropical climate, they love to smile even when they feel disturbed. Most people love sweet melodious music, stories about love and affection, have a firm belief in the existence of God, and believe in religion and its rituals. They seem to take life

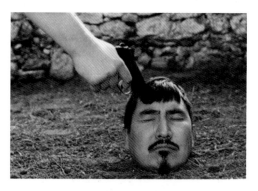

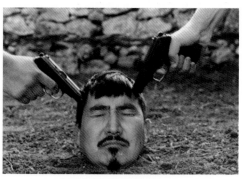

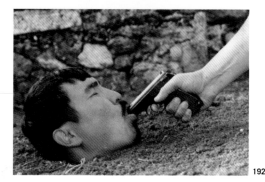

192

191 Arahmaiani,
Offerings from A-Z, 1996-1997.
Performance

192 Erbolsyn Meledbekov,
Pol Pot #6: Project Invasia, 2001.
Performance

easy; people move gently and elegantly and speak softly to show their politeness and harmony with the surroundings. This is one side of it, one face of Indonesia, very sweet and nice. At the same time it has another face which is horrific. Indonesians, sweet Indonesian people are also capable of practising all kinds of violence, such as genocide, rape, and abuse of the weak, without feeling guilt and remorse.'4

From Kazakhstan itself comes another Performance artist not afraid to tackle difficult issues. Erbosyn Meldybekov (b. 1964) belongs to a group of post-Soviet artists working in the Kazakh capital, Almaty. Like Oleg Kulik in Moscow, Meldybekov specialises in scandal and transgression. Where Kulik becomes a human dog, Meldybekov, in some of his performances, has taken on the persona of an Asian slave or prisoner, having himself led around on a chain, with a traditional Chinese cangue locked round his neck (a cangue is a heavy wooden collar that allows a prisoner to move around but prevents him from feeding himself). Even more disturbing are images from Meldybekov's *Pol Pot* series (2000). Apparently modelled on atrocity photographs from Cambodia, these show the artist buried up to his neck in the ground, being threatened by a gun or guns held to his head or thrust into his mouth. These images, like those of the man in the cangue, stress the helplessness of those who inhabit the margins of a new post-Soviet society.

Many of the images created by Performance and Body artists are concerned with a search for identity. Oreet Ashery's (b. 1966) *Self Portrait as Marcus Fischer* (2000) concerns both gender and Jewishness. The artist, a woman, has written about her Marcus Fischer series as follows:

Leaving Israel for England, Jerusalem for London, produced a constant sway between the privilege of having two 'homes' and having no 'real home'. My work explores this movement. A series of self portraits dressed as a male orthodox Jew, started in tribute to a close friend who 'left' when he entered Jewish orthodoxy. My research of the specific cross/dressing codes for these portraits became quite fetishistic. Gradually this male persona developed and emerged as 'Marcus Fischer'. In Hebrew 'Mar' translates as 'Mr' and 'Cus' as 'Cunt'. Sometimes I think I might be creating a Golem or maybe a Dybbuk . . .

Recently I discovered that in the Bible there is a direct ban on cross-gender activities: A woman shall not hold a man's tool and a man shall not wear a woman's dress. The ban doesn't express a fear of sexual deviancy, but

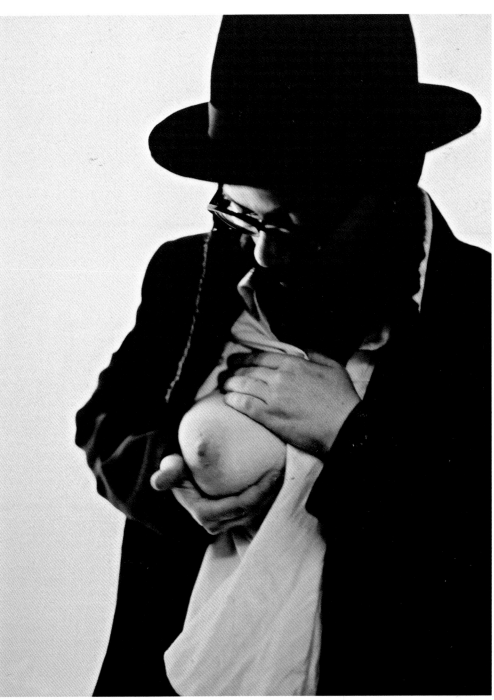

193

193 Oreet Ashery,
Self-Portrait as Marcus Fischer #1, 2000.
Digital print / ed:5, 10 x 10 cm

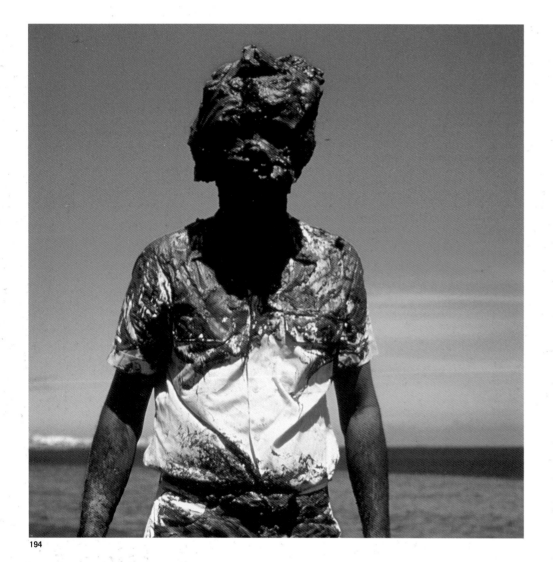

194

is an acting out of his own sense of otherness, his feeling of being isolated and estranged, part of francophone culture yet visibly not French. Similar motivations inform the work of the British black photographer Ajamu X (b. 1963), who says: 'Although many forms of physical difference are now classified in acceptable liberalised ACCEPTABLE TERMS there is still a perverse curiosity for the freak. I am exploring the concept of freak as a metaphor for those dislocated, estranged, alienated and marginalised within contemporary culture. It is my intention to develop further lines of inquiry I have been pursuing with regard to otherness and difference from a black queer perspective, making links between freaks GROTESQUE and representations of the cultural OTHER.'[6] Much of Ajamu's work, like that of Thierry Fontaine, is self-portraiture, and even when this is not the case, his interest in the idea of 'otherness' is self-evident. As we have seen, this is something photography is especially well adapted to expressing, because of its emphasis on the particular, as opposed to the general. Interestingly enough, some of Ajamu's symbolism is accidental, or at least coincidental. When I asked if the top hat worn by the model in *Untitled* (1997) was anything to do with Baron Samedi, the God of Death who is the most important figure in the voodoo pantheon, Ajamu said the idea had never occurred to him.

Some of the most interesting recent self-portraits are the work of the Chinese artist Zhang Huan (b. 1965), who is now resident in New York. His instinctive mixture of elegance and brutality found expression in large, full-colour photographic close-ups, showing his face dripping with soap bubbles. In his open mouth were little snapshots of his family, as if he was somehow giving birth to them. Another series of self-portraits showed him wearing the ribcage of a newly slaughtered pig. His *Family Tree* series (2001) is less theatrical, showing his features being gradually obscured by writing in Chinese characters (*Family Tree, no. 5,* 2001). Zhang Huan says: 'The face, gradually covered by current culture, is turning black. It is impossible to take away your inborn blood and personality. The shadow walks suddenly from early morning to late night, from the first cry of a baby to white-haired old age, standing lonely in front of the window looking at, and eventually peeping into the world, reminiscing about an illusory life.'[7]

In the *Family Tree* series, Zhang Huan's face looks as if it might be tattooed, though in fact it isn't. Tattooing, which has risen in popularity recently, especially among members of the gay community, has now started to play an

194 Thierry Fontaine,
La Réunion: Sculpture #3, 1998.
Colour print, 146 x 106 cm

rather it is part of the list of things that must not be combined or hybridised by human intervention: milk and meat, horse and donkey, wool and cotton, male and female. The punishment is pelting with stones.

Marcus Fisher changes context wherever he goes. In London's Soho he is visibly Other, but really more of a 'double agent'. In Tel Aviv he makes a political body, flirting with Jewish patriarchy and law. Is Marcus mobilising the territory?[5]

Thierry Fontaine (b. 1969) is from La Réunion, a French island off the eastern coast of Africa. His work consists of a series of self-portraits in which he both reveals and conceals himself – in many of them, he plasters his features with mud so that they become unrecognisable. This

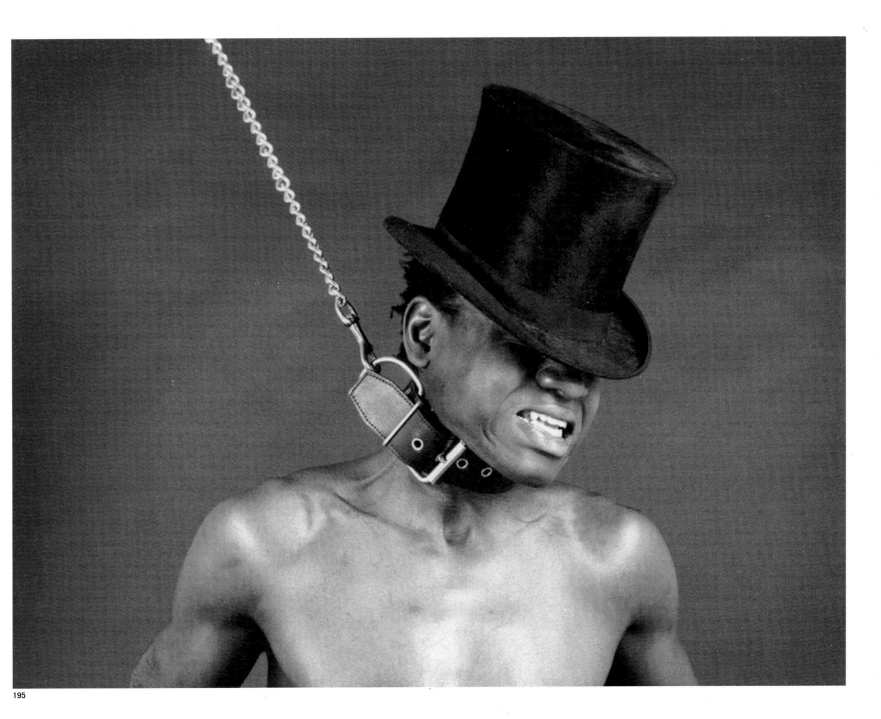

195 Ajamu, *Untitled,* 1997.
Silver gelatin print

Following pages:
196 Zhang Huan,
Family Tree, 2001.
8 colour prints on paper, each 180 x 220 cm

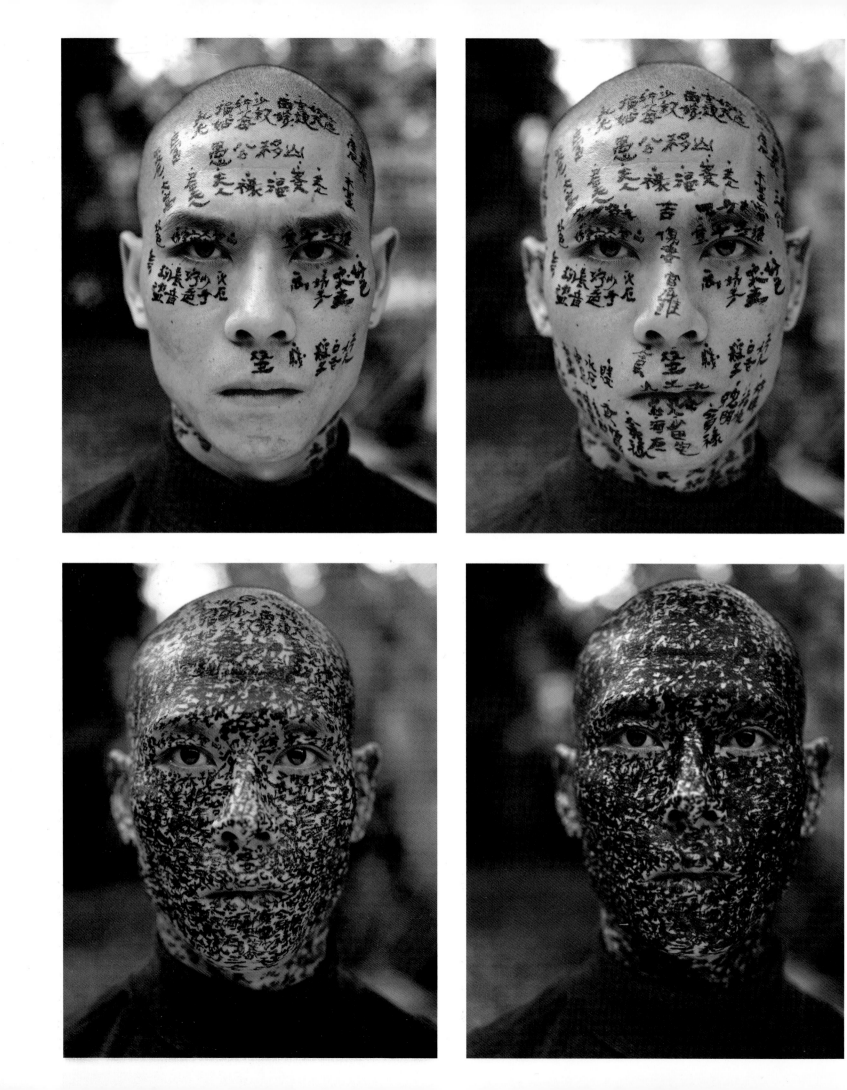

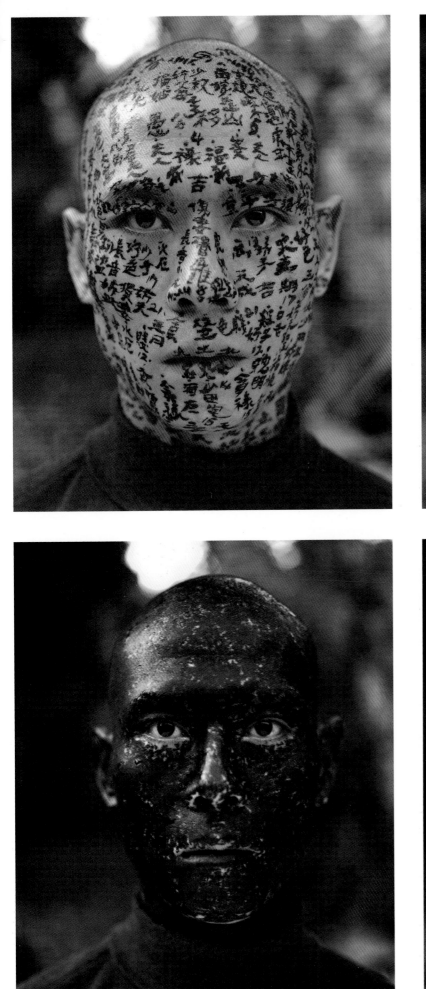
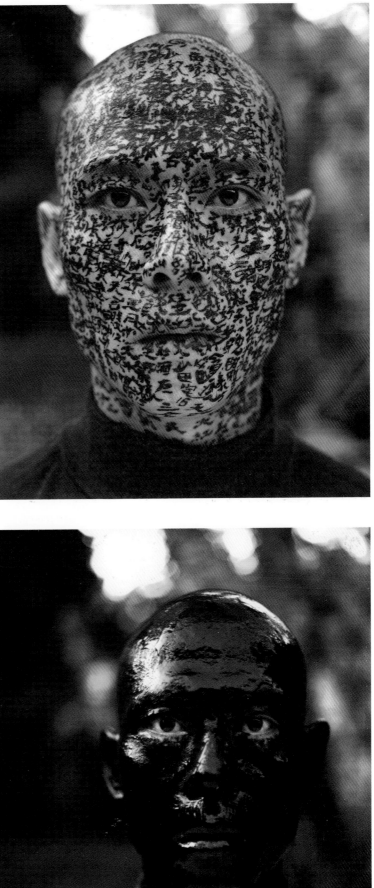

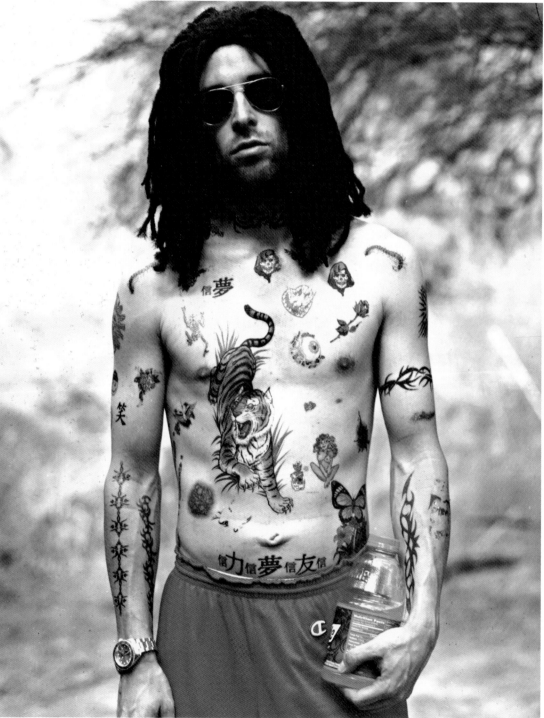

197

197 Olaf Breuning,
Ray, 2000.
Colour print / ed:3, 394 x 310 cm

198 Catherine Opie,
Untitled, 2000.
Polaroid, 280 x 105 cm

increasingly prominent role in the avant-garde visual arts. The young Swiss photographer and Performance artist Olaf Breuning (b. 1970) is a composer of elaborate fictions. His fictional world includes elements that recur, among them the idea of face-painting. It is therefore difficult to be certain if his portrait of *Ray* (2000) is a likeness of someone who is genuinely tattooed, or if it is simply an image of an actor made up to fit one of Breuning's fantasies. In an interview, Breuning said: 'For me the separation between reality and fiction is blurred. Sometimes I do not know if I have really experienced things or if I have seen them in a film and I don't think that I am an exception. Our lifestyle is so privileged that we no longer need primarily be concerned about where to get the next loaf of bread. Rather we ask ourselves which video we would like to watch today. And this probably has certain consequences.'[8] Thus the tattooed figure is possibly only an invented stereotype.

Genuine tattoos appear in other contemporary photographic artworks. They are on prominent display in some series by Catherine Opie (b. 1961). Opie, a lesbian, is interested in documenting gay lifestyles, especially where these are linked to sadomasochism. The robed and tattooed figure shown in *Untitled, 2000* is evidently intended to read as a 'queer' version of the traditional religious image of 'Christ Shown to the People'.

Another artist, himself heavily tattooed and also heavily involved with the idea of queer culture, is the French photographer, Performance artist and mime Jean-Luc Verna (b. 1966). In December 2001, Verna shocked the readers of French *Vogue* with a graphic account of his early life and his experiences as a teenage male prostitute. 'Prostitution was my school of love,' he said bluntly. 'The savings made from the sweat of my bum paid for (a) trip to London.' Some of Verna's most engaging works are the equivalent of the famous 'attitudes' struck by Lord Nelson's mistress Emma, Lady Hamilton. These were poses inspired by various classical works of art, some of them recorded for posterity by the painter George Romney (1734–1802). Verna's models cover a wide spectrum, from the Zeus or Poseidon of Sunion, an original Greek bronze c. 450 BC now in the National Museum in Athens, to Edgar Degas's (1834–1917) *Petite danseuse de quatorze ans* (c. 1881). The tattoos on his body give a special spice to these impersonations. Verna often associates these images with favourite rock music tracks. The Zeus, for him, is associated with Iggy Pop's 'American Caesar' and Siouxsie's 'Premature Burial'. The Degas is

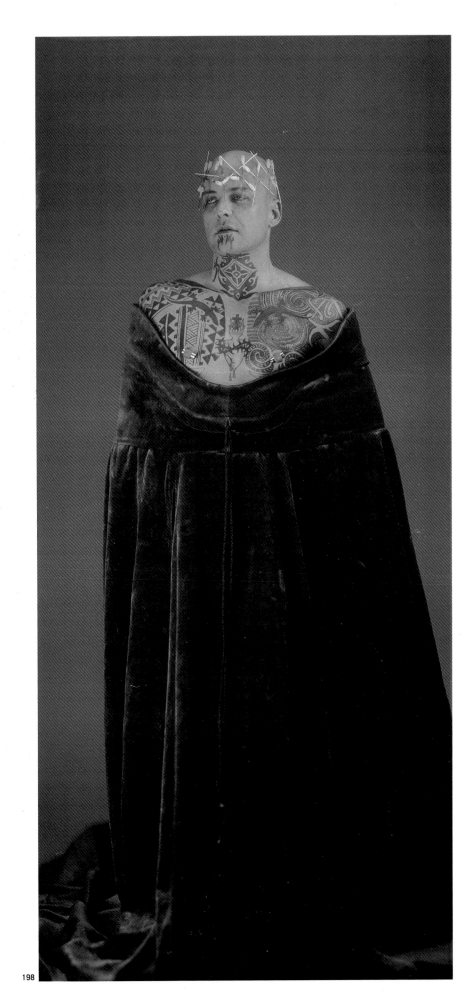

198

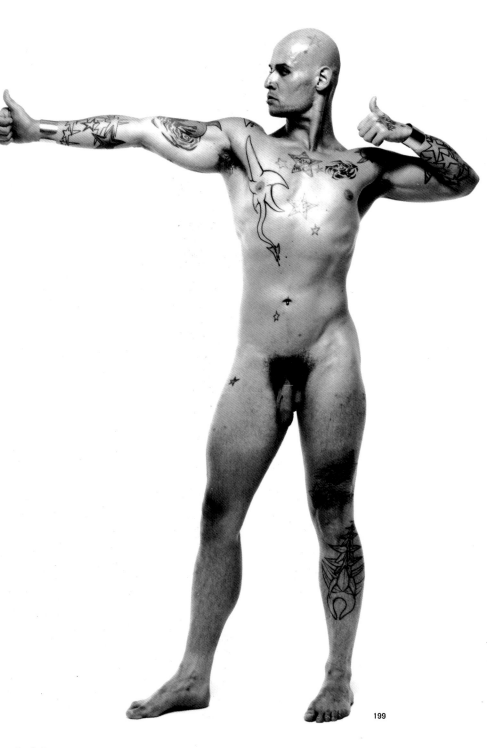

199

199 Jean-Luc Verna,
Zeus or Poseidon, Greek bronze, antiquity /
Iggy Pop (American Ceasar) / Siouxsie dance
intro *Premature Burrial,* 2000.
Silver gelatin print, 30 x 24 cm

200 Jean-Luc Verna, *Degas, Ballerine
de 14 ans /* Harry (Blondie), live in Paris
1999-2000.
Silver gelatin print, 30 x 24 cm

200

201 Huang Yan,
Body, Tattoo, Landscape, 2001.
Photo

201

linked to the 1999 reunion tour of the band Blondie, with their charismatic lead singer Deborah Harry.

In China, another Chinese artist, Huang Yan, has had his body covered with temporary tattoos representing traditional Chinese landscapes (*Body Tattooland*, 2000). The most comprehensive venture into the tattoo as a vehicle for art has, however, been that of the British artist, Lee Wagstaff (b. 1969). Wagstaff says that his reasons for choosing tattoos as a means of expression were complex. First and foremost, there was disillusion with the London art scene: 'I thought art must be primarily a means of personal expression, rather than just a means of making a living.' After ceasing to make art for some time after gaining his first degree, he began working seriously again in 1996. 'I thought that this way I could make art

seen as the ideal it once represented.' She continues: 'As distinct from Body Art, Carnal Art does not conceive of pain as redemptive or as a source of purification. Carnal Art is not interested in the plastic-surgery result, but in the process of surgery, the spectacle and discourse of the modified body which has become the place of a public debate . . . Carnal Art transforms the body into language, reversing the biblical idea of the word made flesh; the flesh is made word.'[10]

Orlan's form of expression is plastic surgery. She submits herself to this in order to modify her body to conform to some predetermined model – a model supplied by the art of the past. At the same time, as she declares, 'Carnal Art loves parody and the baroque, the grotesque and the extreme. Carnal Art opposes the conventions that exercise constraint on

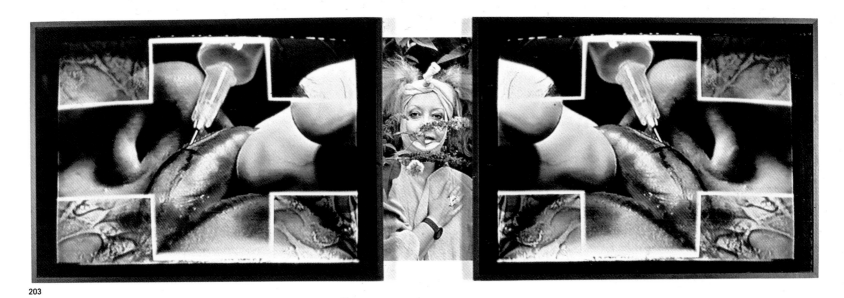

203

and decide whom I'd show it to, and also how . . . I wanted to make images that were simultaneously decorative, aesthetic, religious and ritual . . . While I am Catholic (I read the bible every day), I also have a cultural and ancestral link with Asiatic religions – my father is half-Indian.'[9] The result of this impulse is a body completely covered with intricate and permanent symbolic designs.

The artist who has most comprehensively altered his or her appearance is not, however, Lee Wagstaff but Orlan (b. 1947). In her 'Carnal Art Manifesto', published on the Internet, Orlan says: 'Carnal Art is self-portraiture in the classical sense, but realised through the possibility of technology. It swings between defiguration and refiguration. Its inscription in the flesh is a function of our age. The body has become a "modified ready-made', no longer

the human body and the work of art. Carnal Art is anti-formalist and anti-conformist.'[11]

In an article written for *Art in America*, and published as long ago as February 1993, the influential critic Barbara Rose (b. 1938) offered the following verdict – one clearly influenced by American feminist theory:

Orlan's performances might be read as rituals of female submission, analogous to primitive rites involving the cutting up of women's bodies. But actually she aims to exorcise society's program to deprive women of aggressive instincts of any kind. During the process of planning, enacting and documenting the surgical steps of her transformation, Orlan remains in control of her own destiny. If the parts of seven different ideal women are needed to fulfil Adam's desire for an Eve

202 **Lee Wagstaff,**
The Oracle, 2001.
Colour print on paper, 200 x 150 cm

203 **Orlan,**
Operation: Seduction versus Seduction, 1990-1996.
Triptych

202

204

204 David Buckland,
Self-Portrait, 1999.
Film, steel, glass / ed:3, 35 x 30 x 4 cm

205 Alexander de Cadenet, *Rabbi, 24.01.00, 2000.*
Cibachrome print on aluminium, 250 x 150 cm

made in his image, Orlan consciously chooses to undergo the necessary mutilation to reveal that the objective is unattainable and the process horrifying. Orlan the artist and the woman will never play the victim: she is both subject and object, actress and director, passive patient and active organizer. This still leaves us with the disquieting question of whether masochism may be a legitimate component of aesthetic intention, or whether we are dealing here not with art but with illustrated psychopathology. This is the crucial question in a context in which real and fake, art and anti-art view for attention.[12]

In fact, Orlan, Verna, Wagstaff and several others featured here represent a more extreme frontier of contemporary art than almost any of those featured in chapter six. Their work seems to me to contain an element of real desperation, clearly motivated in part by the feeling that none of the accepted artistic strategies seem to work any longer. At the same time, however, one notes the constant reference made by artists in this group to the pre-Modern tradition. This is ground that they have in common with the artists discussed in the context of an apparent revival of classicism.

One thing that is noticeable about Orlan is her willingness to make use of modern scientific and medical techniques in pursuit of her artistic aims. More and more artists seem to be ready to adopt this strategy. The veteran Chilean avant-gardist Eugenio Dittborn (b. 1943), for example, makes use of X-ray images of an unborn child in one of his airmail paintings (*Unborn*, 2000). The X-ray image is not, however, his primary focus. The airmail paintings, which he has been making since 1984, employ a wide variety of different subjects and processes, including images from news stories, how-to-draw books, crime journals and anthropological studies. Stitched to cotton duck panels and folded, these travel through the international postal system, gathering a history as they go. It is this history that is the subject of the work, as much as what it actually shows.

The British photographer and stage-designer David Buckland (b. 1949) also used X-rays for his *Self-Portrait* (1999). This offers a dramatic view of the artist's torso, with his ribcage visible. It is clearly intended as an image of mortality. When it was shown at the National Portrait Gallery in London, Buckland associated it with the concluding lines from 'The Circus Animals' Desertion' by W. B. Yeats (1865–1939): 'Now that my ladder's gone,/I must lie down where all the ladders start,/In the foul rag-and-bone shop of the heart.'

The artist who has probably made most consistent recent use of X-ray photography is Alexander de Cadenet (b. 1974). Perhaps taking a hint from Meret Oppenheim's (1913–1985) celebrated self-portrait, he has made a series of celebrity portraits that are X-rays of the heads of his subjects, showing the bony structure of the skull beneath the fleshly envelope. De Cadenet enlarges these X-rays and presents them in vivid colours, chosen to suit the personality of the subject (*Rabbi, 24.01.00*, 2000). He notes that the skull is the most immutable thing about anyone's physical appearance. The overlying flesh may age and change, but the skull does not alter with it.

Marilène Oliver (b. 1977) employed a different set of technologies for a piece entitled *I Know You Inside Out* (2001). The image is a lifesized version of American murderer Joseph

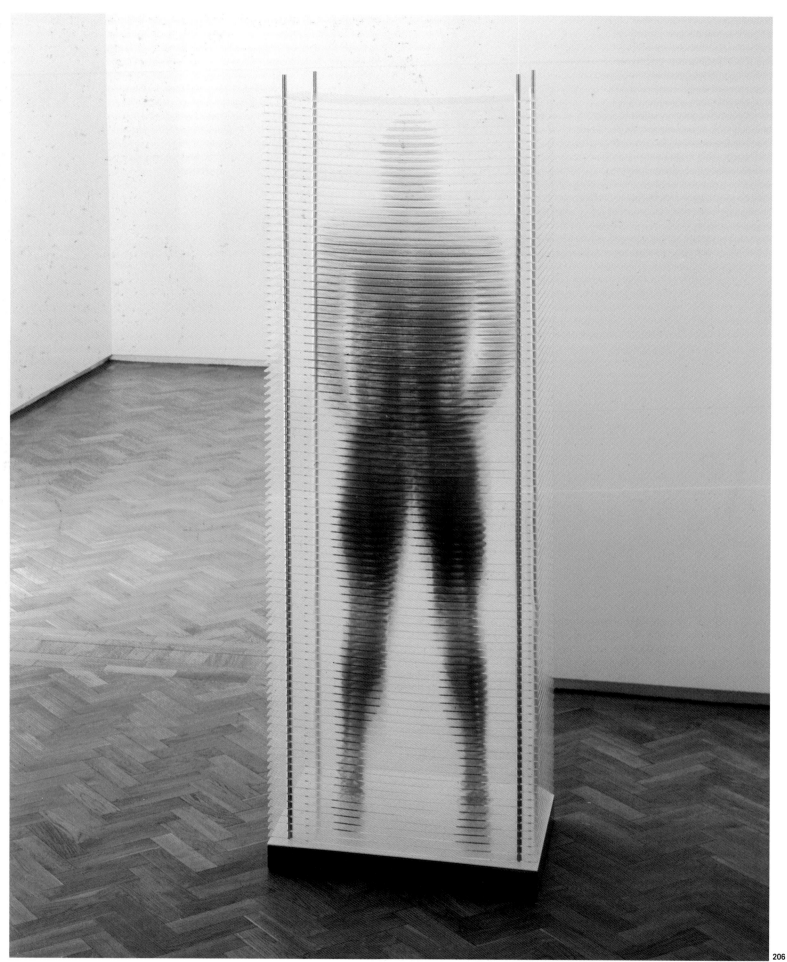

Jernigan, who left his body to science when he was condemned to die by lethal injection in 1993. His frozen corpse was cut into more than 1,000 wafer-thin slices, and these were then photographed and uploaded onto the Internet for general scientific use. Oliver discovered this cache of images when she was a student in Japan, and used them to reconstruct Jernigan's body on a series of plastic sheets mounted in a cabinet. She says that the fact that the subject was a killer is irrelevant: 'The fact that you could download a man from the Internet was what interested me.' Yet there is certainly a sinister frisson to be obtained from the result – rather like the frisson people get from the preserved corpses exhibited by the German anatomist Professor Gunther von Hagens, who in this case claims that the results are not to be regarded as art.

Another artist who has used quasi-medical techniques is Rebecca Stevenson (b. 1971), who makes sculptures in wax. She writes:

Wax sculpture is traditionally associated with the creation of doubles or stand-ins for the human body, whether for religious or medical purposes. My work references these traditions, using wax bodies to explore fantasies of growth, decay and fragmentation.

I begin the pieces by modelling a figure in clay, which I then cast into layers of coloured wax. The resulting casts are then cut and opened out to expose the interior. In this elaborate 'unmasking', the internal body becomes a visionary landscape, and the inherent violence of the action is masked by the transformation of wax skin and flesh into forms that resemble corals or flowers.

In my research, I spend a lot of time looking at medical imagery and drawing from dissections and anatomical specimens. My intention, however, is less to represent what I see than to investigate how we approach the body and its interior. The wounded or opened body is taboo in that it is deemed dangerous or polluting, yet also signifies the sacred. When looking at such material myself, I have frequently found my initial revulsion transcended by a sense of awe at the fragile complexity of the human body.[13]

Stevenson's *Cold-Rose: Blue* (2001), a bust with a skull stripped of its flesh, yet breaking out into delicate wax flowers that seem to celebrate both death and rebirth, is reminiscent both of the medical models in wax that Stevenson mentions, and of the fantastic, often somewhat sinister objects which populated Renaissance *Wunderkammern*.

207

De Cadenet, Oliver and Stevenson are all British, and their work seems in some ways to be a continuation of the more original aspects of Damien Hirst's oeuvre, which also alludes frequently to medical science and displays an obsession with death. Another young British artist, John Summer, seems to have been influenced both by medical prostheses (not an entirely new subject in art, since Cindy Sherman once made a photographic series based on them) and by the work of Francis Bacon. His extraordinary wearable sculpture *The Dude*

206 Marilène Oliver, known as: **Marilene**
I Know You Inside Out, 2001.
Screenprints on acrylic sheets, 50 x 70 x 200 cm

207 Rebecca Stevenson,
Cold-Rose: Blue, 2001.
Wax

208

210

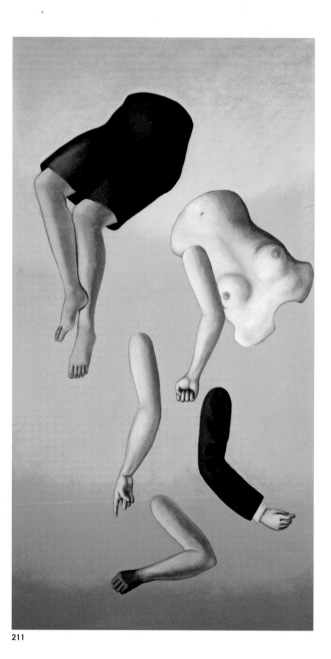

211

Previous pages
208 John Summer,
The Dude, 2002.
Mixed-media: wax, oil pigments, wood, steel,
cotton, 180 x 90 x 90 cm

209 Marina Nùñez,
Ciencia Ficcion, 1999-2001.
Oil on canvas on aluminium and light,
3 x (85 x 70 cm)

210 Ignacio Hernando,
Serie azul H, 1999. Computer-generated image
on aluminium, 120 x 90 cm

211 Paola Gandolfi,
Clitemnestra, 1998.
Oil on canvas, 380 x 200 cm

212 Inci Eviner,
Milk, 1999.
Watercolour on paper, 35 x 25 cm

(2001) is like something out of Mary Shelley's gothic novel *Frankenstein* (1818) – the reference becomes all the more apt when one recalls that the secondary title of the book is 'The Modern Prometheus'. In fact, the engagement of contemporary artists with science often has something deeply romantic about it, often combined with a frisson of horror, as can be sensed from a number of the works illustrated here.

New ways of image making and representing the body now compete with more traditional ones. The Spanish artists Marina Nùñez (b. 1966) and Ignacio Hernandez (b. 1964) construct purely cybernetic images – what one commentator has described as 'bodies that do not belong to themselves'.[14] Nùñez's representations of the body in her *Ciencia Ficcion* series seem to stand part way between pure fantasy and sober medical analysis. She has in fact studied the research of Jean-Martin Charcot (1825–1893),

pioneer in the study of human neurology, and the immense archive of medical photographs made in the late 19th and early 20th century – images that now, thanks simply to the passage of time, tend to take on a fictional or fabulous quality for the spectators of today.

Paola Gandolfi and Inci Eviner (b. 1966), Italian and Turkish respectively, use more traditional means, but with even more disturbing results. Gandolfi's *Clitemnestra* (1998), like many of her paintings, features a dismembered female body. Its fragmentation seems to reflect a profound feeling of unease about physical identity, and a passionate wish to escape from its constraints. Eviner's *Milk* (1999) reduces female existence to basic anatomical components, which are reassembled in a form that resembles an illustration in an old-fashioned medical textbook.

There is a certain resemblance between Eviner's image and a recent untitled sculpture

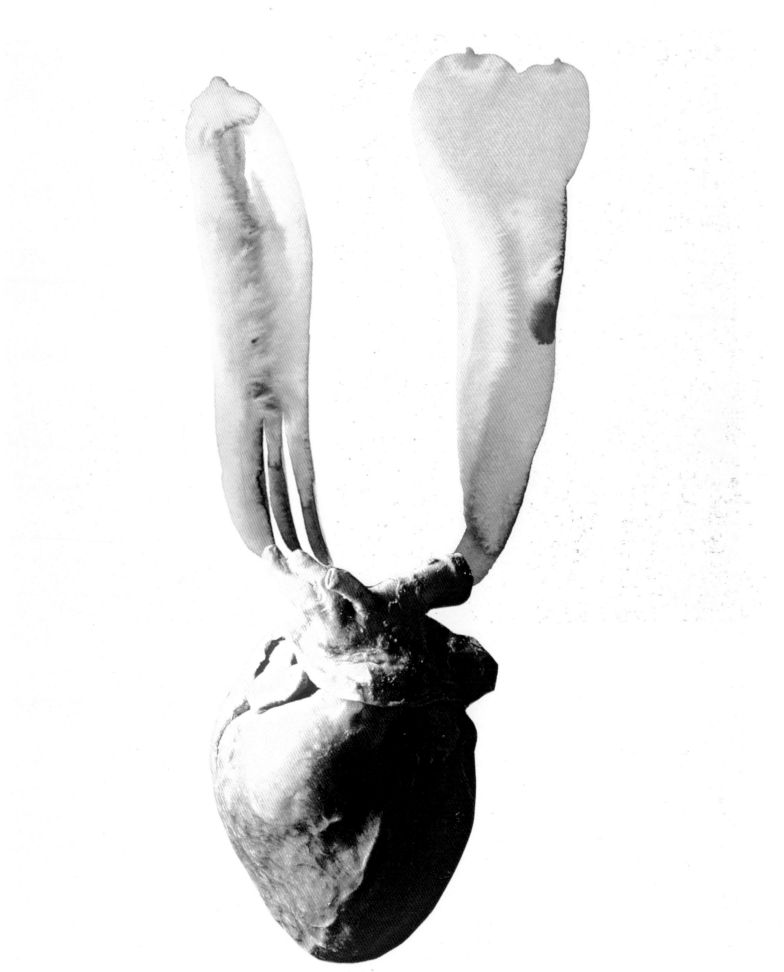

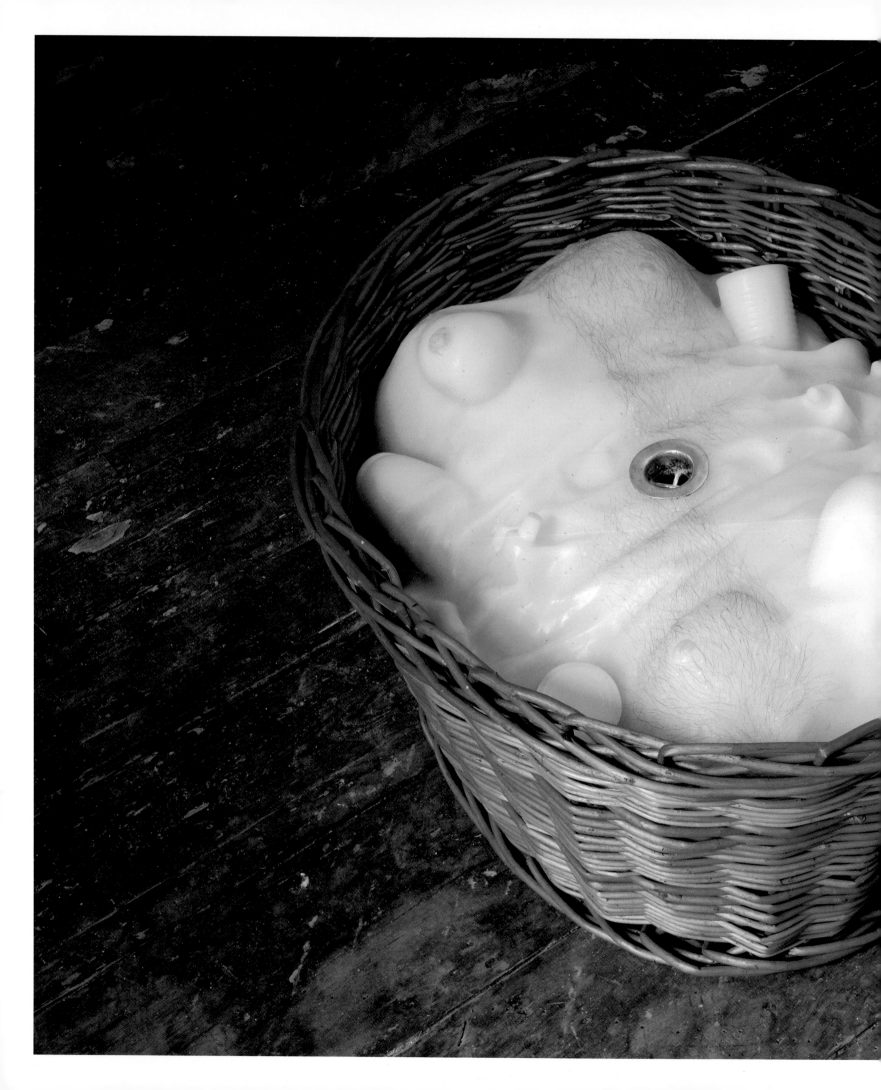

213 Robert Gober,
Untitled, 2000-2001.
Willow, wood, beeswax, human hair, silver-plated
cast brass, pigment, 41 x 83 x 66 cm

(2000) by the American sculptor Robert Gober (b. 1954). Gober's image of an androgynous torso tightly enclosed in a basket is a deeply disturbing image by anyone's standards. Gober showed it at the 2001 Venice Biennale as part of an installation that also included a small etching made after a newspaper clipping. The headline of the clipping read 'Bomb Suspect's Brother Mutilates Himself'. Amei Wallach wrote as follows: 'Mr. Gober is not naïve about cause and effect, but he's reaching for deeper resonances. He's a Brother Grimm, constructing postmodern fairy tales that probe the unquiet American psyche. In Mr Gober's America, hate crimes proliferate, but so does humour, wonder and a kind of transcendence.'[15]

In fact, Gober's sculpture is only one of a large number of memorable new artworks that inventively explore both the wonder and the horror of humanity's physical existence, while at the same time asking probing questions about what it means to be a human being.

1. *Parkett,* November 1999.

2. Published on the Internet in *ArtNet.com.*

3. Website of the Barbican Art Gallery, London, 2001.

4. www.javafred.com.

5. Artist's statement from www.sexmutant.com.

6. Artist's statement from www.janvaneyck.nl.

7. Artist's statement from www.benamou.net.

8. Interview with *nyartsmagazine.com.*

9. Interview in French with Muriel Carbonett on www.exporeview.com.

10. www.cicv.fr/creation_artistique/online/orlan/manifeste/carnal.html.

11. Ibid.

12. *Art in America,* February 1993, pp. 83-125.

13. www.the-e-gallery.co.uk.

14. Ana Carceller and Helena Cabello, 'Unforeseen subjects (disgressions on what they were, are and will be)', in 'Zona F,' catalogue, Valencia: Generalitat Valenciana, 2000.

15. Arts supplement of *The New York Times,* 3 June 2001.

art and science

chapter eight

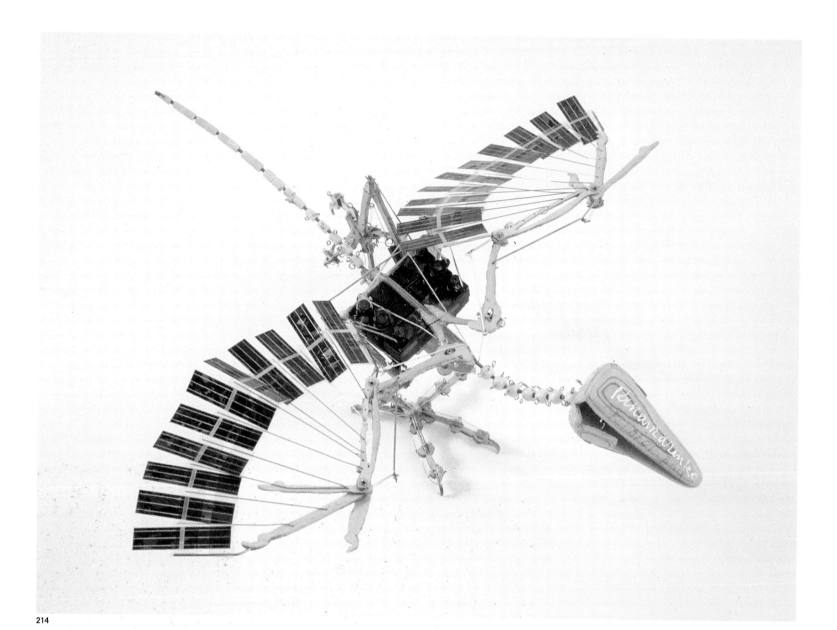

214 Panamerenko,
Archaipteryx, 1991.
Mixed media, 23 x 40 x 39 cm

The visual arts have long conducted an inter-mittent romance with science. The best-known example of the artist-scientist is Leonardo da Vinci (1452–1519), but there was another upsurge of scientific curiosity among artists in the late 18th century. On this occasion the pro-tagonists were largely British, notably George

Stubbs (1724–1806), with his study of equine anatomy (*The Anatomy of the Horse,* 1766), and Joseph Wright of Derby (1734–1797), who produced a small group of impressive Cara-vaggist paintings depicting scientific experi-ments, the best-known of which is *Experiment on a Bird with the Air Pump* (1768), now in the collection of the Tate Gallery, London.

In the early years of the 20th-century pioneer Modernists, especially in Russia and Central Europe, were pushed towards abstraction by the rapid advances then being made by science. Kasimir Malevich (1878–1935), for example, was influenced by his knowledge of the new physics of Max Planck, the originator of the quantum theory, which removed the micro-physical world — the world of atoms — from the realm of classical mathematics. The result was to take a world that had previously seemed to consist of solid, material, immediately verifi-

able objects, and turn it into something purely conceptual, a void filled with invisible energies. In Russia, violent political change presented itself as a form of scientific rationalism, and artists followed suit. After the October Revolution of 1917, Malevich was to write: 'So the modern artist is a scientist . . . The artist scientist develops his activity quite consciously, and he orients his artistic effect in accordance with a definite plan; he reveals the innermost motives of a phenomenon and for its reflex action; he endeavours to move from one phenomenon to another consciously and according to plan; his system is an objective and legitimate course of his effective force.'

The artists of our own time, however, are faced with a series of uncomfortable choices, the most basic of which is the choice between real science and a kind of absurdist pseudo-science. They are tempted, too, by the romance of science in its more primitive forms. It is interesting to note, for example, how many recent artworks show the influence, not only of Leonardo's own experiments, but also of the contents of 16th-century *Wunderkammern* and the scientific and anthropological displays offered by 19th-century museums. The weird models and machines devised by the Belgian artist Panamarenko (b. 1940), for instance, would surely never have come into being without the benefit of Leonardo's example (*Archæopteryx*, 1991). Attempting to classify material that is related in one way or another to the idea of 'science', one finds a number of related categories. Not surprisingly, one of these is to do with space and the exploration of space. An example is Adam Straus's (b.1956) *Space Junk* (1997). This simultaneously condemns humankind's tendency to pollute whatever it touches and refers to the romance purveyed by Science Fiction illustration and perhaps most potently of all by Stanley Kubrick's (1928–1999) classic movie *2001; A Space Odyssey* (1968). The Japanese artist Hiro Yamagata (b. 1948), who in the 1970s worked as a set designer for the celebrated director Peter Brook (b.1925), when Brook was working mostly with the Paris-based Centre for Theatre Research. Yamagata's installation *NGC6003* (2001) uses an immense panoply of technical resources, including lasers and mirrors, to create a space which would completely disorient the viewer and give the impression that he or she was floating in the void. Here, too, the lingering influence of Kubrick's *2001* is clearly apparent. Yamagata has excellent populist credentials. In the 1980s Arnold Schwarzenegger (b.1947) became one of his patrons — the bodybuilder turned actor has devoted much of his career to Science Fic-

tion-themed movies. Yamagata also designed the official posters for the Centennial Olympics in Atlanta in 1996.

Artists have also been ready to explore the visual world opened up by microphotography, which sometimes produces pictures that bear a resemblance to images of the remoter reaches of the cosmos. Perhaps the best-known examples are paintings by the American artist Ross Bleckner (b. 1949), such as *Auto-Immune* (1999), which alludes to the prominent role played by Bleckner in the fight against AIDS. Not surprisingly, another aspect of science that has exerted a considerable influence over recent art is the diagram. The diagrams made by scientists in order to explain their ideas can be seen, and indeed have been seen, as direct forerunners of Conceptual Art. One artist who has recently put this thought to good use is Keith Tyson (b. 1969). At one stage Tyson produced much of his work using a device that he christened the 'Artmachine'. This enabled him to combine arbitrary thoughts and ideas to create new, apparently logical artistic structures. *Molecular Compound No. 8* (2001) has a strong

215 Adam Straus, *Space Junk*, 1997. Oil on panel, 30 x 30 cm

215

216

resemblance to the blackboard drawings made by Joseph Beuys, but it is also related to Picabia's Dadaist drawings of machines. It subverts scientific method while seeming to adhere to it. Aziz+Cucher (Antony Aziz and Sammy Cucher, working collaboratively since 1991) are perhaps best known for their *Dystopia* series (1994–95) featuring constructed cyborg heads without mouth or eyes. However, they too have been interested in the possibilities offered by the diagram. And they too, like Ross Bleckner, have been led to an investigation of scientific metaphor in part at least because of the threat of AIDS. In an interview, Sammy Cucher said:

Yes, we experience the new biotechnological reality as both something comforting and disconcerting . . . I'll talk about my own experience. I was diagnosed with HIV in 1989, and was very ill for a couple of years. Yet, I owe my current active life to the fact that there were medicines developed out of recent research in bioengineering which allowed scientists to study the AIDS virus and design these very particular drugs that attack or inhibit its replication. It's an example of how our ability to tamper with the bio-molecular world through technology has produced Protease Inhibitors which have literally changed the relationship of my body to the AIDS virus. Whereas once my body was just deteriorating before my very eyes, now it's a body that functions very well. It's an active body.

TNG: Your discussion of your body as 'deteriorating' before your very eyes makes me think about the relevance of abjection to the 1980s and early 1990s and how abjection is no longer as useful, or prevalent a mode, to the art of the mid- to late 90s. Currently we are in a different paradigm, one where 'the active body' of biotechnological research is what is at issue and therefore different notions of what we are 'naturally'. And such a new notion of the body has a future; it is actually about the future.

C: Right, in the mid- to late 80s in relation to AIDS, the abjection of the body was its 'truth'; one couldn't understand the body in any other way because all we knew was illness and death. Now the reality of living with AIDS as an active body with a future is my reality.

A: Perhaps AIDS made us both more aware of this split between the experience of the deteriorating body versus the active/reanimated body. With this in mind, it's interesting how our work has always dealt with both the very attractive and the very abject.[1]

217

216 Ross Bleckner, *Flow and Return*, 2001.
Oil on linen, 213 x 366 cm

217 Hiro Yamagata,
NGC6093, 2001.
Installation view: lasers, refractive
holographic panels

218

218 Keith Tyson,
Molecular Compound No. 8, 2001.

nodal zones of psychoactive interaction (II.2.1)

Frigg's rupture

schematics of Ingwert's method

Hia₁₂

RNA

His₁₁₉

E

Base

diffuses out

E

Base

E

electropathic emotion diagram

mhz÷hi

pap

sic

ecto

nup

sed

Rings of Bugli
655mfd/sec

silicobacteric glass
(964.999.343.5.221.1)

branchiadic growth

orthogenic configuration of
celluloblasts

Pachydoteric Junction

PLATE VII.a

described in Grets: *Onomanomerics of the P-cycle*
sts/hvlt~45@hua.bio

ng: on ratio-blood

219

219 Antony Aziz and Sammy Cucher known as:
Aziz+Cucher,
Naturalia: Plate VII-a, 2001.
Iris print on Somerset paper, 51 x 41 cm

art and science / 223

220 Christine Borland, *This Being You Must Create*
(Spy in the Anatomy Museum), 1997.
80 laminated cibachrome prints on perspex,
15 x 20 cm

220

In 'Notes for a Talk on Our Recent work'
(1999), the duo quote Ovid's *Metamorphoses*:
'My purpose is to tell of bodies which have been
transformed into shapes of a different kind.'
They add: 'Recent advances in Genetic Science
and the confluence of Computer, Bio, and Nano
Technologies have opened up the possibility of
a completely mutable universe, providing meta-
morphoses wholly different from those in Ovid:
While his beings transformed themselves from
one known form into another known form, we
are poised to be transformed from known forms
into unknown forms. This possibility of forms
dictated by the imagination introduces Aesthet-
ics as a fundamental organizational component
to Biology.'[2] This attitude is clearly the main-
spring of their *Naturalia* series (2000–01). At
the same time *Naturalia* operates as a kind of
parody of a Victorian scientific treatise, with
elaborate hand-coloured plates.

A somewhat similar attitude towards science
can be discerned in Christine Borland's
(b. 1965) *This Being You Must Create (Spy in
the Anatomy Museum)* (1997). The more sin-
ister aspects of traditional museums of anato-
my have long obsessed Borland. The work re-
creates her experience in a museum of this kind
that was very reluctant to admit her at all. In an
interview, Borland said:

I think these things need to be dragged out of
the closet of history. The way that I try to pres-
ent them or deal with them is not by attempting
to achieve justice, it's even simpler than that; I
attempt to create a reminder of all these people
who end up in museums and medical collec-
tions. It's not only historical of course; today
there are many ongoing ethical issues in medi-
cine which I think the work touches upon,
which have to do with developments in genet-
ics and so forth. So it's something that's ongo-
ing; in the face of scientific discovery and great
trumpet blowing, there's always the fact that
the material used is, of course, people who
were once alive and who had an identity; that
fact should be somehow referenced as far as
possible. I'm always trying to point the finger
to show that can happen.[3]

The Greek artist Viktor Koen (b. 1967) takes a
somewhat more positive attitude, as well as a
somewhat more mystical one. His digital print
Meta4 (2001) uses the fluidity of digital pho-

221

221 Victor Koen,
Meta4, 2001.
Digital print on wood, 100 x 145 cm

222 Susan Derges,
Aquae, 2001.
Ilfochrome print, 140 x 100 cm

tography, its power to link things in ways that could never exist in nature for philosophical ends. The image, according to the artist, combines symbols for earth, air, water and fire — the four main components of chaos according to the ancient Greek philosopher Empedocles. Koen says: 'This ancient and perhaps mythological creature doesn't only bring back a time when abstract ideas had faces, but it also connects the past with a contemporary chaos where man plays god and genetic engineering facts will surpass our wildest fiction. The winged, walking, swimming, fire breathing prototype of life is placed in the depths of the sea, where our evolutionary process started and just like chaos was there before us and will be after us. The X-ray like, transparent and liquid aesthetic treatment gives the image an almost medical look and at the same time a mystical aura.'

Susan Derges (b. 1955), a British photographer, has also made images of the four elements, but she treats them separately (*Aquae,* 2001). Nevertheless, it is clear that she too is interested in processes of transformation. Her beautiful image of water swirling restlessly in a bottle seems intended to evoke not modern science, though the bottle itself is the kind of object one might find in a laboratory, but alchemy, which was the predecessor of modern science. The image has been produced using a cameraless technique, through a skilful manipulation of photographic chemistry.

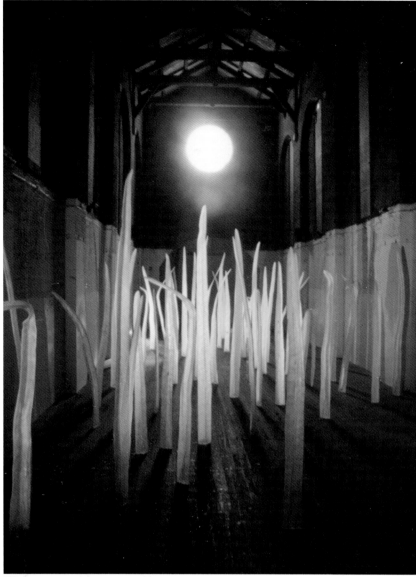

223

223 Tim Maslen and Jennifer Mehra known as:
Maslen and Mehra,
Drift, 2001.
Sculpture installation: resin, sound, light projectors

224 Michel Blazy,
The Greenhouse Effect: (Untitled), 2000.
Mixed media

224

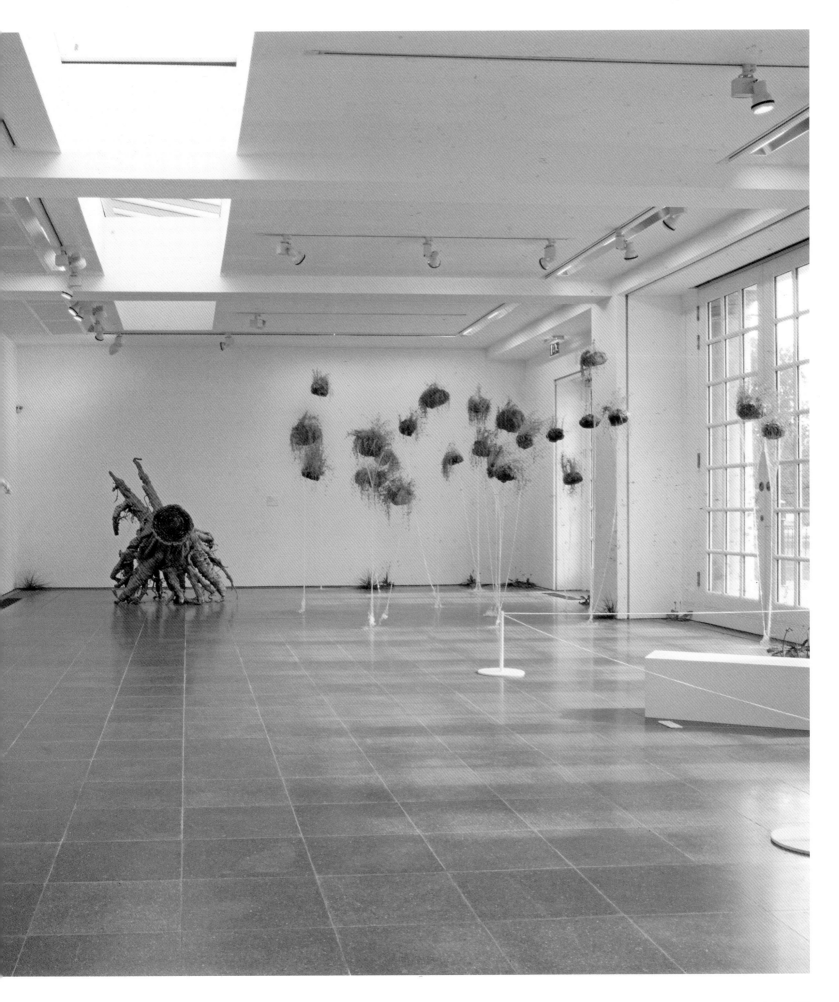

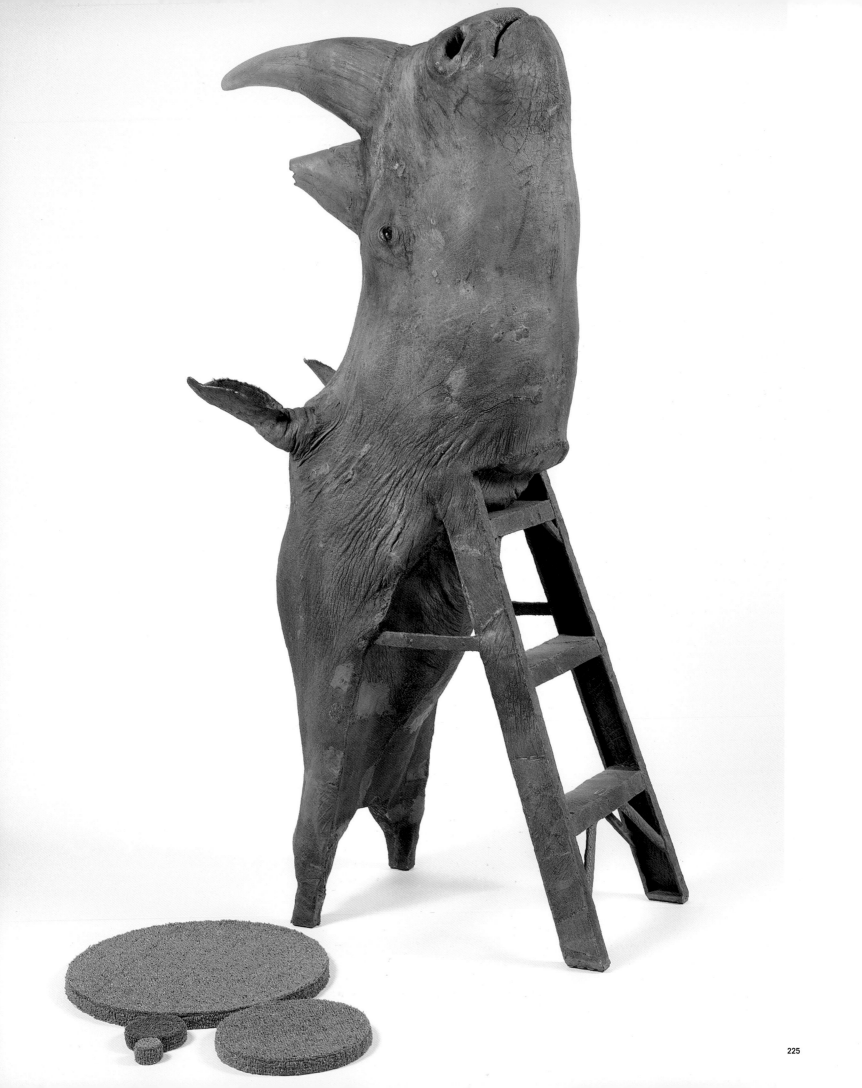

Koen, Derges and the artistic duo Maslen and Mehra (Tim Maslen [b. 1968] and Jennifer Mehra [b. 1970]) all use science as a means of communing with nature. Maslen and Mehra's collaborative installation *Drift* (2001) consisted of a series of sixty gigantic translucent blades of grass, each more than 10 feet tall. Lit by fibre optics, these shifted in colour and tone, encroaching on the space and challenging the visitor's perception of scale, introducing him or her to a drastically altered perception of natural forces. The high-tech artificiality of this environment makes a fascinating contrast with the very different artificiality cultivated in an installation dating from almost exactly the same moment by the French artist Michel Blazy (b. 1966). In this work, the components were real living plants. Blazy's *Greenhouse* (2000) at London's Serpentine Gallery was not a gesture of identification with nature, but one of opposition to the lush surrounding landscape of Kensington Gardens — a supposedly 'natural' realm, but one shaped over centuries by the hand of man.

Museums of taxidermy long formed an important component of museum culture in general. They began as simple collections of supposedly natural wonders, and developed a more serious scientific purpose in the 19th century. In fact, the creation of the great 19th-century collections of stuffed animals, made in the name of science, were also one of the ways in which western nations, with their developing industries and expansionist colonial policies, asserted their superiority over the other regions of the globe. Exotic species of all kinds were placed in these animal mortuaries for the combined education and edification of a new bourgeois public, and the process was justified in the minds of those who undertook it by the argument that only thus could the natural world become thoroughly known, thanks to the process of classification that these accumulations of dead things made possible.

In an earlier chapter, I noted the way in which the German artist Thomas Grünfeld, by creating taxidermic hybrids, reverts to the procedures of the old-fashioned fairground showman, who created a mermaid by marry a dead fish to an equally defunct monkey. A number of other artists have been attracted to procedures of this type. One of the wittiest and most original is the West Coast American Carlee Fernandez (b. 1973). In her *Friends* series, Fernandez converts old, damaged examples of taxidermy into objects of apparent domestic use. A stuffed rhinoceros, for example, acquires a new use as the basis for a stepladder (*Hugo Parlier*, 2001).

Another German artist, Iris Schieferstein (b. 1966), constructs sculpture from the bodies of dead animals, sewn into new shapes and preserved in formaldehyde. *Life Can Be So Nice* (2001) has a certain gruesome resemblance to the animal tableaux under glass domes. Popular as domestic ornaments in certain Victorian households, the latter displayed stuffed weasels or mice dressed in appropriate garments acting out small sentimental dramas. Schieferstein is of course aware of the cultural clash she creates with these pieces, just as she is aware of her part in an anthropomorphic tradition that can be traced to very remote antiquity. We know from ancient papyri that the ancient Egyptians enjoyed beast fables in which animals behaved like human beings.

There is a kind of undeclared relationship between these pieces and the performances involving animals that have also found a place in the world of contemporary art. Yannis Melanitis's (b. 1967) *Bio-Robotic Symbiosis* (2000–01) uses a webcam to send images of mice in an artificial maze-like environment, and also of the spectators watching them, to a computer. The computer translates the data into musical sounds and random robotic movement. The Czech artist Jiri Kratochvil's *Mercury* (1998) also used a computer. The piece consisted of three laboratory vessels made of glass, each lit by a different coloured light, and each containing some goldfish. Glass tubes fitted with infrared movement sensors linked the vessels. As the fish swam from one bowl to another, via these tubes, the sensors recorded their progress, and relayed the dated to a bank of computers that duly logged their progress. Work of this type has some of the characteristics of the very expensive clockwork toys that were made to amuse European potentates in the 16th century. Had the technology been available, Kratochvil's goldfish might have caused a certain frisson at the court of the Habsburg emperor Rudolph II in Prague.

The most impressive examples of scientific and/or technological art being made at present usually seem to concern themselves with two interlinked themes: genetics and ecology. Strange as it may seem, it is useful to begin a discussion of this with an artist who uses strictly traditional means of expression. Alexis Rockman's (b. 1962) painting *The Farm* (2000) prompts a comparison with two other very celebrated paintings. One is Joan Miró's (1883–1983) youthful masterpiece of the same title (1921–22), which once belonged to Ernest Hemingway. The other is Edward Hick's (1780–1849) *The Peaceable Kingdom*, the best-known version of which dates from 1832–34.

225 Carlee Fernandez, *Hugo Parlier*, 2001. Altered taxidermic animal, 190 x 70 x 60 cm

226 Iris Schieferstein,
Life Can Be So Nice: Life, 2001.
Organic sculpture in formaldehyde solution,
59 x 102 cm

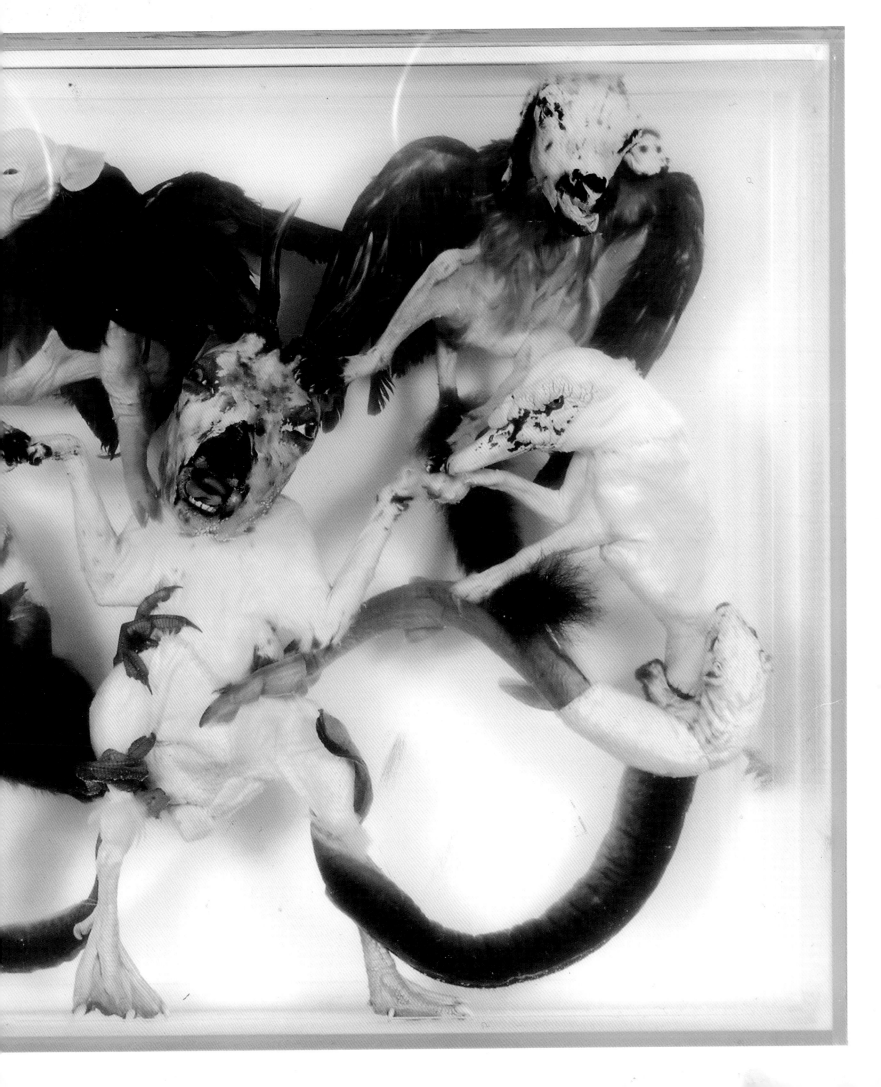

music produced by animals biomusic

music produced by animals biomusic

227

227 Yannis Melanitis,
Bio-Robotic Symbiosis #2, 2000/2001.
Interactive performance

228 Jiri Kratochvil,
Mercury, 1998.
3 lab glass-vessels, infrared sensors,
colour bulbs, goldfish, computer

228

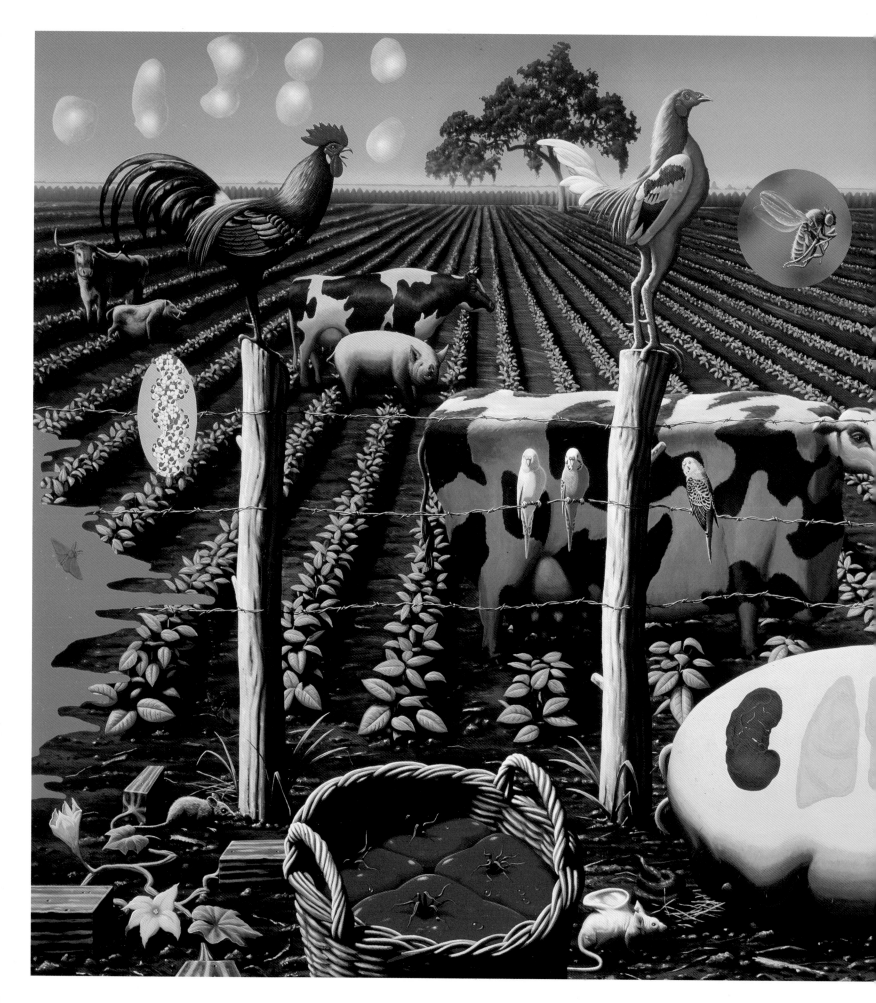

229 Alexis Rockman,
The Farm, 2000.
Oil and acrylic on wood, 245 x 305 cm

Though Rockman, by choosing this particular title, clearly wants one to think of Miró, Edward Hicks is really the more relevant of the two. Hicks was a Quaker minister and his painting is based on a passage in Isiah (chapter 11, verses 6–9), which describes how, in an ideal world, 'the lion will lie down with the lamb'. For Hicks, this phenomenon would have been a manifestation of what he and his fellow Quakers called the Inner Light. Rockman's universe is dystopian rather than utopian. He describes the intention of his painting as follows:

My artworks are information-rich depictions of how our culture perceives and interacts with plants and animals, and the role culture plays in influencing the direction of natural history. The Farm contextualises the biotech industry's explosive advances in genetic engineering within the history of agriculture, breeding, and artificial selection in general. The image, a wide-angle view of a cultivated soybean field, is constructed to be read from left to right. The image begins with the ancestral versions of internationally familiar animals — the cow, pig, and chicken — and moves across to an informed speculation about how they might look in the future. Also included are geometrically transformed vegetables and familiar images relating to the history of genetics. In *The Farm* I am interested in how the present and the future look of things are influenced by a broad range of pressures — human consumption, aesthetics, domestication, and medical applications among them. The flora and fauna of the farm are easily recognizable; they are, at the same time, in danger of losing their ancestral identities.[4]

Rockman's crisp style and his impulse to popularise complex scientific information are echoed in the paintings of Frank Moore (b. 1953), although Moore tends to be even more sardonic. *Human Genome Project* (2000) represents the accumulated data on paired chromosomes as if all they really added up to was something equivalent to an undistinguished office building, now being assailed by a wrecker's ball. Like Sammy Cucher, Frank Moore arrived at his interest in genetics by a very personal route: through being diagnosed with AIDS. Long before this, however, he had become aware of the growing ecological crisis thanks to childhood summers spent in the Adirondacks. In an interview with Thomas Woodruff, chairman of the Department of Illustration and Cartooning at the School of Visual Arts in New York, Moore said:

As a painter, I see myself as providing a visual form for people to reflect on what their rela-

tionship with nature is and how they feel about such issues as genetic engineering, our use of chemicals and fossil fuels, pollution, and our relationship with technology. There is a whole range of issues that are all ultimately interrelated. You can take any aspect — from health care to food production to whatever — and they ultimately involve a similar range of issues. To a certain extent, art is a luxury, but it can have an impact on the ways people think.[5]

A review in *Art in America* said of Moore: 'One of the most compelling painters to deal with the AIDS crisis as well as environmental issues, Moore has a realist's brush but a surrealist's heart. Even when humorous, his is an allegorical brand of beauty that is never entirely divorced from sorrow.'[6]

230 Frank Moore,
Human Genome Project, 2000.
Gouache and oil on Arches paper, 31 x 50 cm

230

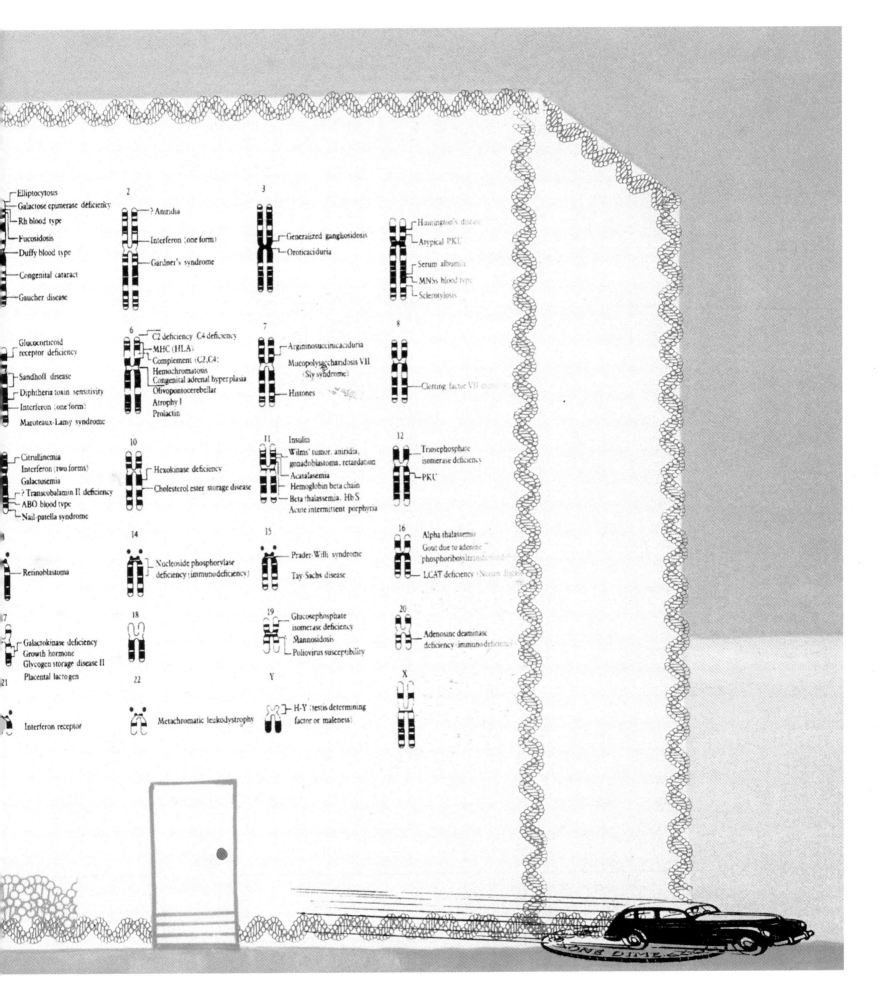

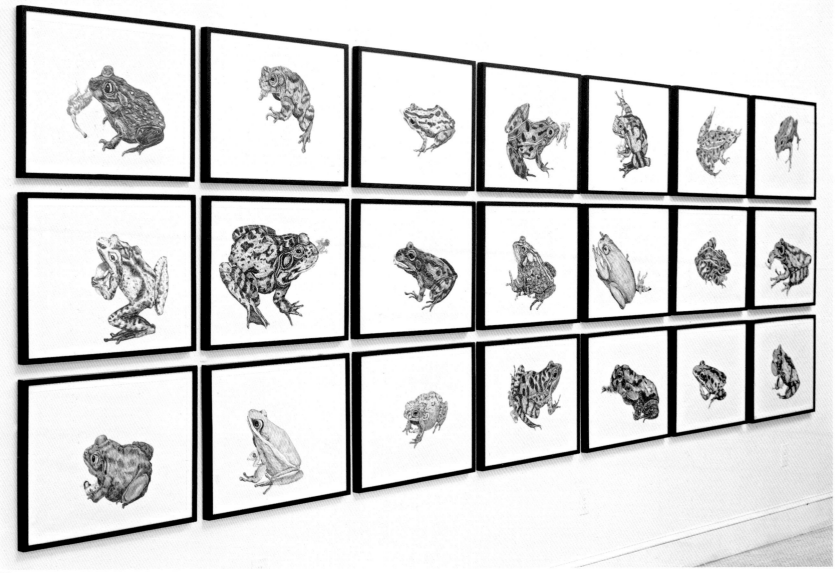

Jane Lackey (b. 1948) also makes works that relate to genetics, but in a more conceptual way. Her 'receptors' (*Smear* 3, 2001) are paired convex/concave sculptural disks made of bent wood, whose shapes, she says, 'bring multiple references to sites where information is collected and scrutinised; screens, satellite dishes or – microscopically – the "receptors" in our skin and sense organs. The delicate surface patterns built within layers of fluid paint on cloth-backed cork are laminated to the wood. Limited to two marks – dots and dashes – the patterns mix codes that refer to sound explore the physical motion of scrapping or blotting while following the disciplined binary systems of mapping and analysing DNA.'

Another American artist keenly interested in both genetics and ecology is Brandon Ballengée (b. 1974). His *Atomic Frogs* series (1995–98) is a chronicle of genetic damage.

He speaks of the amphibians he draws as 'transmutable protagonists', and notes that 'scientists consider amphibians to be a "sentinel species". Due to their aquatic gestation period they are peculiarly sensitive (in early development) to waterborne agents. Also, due to the mucous based skin membrane, they are susceptible to damage caused by airborne contaminates, which may prove fatal to the organism and/or result in residual contamination in the animal's offspring.'[7]

Gail Wight (b. 1960) is another conceptual artist who engages with contemporary science. *Zoo Kit* (1997) is a kind of Noah's Ark for the present day. It consists of a wooden box containing DNA of land, sea and air animals, plus plant DNA for sustenance, and the DNA of a zookeeper (Noah himself, or Mrs Noah?) to look after them. Wight says: 'The intersection of art and neurology, theories of memory, mental

231 Jane Lackey,
Receptors: Smear, 2001.
Mixed media (detail)

232 Brandon Ballengée,
The Atomic Frogs, 1995–1998.
Selection from series: graphite and charcoal
on paper, each: 46 x 61 cm, overall: 183 x 427 cm

illness and cognition form the groundwork for my thoughts. How much of the body is brain? In what ways do we resemble worms? What thoughts am I unable to express because my language doesn't acknowledge them? To what extent do complex dynamics shape our ideas? Is a machine more or less reliable due to its lack of endorphins, emotions, and opiate addictions? What does compassion look like at the neuroanatomical level? These are the sorts of questions that infect my thoughts, expressed in installation, computer, text, and performance.'[8]

Somewhat similar attitudes to making art are expressed in the work of Catherine Wagner (b. 1953). Wagner says: 'When I began reading about the Human Genome Project, I was struck by the intent to determine a "genetic blueprint", first by mapping chromosomes and then by sequencing the entire gene structure of the human race. This project has gathered some of the most powerful minds in science to act as modern cartographers for our future. I am interested in what impact the changes that emerge from contemporary scientific research will have in our culture socially, spiritually, and

physically. In my work I try to ask the kind of questions posed by philosophers, artists, ethicists, architects, and social scientists. All of these questions revolve around two central ideas: Who are we? And who will we become?'[9]

The work illustrated here, *Twelve Areas of Concern and Crisis,* is a collection of conceptual still lifes of evidence found in 86-degree freezers containing the archival samples of Alcoholism, Alzheimer's, Bipolar Disorder, Breast Cancer, DNA Synthesis, HIV, and other research from the Human Genome Project to formulate the 86 Degree Freezers typology. Wagner comments: 'This freezer typology confronts the new millennium. It forces us to ask how, in the future, we will construct our individual and cultural identities.'[10]

Probably the most ambitious artist, and also perhaps the most controversial, to have concerned himself with genetics is the Brazilian-born Eduardo Kac (b. 1962). Kac's ambitious transgenic work, *The Eighth Day* (2001), raises a whole series of issues – scientific, technological, theological and above all moral. The title alludes to the biblical book of Genesis. The eighth day is the day when creation became complete and the creator, having rested, left it to develop in its own fashion. Now, Kac tells us, it has reached a point in that development when humankind is able to make new life forms independently. In this case, the novelty manifests itself by the presence in these life forms of an artificially introduced gene. The gene asserts its presence through bioluminescence, which is visible to the naked eye. The bioluminescent marker appears in living things that are otherwise very different from one another – plants, amoebae, fish and mice. For the duration of the exhibition, these life forms existed in a terrarium that was in fact an artificial universe. They shared it with a *biobot* – a robot that was also a container for an active biological element that affected its behaviour. In this case the 'brain cells' were a colony of bioluminescent amoebae. As these exhibited a greater or lesser degree of activity the biobot ascended or descended, or moved about the world that had been created for it. The biobot had another function as well. In addition to moving of its own volition, it could to some extent be controlled from outside the terrarium. Its audovisual system enabled participants linking to the exhibition site from the web to experience the terrarium environment from within. A pan-tilt actuator allowed these participants to control the biobot in terms of what was visible to them through its 'eyes' at a given moment. In other words, it was possible to have both subjective and objective experi-

233

ence of this artificial world. As Kac remarks, 'By enabling participants to experience the environment inside the dome from the point of view of the biobot, *The Eighth Day* creates a context in which participants can reflect on the meaning of a transgenic ecology from a first-person perspective.'

The most ambitious artistic/scientific project of them all, on a much larger scale than Kac's experiments, and with a much broader focus, is the Makrolab (*Makrolab Mark II*, Rottnest Island, Australia, 2000), inspired and organised by the Slovenian artist Marko Peljhan (b. 1969). Peljhan graduated in1992 from the Academy for Theatre, Radio, Film and Television in Ljubljana. In the same year, he founded the arts organisation Projekt Atol as a framework for social and artistic activities, including work in different media (theatre, film, performances, lectures). This in turn led to the creation of Makrolab. As Peljhan has said: 'Makrolab's main aims are to explore and reflect upon three complex and dynamic fields of global activity: telecommunications, weather systems and migrations. The machine was built to receive, observe, process and reflect information that is generated within these fields.' The enterprise, a portable laboratory that can be set up in various locations, is therefore more an arena within which things can happen, than an independent artwork in itself. Projekt Atol and Makrolab sprang from the specific conditions that existed while Slovenia was making the transition from Communist to post-Communist rule. Peljhan remarks, for example, that

During socialist rule, it was very difficult for us to import a computer, the prices for the duties were enormous and we could not afford to pay them. The world of young computer programmers and enthusiasts (talking about a pre-hacker period of course) was an enclosed underground, tightly connected with the social underground and the move for social change and democratisation. The first to use computers after the kids of course were professionals from the publishing field and of course the sciences . . . It is very interesting to note that some of the first companies in Slovenia that were run by the opposition or at least semi-opposition figures were companies that imported and assembled computers . . . Our media culture has developed tremendously in the last ten years. From a small 'enclosed world' it definitely has become a transcultural global movement in this time, with its own reflection mechanisms and structures . . . But the global dynamics of change are very powerful and the knowledge distribution is uneven, in both economic

234

235

and geographic terms. This needs to change, and communication technology is one of the possible vehicles for this change, but only if we will be able to liberate it from the grasp of the blind, solely capital-based use.[11]

Projekt Atol made its major international debut at Documenta X in Kassel (1997), which made a special feature of Internet-based artworks and projects. Until his death, successive Documenta exhibitions provided an important platform for the ideas and activities of Joseph Beuys. In some respects, it is easy to relate Peljhan's ideas to those of Beuys, though the latter embraced a kind of primitivism that was hostile to technology.

There is also another, and perhaps more important influence, which more or less brings us full circle to where this chapter began. It is that of the ideas of the Russian poet and theorist Velimir Khlebnikov (1885–1922). Like Peljhan, Khlebnikov was an idealist and a universalist. His studies covered a wide range of fields – physics, mathematics, biology, Sanskrit and, later on, Slavic languages. As a poet, he aimed first to deform and then to completely remake the Russian language. In this respect he can be seen as a Russian equivalent of the Anglo-Irish writer James Joyce, who aimed to do the same thing to English. For Khlebnikov, the ultimate result of these linguistic experiments would be what he called 'zaum' – language beyond reason, or, better still, beyond the reach of the logical mind. One gets intimations that Peljhan might like to deform ordinary scientific logic in the same fashion. Even if this is not completely the case, the utopianism of Projekt Atol and the Makrolab is deeply rooted in the sensibility of early Modernism. After just short of a hundred years, the wheel has come full circle.

1 Interview with Thyrza Nichols Goodeye published on the duo's website, www.azizcucher.net.

2 Ibid.

3 Interview with Anne Barclay published on www.sculpture.com.

4 www.geneart.org/rockman.

5 Interview conducted for the New York Academy of Science and available on their website, www.nyas.org.

6 *Art in America*, October 1998, p. 132.

7 www.geneart.com

8 Ibid.

9 Ibid.

10 Ibid.

11 Quotation from the Projekt Atol website.

236

235 Edouardo Kac, *The Eighth Day,* 2001.
Transgenic ecology, biological robot, Internet,
video, sound

236 Zavod Projekt Atol, *Makrolab Mark II, Rott-
nest Island, Australia,* 2000.
Colour print

new geography

chapter nine ••••

The plural nature of the contemporary art has already been amply demonstrated in this book. This pluralism is due to many factors: the break up of the Modernist consensus and the appearance of Postmodernism; and the growth of museums of modern and contemporary art, both in number and in scale, and the increasingly central position that they have come to occupy in our culture.

Thanks to this and other factors contemporary art has become 'official'. In fact, it occupies very much the same position in today's society that the officially recognised and honoured Salon painters occupied in the society of the late 19th century. The major recurring displays of current art – the Kassel Documenta, the Venice Bienal, the São Paulo Bienal – occupy the same position that the annual Paris Salons enjoyed with educated and cultivated people a hundred years and more ago.

There are of course differences, but on close examination these seem largely superficial. The notion of an 'avant-garde' – something transgressive and controversial, something that challenges social and even moral norms – is deeply rooted in the contemporary psyche. Art proves its genuineness, and also its essential originality (that most previous of all qualities) by shocking us – or at any rate by shocking the people who stand next to us. However, these attempts to shock, and also the public response to them, seem increasingly ritualised. One might compare it to the old custom of intertribal marriage, where the bride is 'raped' – carried off from the members of her own group by her future husband and his comrades. Everyone concerned knows, however, that this rape is committed by arrangement. If the bride resists, it is only for show.

One might also claim that one of the ways in which contemporary art differs most clearly from the art of a hundred years ago is in its commitment to popular culture, and in particular to the mass-culture of the great conurbations that are the products of ever-accelerating technological development. Certainly the Pop Art that emerged at the beginning of the 1960s has made a profound impact on the visual arts. Both the subject-matter of art and its presentation have been revolutionised by an alliance with a kind of mass-consumerism that was previously unknown, because the consumer culture itself did not exist.

To a certain extent this is true. What is also true is that the return of subject-matter to art, in the wake of the gradual collapse of the Minimalist consensus that was the last gasp of high Modernism, has produced a situation with which the late 19th-century Salon painters and their audiences would have felt at home. Art now, like art then, supplies its audience with a way of debating issues that are in the forefront of the popular imagination – race, sexuality and gender difference being three of the most prominent.

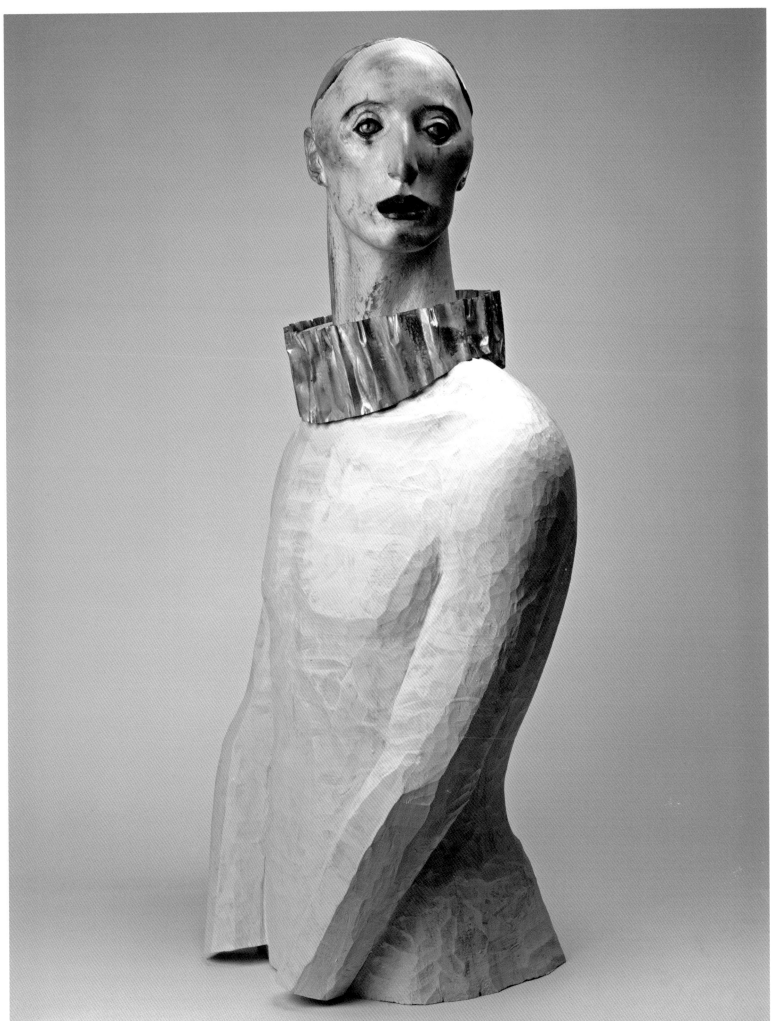

238 Ravinder Reddy, *Untitled,* 2001.
Installation

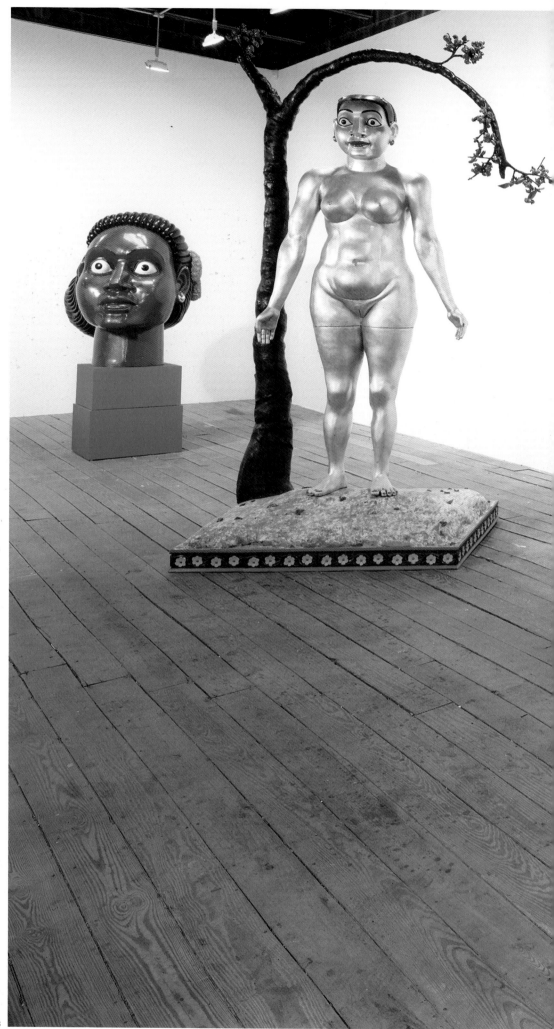

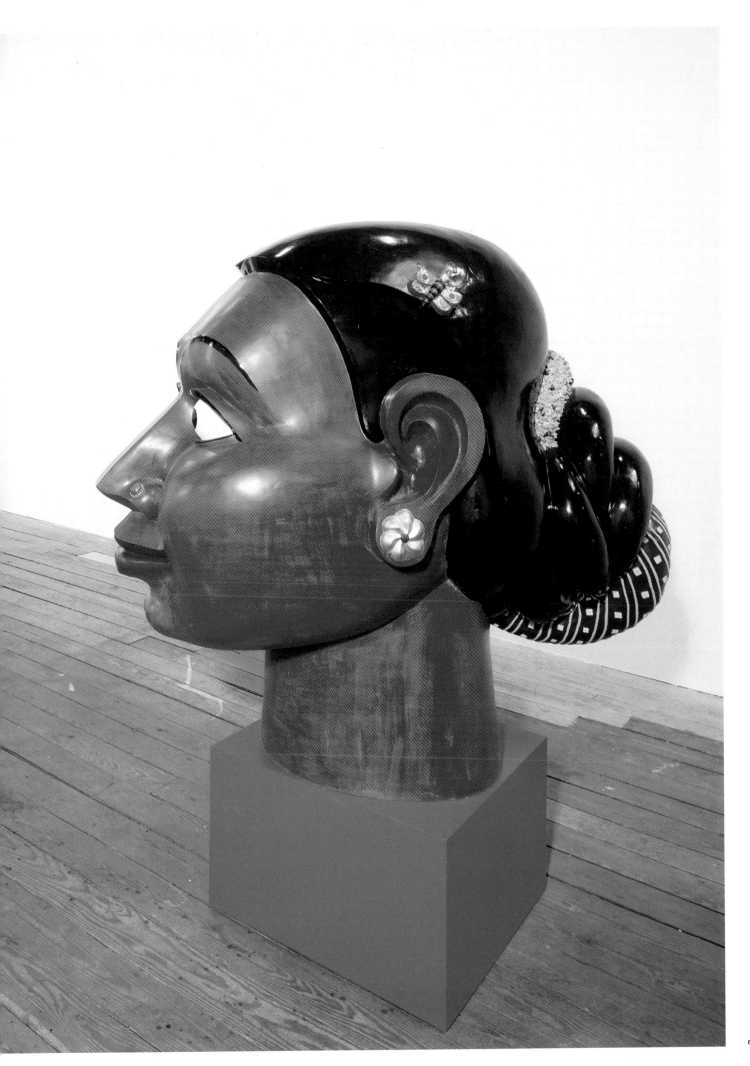

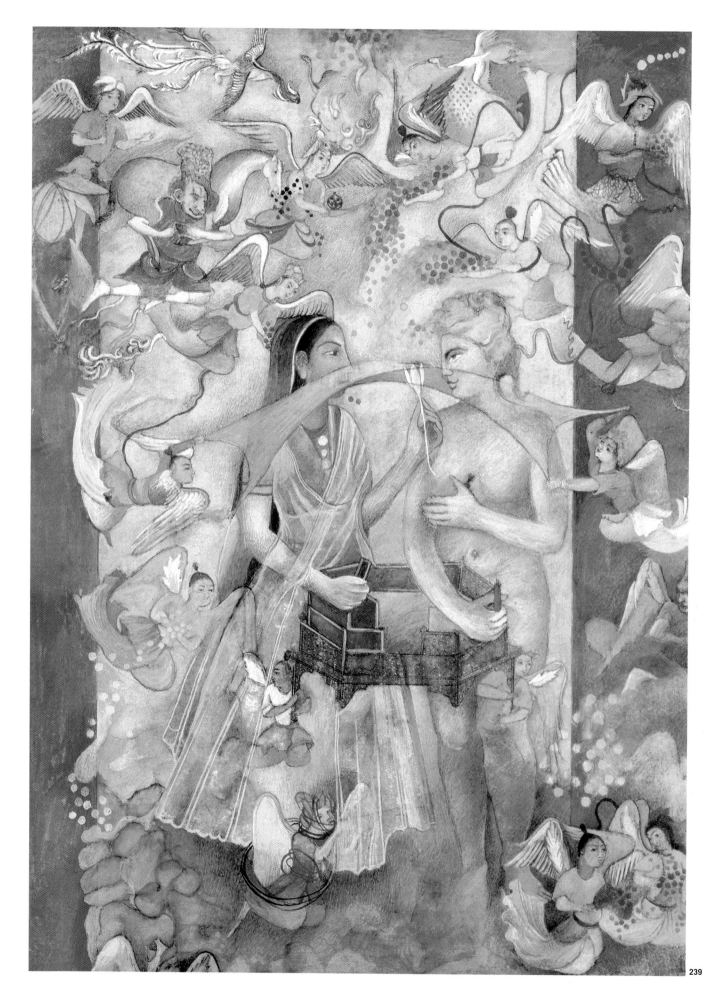

239 Shahzia Sikander,
Sly Offering, 2001.
Vegetable colour, dry pigment, watercolour,
tea on hand-prepared wasli paper, 22 x 13 cm

It is sometimes claimed that one of the ways in which the art of the present differs most profoundly from the art of a hundred years ago is in its enthusiastic embrace of a wide range of new technologies. It is undoubtedly true that a wide range of new methods of creating visual images has ensured that the artworks of today often seem very different from those made by artists not so very distant from us in time. Yet one must be careful about adopting too drastic a view. The often repeated claims that 'painting is dead' are self-evidently untrue. A great many artists continue to paint, and their work continues to be shown and to interest the public.

What has happened is something subtler than the displacement of one form of image making by another. Now there is a much larger choice of methods, and the range of choices is widening all the time. In the race to be the most contemporary, the most obviously up to the minute, the lead continually changes hands. Photography challenged the primacy of paintings – painters already perceived it as a threat in the 19th century. In the late 20th century, the still, fixed image was challenged by the moving one. The 1980s and 1990s witnessed the apparently irresistible rise of video. Now video, in turn, is being challenged by digital photography and by other methods of digital image production.

The rise of photography and its move to a central rather than a marginal position in the world of contemporary art is certainly one of the most striking phenomena of the last twenty or thirty years. Yet there is also something ironic in its success within this arena, since in a wider world one gets the sense that the photograph is no longer the main carrier of visual information, but has been devalued and subverted first by television, then by the computer. Computers offer a particular challenge because,

although people knew that photographs could be made to lie, there was still, until comparatively recently, a deep, visceral feeling that photographs offered a kind of veracity that more obviously subjective ways of holding up a mirror to the world could never attain.

When one thinks of popular culture, then of popular culture in conjunction with photography, and then – in a logical transition – of popular culture and its relationship to film, one immediately stumbles on something perhaps unexpected but also important, and that is the question of the relationship between the visual arts and some kind of enabling myth. If one agrees that Modernism had its roots in 19th-century Impressionism, and yet more profound and tenacious roots in the work of Cézanne (1839–1906), one is perhaps entitled to conclude that one of the prime tasks of the Modern Movement in art was to get rid of mythology. The Impressionists, Cézanne, the Cubists – what interested all of them was the world of appearances, the here and now. Of course there were quite frequent backslidings. From the 1920s onwards, Picasso toyed from time to time with the world of classical gods and goddesses, but in a way that made it plain that such things were not to be taken seriously. The Surrealists, following Freudian interpretation, contributed some dark myths of their own.

However, it was not until recently that artists once again began to look seriously for archetypes that would give additional resonance to their work. One impulse, common in countries where the cinema has long been a universal amusement, and where cinematic allusions were easily understood, was to treat the movies as the new mythology – to see if Mount Olympus and the Bible could be replaced in some fashion or other by Hollywood. Andy Warhol's

Marilyns – some of the most familiar artistic products of the late 20th century – were an early example of this endeavour. One striking thing about this phenomenon is that the movies used as source material are, perhaps necessarily, not new movies but old movies. The work of Alfred Hitchcock has been a special favourite. Yet there are obvious problems here. One is the difficulty of apportioning credit. If an artist 'appropriates' Hitchcock, is he or she to be regarded as author-in-chief of the resulting work? Or is Hitchcock himself still the prime mover, from a creative point of view? The great director, with an element of mock modesty, always declared that his work was not art and that he himself was not to be thought of as an artist.

Another problem is the inflexibility of the material when compared to an inherited myth that was passed through many hands. A film has a rigid narrative structure; its images, however mysterious, exist in a fixed relationship to one another. The only escape offered to the contemporary artist who focuses on the mythic quality of film is the possibility of homing in on a star personality, rather than on an actual narrative. This is what Warhol did in his images of Monroe. Traditional mythological material, on the other hand, can be, and often is, both ambiguous and amorphous. The artist can shape it how he or she pleases.

A third difficulty with film is quite simply that films become dated. This is partly, but only partly, due to technological obsolescence. It also has something to do with the way that filmed material treacherously freezes not only things such as fashions in dress but also moral and social attitudes. A once-admired masterpiece, such as D. W. Griffith's *Birth of a Nation*

(1915), becomes unwatchable not just because it seems increasingly crude technically, but even more because of its crude racism.

A striking characteristic of much recent art is the way in which it tries to leap over the great Modernist divide, in order to find nourishment in traditional sources. As we have seen, the great archetypes of Christian art now reappear astonishingly often in the work of experimental artists. On reflection, it does of course seem perfectly natural that artists should dig deep into art history. The only surprising thing is the fact that critics, curators and commentators – those who bring information about current art to this public – should so often have ignored this phenomenon.

The tendency to plunder the whole history of art for new source material is not an activity confined to purely western artists. If there are radical changes taking place in the art world – and I believe there still are – many of them are now the consequence of an ever-increasing impulse towards globalisation. This is a noun that has acquired a pejorative ring, but here I do not mean to give it such a colouring.

From its beginnings the Modern Movement in art laid claim to universal validity. Art was to respond to the same impulses and embrace the same values everywhere the artistic impulse was to be found. In fact, this was not the case. Modernism was a Western European phenomenon, which first rooted itself in Europe, then spread to the United States and Latin America. There were large tracts of the globe where anything that could describe itself as 'modern art' remained unknown. During the first half of the 20th century, Modernism conquered some regions but lost control in others. Russia, one of the original heartlands of Modernist experi-

241

241 Imran Qureshi,
A Lover Waiting for his Beloved, 2001.
Mixed technique on wasli paper, 26 x 20 cm

ment, ceased, under Soviet rule, to be part of the Modernist consensus. So, too, did Germany under the Nazis.

Postmodernism brought with it a plurality of attitudes that made it possible to incorporate a plurality of cultures. Early Modernism had begun the process through its love affair with the tribal art of Africa. However, this love was mingled with a good dose of condescension. African sculpture was admired because it seemed 'primitive'. The basis of this primitivism was never analysed, and the artists who used tribal sculpture as an important part of their source material – Picasso, for example – actually preferred not to know what these sculptures signified to those who originally made them. Where the process was reversed, and non-western artists made borrowings from Modernism, mingling these with indigenous traditions, their work was dismissed as weak and derivative.

The situation is very different today. The artists discussed in previous chapters of this book come from a wide variety of ethnic and cultural backgrounds. Some have chosen to live and work in the west, others remain in their own countries. The great civilisations of the Far East, for example, were once seen as cultural enterprises that had succumbed to contact with the west, and which had little or nothing to offer in the shape of vital new art firmly rooted in local cultural traditions. That is not the case today. Katsura Funakoshi's (b. 1951) much admired sculptures in carved wood (*Panther*, 1999) are undoubtedly contemporary in spirit, yet also look back to the realistic portrait sculptures made, using very similar techniques, by Japanese artists in the Kamakura period (1192–1333).

In India, Ravinder Reddy (b. 1956) makes sculptures inspired by Indian popular traditions, but often uses modern industrial materi-als, such as fibreglass and the acrylic paints used for automobiles (installation view, 2001). The result is a kind of Indian Pop Art, expressing a sensibility linked to the romantic movies produced by India's thriving Bollywood film studios.

Shazia Sikander (b. 1969), born in Pakistan but now living in New York, makes use of a different set of Indian traditions. Her paintings are based on the exquisite miniature produced by the court artists of the Mughal emperor Shah Jahan (reigned 1628–58), but with an element of ironic contemporary commentary. Many of the paintings of the Shah Jahan period are courtship scenes, where a prince offers a flower or some other object to a woman. In *Sly Offering* (2001) it is an Indian woman who offers the flower, and the person she courts is a classical 'Venus Pudica'. The appearance of the Venus in this context is among other things a reminder that Shah Jahan's artists often borrowed figures from European engravings.

Two artists still living and working in Pakistan, Aisha Khalid (b. 1972) and Imran Qureshi (b. 1972), are members of what has come to be called the Pakistani 'neo-miniature' school. Like Sikander, they revive old techniques but employ them for modern ends. Khalid speaks of the elements that appear in her work as 'characters' (*Untitled*, 2001): 'My characters come in the form of a clothed table, a covered human figure and a curtain. These characters tell a different story, each time with different sets of motifs like flower, fruits bunches, eyes and geometrical patterns. The patterns may or may not be divisible in to having feminine or masculine attributes.'[1] Some of Qureshi's works touch on topics that it is difficult to discuss in his country, such as homosexuality (*Lover and Beloved*, 2001).

242 Wenda Gu,
Babel of the Millennium, 1999.
Site-specific installation, H: 2000 / D:1000 cm

242

243 Zhang Wang,
Ornamental Rock, 2000.
Stainless steel

One of the regions of the Far East where there has recently been an amount of contemporary art activity is China. Since the end of the Cultural Revolution in 1976 there has been an outburst of creative activity. A number of examples have already been illustrated. The new Chinese art is very various, and restlessly creative. However, it is also increasingly mindful of deep-rooted Chinese cultural traditions. Wenda Gu (b. 1955) has become famous in the west for his ambitious installations made of human hair. *Babel of the Millennium* (1999), shown at the San Francisco Museum of Modern Art, was a huge tower made entirely of hair, and featuring various forms of nonsensical languages – pseudo-English, Hindi, Arabic, Chinese and synthesised English/Chinese. The hair had been collected from over three hundred and twenty five barber shops and hair salons throughout the world – in Poland, Italy, the US, Israel, Russia, Sweden, England, Hong Kong, Taiwan, South Africa, Canada, Japan, Korea, India, Egypt and China. Yet there is also in Wenda Gu's work a strong respect for the age-old Chinese Confucian tradition.

The sculptor Zhang Wang (b. 1962) looks at a different part of the Chinese literate tradition: the passion for ornamental rocks. The reason that there has been so little major sculpture in China since the period of the Southern Sung dynasty (960–1279) is that the Chinese became fascinated with stones whose 'accidental' configurations reminded them of the forms seen in Chinese landscape painting. Zhang Wang now makes these forms in stainless steel, thereby setting up an ironic confrontation between the idealisation of nature and the ever more insistent presence of industry. He has also made scholars' rocks in the form of plastic inflatables.

These examples have been taken from new artistic activity in the Far East, but in fact everywhere one looks one now finds a coming together of ideas, some of which belong to the world of contemporary art considered as a whole and others which are defiantly and even somewhat self-consciously local. In New Zealand, for instance, the Maori painter Robyn Kahukiwa (b. 1940) makes powerful canvases filled with both Maori and feminist symbolism (*Te Ao Marama*, 1998). In Iran, the young woman photographer Shadafarin Ghadirian (b. 1975) has made a remarkable series of images showing young women in the dress of the Qajar dynasty (1794–1925), which was even more enveloping and restrictive than the clothes Iranian women wear today. In each case the sitter is accompanied by some defiantly modern and generically western object as a symbol of revolt. In the example illustrated, she carries a ghetto blaster. Ghadirian says:

For the project, I had everything reconstructed, I had a friend who was a painter who prepare the backdrop, I borrowed the dresses and made some myself, and so on. I also had the models re-enact the poses that you see in the Qajar pictures – back then, photography was still very unusual and intimidating, and I tried to reconstruct the stance that the models would take, which was very different to that of contemporary models.

Until that time, portraits had been forbidden on religious grounds, even paintings. So the impact of photography, once it arrived in Iran, was enormous, it was something radically new – no-one had ever seen a portrait before.[2]

The Egyptian artist Mona Marzouk (b. 1968) takes a somewhat less polemical line, making paintings and sculptures in which architectural

243

244 Robyn Kahukiwa,
Oriori: Te Wairua, Te Manawa, Te Ao Marama (The Spiritual Soul, The Heart, The World of Light), 1998.
Oil on board / sr:20 (28 x 44 cm)

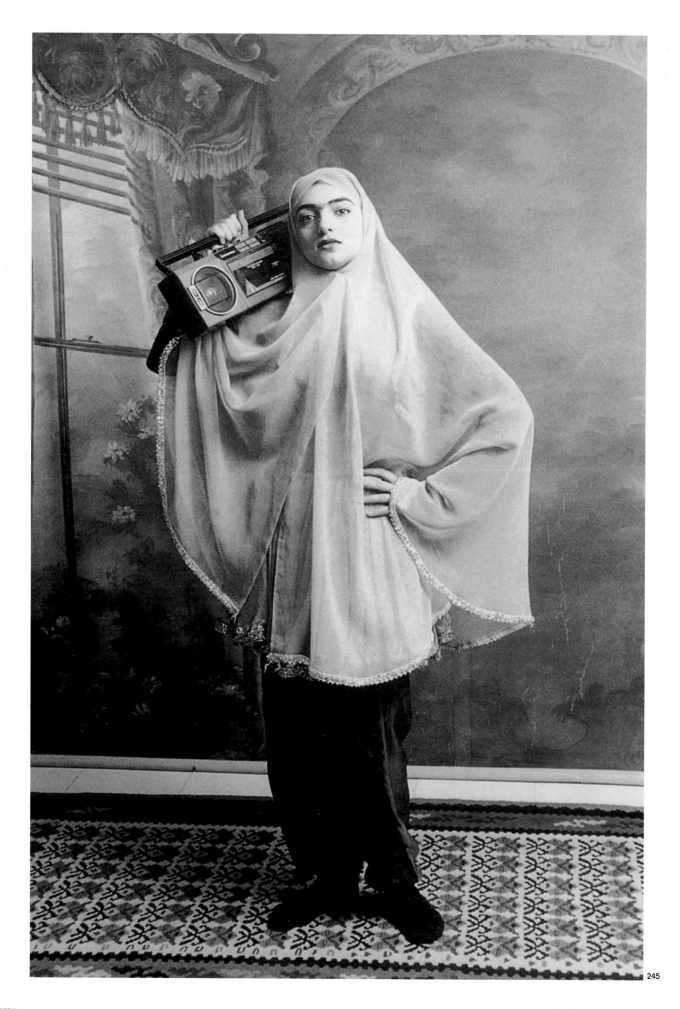

245

elements taken from the civilisations that have flourished in Egypt over the centuries are fused together in order to create a new visual language for contemporary Egyptian art.

It is no accident that so many of the artists cited in this final chapter are women, as feminism is one of the most powerful and universal forces in contemporary art, and one of the most obvious agents of change. Other agents, important if one is trying to predict what might happen to art in the future, are the increasing tendency to reject residual Modernist orthodoxies and the fascination with new aspects of

246

science, especially genetics. Response to the poetry of science is perhaps the thing that has most successfully survived from the world of the 20th-century Modern Movement. Much else that it is orthodox to regard as either 'modern' or 'contemporary', or indeed as a combination of the two, looks, when critically examined, like so much flotsam receding rapidly into the past.

1 Interview on www.opencirclearts.org.

2 Interview on www.badjens.com.

245 Shadafarin Ghadirian,
Untitled, 1998.
Photo: silver bromide print

246 Mona Marzouk,
Untitled (#3), 2001.
Acrylic on canvas, 42 x 27 x 5 cm

index

Numbers in **bold** refer to the pages

ALBERTO ABATE
(Italy, Rome b.1946 / act: Rome)
116

La freccia dell'amore
ct: Il Polittico, Rome

AJAMU
(England, Huddersfield b.1963 / act: London)
195

Untitled
ct: Artist

FRANCIS ALŸS
(Belgium, Antwerp b.1959 / act: Mexico City, New York, London)
92

The Doppelgänger
ct: Lisson Gallery, London

SILVANO d'AMBROSIO
(Italy b.1951)
116

Notturno locustre
ct: Il Politico, Rome

GHADA AMER
(Egypt, Cairo b.1963 / act: New York)
174

The Yellow
ct: Deitch Projects, New York

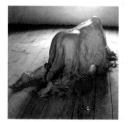

JANINE ANTONI
(Bahamas, Freeport b.1964 / act: New York)
187

Saddle
ph: Anders Norrsell
ct: Artist and Luhring Augustine, New York

ARAHMAIANI
(Indonesia, Bandung b.1961 / act: Indonesia, Jakarta and Bandung)
192

Offerings from A-Z
ex: Crematorium of Pha Daeng Cemetery, Chiang Mai, Thailand

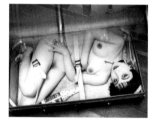

NOBUYOSHI ARAKI
(Japan b.1940)
166

Tokyo Alice: In the Box
ct: Artist

The ART GUYS
JACK A. MASSING
(New York, Buffalo b.1959)
and MICHAEL GALBRETH
(PA, Philadelphia b. 1956)
61

Greetings From Houston #4
ct: The Art Guys and Central Market, Houston
ex: The Art Guys: Sweet and Sour. Central Market, Texas 15.03-01.04.2002

OREET ASHERY
(Israel, Jerusalem b.1966 / act: London)
193

Self-Portrait as Marcus Fischer #1
ct: The Centre of Attention, London

SHIMON ATTIE
(USA, California, Los Angeles b.1957 / act: Rome)
96

Almstadtstraße 43
(formerly *Grenadierstraße 7*): Slide Projection of Former Hebrew Bookstore, 1930 Berlin
ct: Jack Shainman Gallery, New York

FEREYDOUN AVE
(Iran, Tehran b.1945 / act: Tehran – Paris - New York)
150

Pehlivans: Sohrab and Rustum
ct: Artist

AZIZ+CUCHER
ANTONY AZIZ and SAMMY CUCHER
223

Naturalia: Plate VII-a
iris print on Somerset paper (51x41)
ct: Henry Urbach Architecture, New York

BRANDON BALLENGÉE
(USA, Ohio, Sandusky b.1974)
241

The Atomic Frogs
ct: Artist

MIQUEL BARCELO
(Spain, Mallorca, Felantix b.1957)
106

Rebozo
ct: Timothy Taylor Gallery, London
ex: Timothy Taylor Gallery, 22.06-18.08.2001

MATTHEW BARNEY
(USA, San Fransisco b.1967 / act: New York)
74

Cremaster 5
ph: Michael james O'Brien
ct: Barbara Gladstone Gallery, New York

UBALDO BARTOLINI
(Italy b.1944 / act: Rome)
114

Portatrice d'acqua
ct: Il Polittico, Rome

BEDRÍ BAYKAM
(Turkey, Ankara b.1957 / act: Istanbul)
67

Shiver
ct: Artist

WILLIAM BECKMAN
(USA, Maynard b.1942)
103

Studio II
ct: Forum Gallery, New York

JOSÉ BEDIA
(Cuba, Havana b.1959 / act: Florida, Miami)
14

Paso firme
cl: The Los Angeles County Museum of Art
ct: Artist and Iturralde Gallery, Los Angeles

VANESSA BEECROFT
(Italy, Genoa b.1969 / act: New York)
187

VB 46
ph: Dusan Reljin
ex: Gagosian Gallery, Los Angeles
ct: artist

MERSAD BERBER
(Bosnia b.1940 / act: Zagreb)
148

Velika Alegorija IZ Bosne
ct: Artist

CARLO BERTOCCI
(Italy, Grosseto, Castell'Azzara b.1946)
118

Il Barchetta
ct: Il Politico, Rome

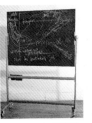

JOSEPH BEUYS
(Germany, Krefeld 1921-1986 / act: Kleve and Düsseldorf)
13

Ecology and Socialism
ph: Jennifer Kotter
ct: Ronald Feldman Fine Arts, New York
ex: Free International University seminar in Kassel, Germany

SIMON BILL
(UK b.1958 / act: London)
47

Lost City Atlantis
ct: Modern Art, London

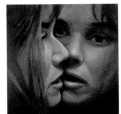

JEAN-LUC BLANC
(France b.1965)
73

Untitled
ph: Marc Domage
ct: Art:Concept, Paris

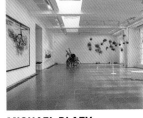

MICHAEL BLAZY
(France b.1966)
228

The Greenhouse Effect: (Untitled)
ph: Stephen White
ct: Art:Concept, Paris
ex: 'The Greenhouse Effect' Serpentine Gallery, London 04-05.2000

ROSS BLECKNER
(USA, New York City b.1949 / act: New York City)
220

Flow and Return
ct: Artist

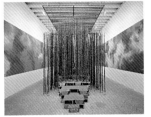

MONTEIN BOONMA
(Thailand, Bangkok b.1953 / act: Thailand)
41

House of Hope
ct: Deitch Projects, New York

CHRIS BOOTH
(New Zealand, Bay of Islands, Kerikeri b.1948 / act: Kerikeri)
84

Cave, Takahanga Marae, Kaikoura, New Zealand
ct: Artist
This is a ceremonial entranceway sculpture.

PAOLO BORGHI
(Italy b.1942)
121

L'ombra del tempo
ct: ArtPlus, Trieste

CHRISTINE BORLAND
(England, Ayrshire Darvel b.1965)
224

This Being You Must Create (Spy in the Anatomy Museum)
ct: The Lisson Gallery, London

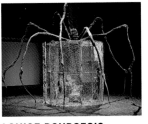

LOUISE BOURGEOIS
(France, Paris b.1911 / act: New York)
182

Spider
ph: Frederic Delpeche
ct: Cheim and Read, New York

OLAF BREUNING
(Switzerland, Schaffhausen b.1970)
198

Ray
ct: Metro Pictures, New York

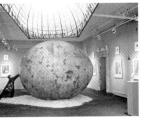

BRODSKY and UTKIN
ALEXANDER BRODSKY
(USSR, Moscow b.1955 / act: Moscow)
ILYA UTKIN
(USSR, Moscow b.1955 / act: Moscow)
42

Portrait of an Unknown Person: Peter Carl / Faberge's Nightmare
ct: Ronald Feldman Fine Arts, New York

TANIA BRUGUERA
(Cuba, Havana b.1968)
10

Untitled
ct: Liebman Magnan, New York
ex: Havana Bienale 2000

DAVID BUCKLAND
(England, London b.1949 / act: London)
206

Self-Portrait
ct: Artist and Focus Gallery, London

ALEXANDER De CADENET
(England, London b.1974)
207

Rabbi
ct: Artist

MERLIN CARPENTER
(England, b.1967)
62

The Estate of Sara Cox
ct: Galerie Max Hetzler, Berlin

JAKE and DINOS CHAPMAN
(UK b.London 1962 & b.Cheltenham 1966 / act: London)
46

Hell
ct: Jay Jopling/White Cube, London

GLAUCE CERVEIRA
(Brazil / act: London)
66

I Made It
ct: Danielle Arnaud Contemporary Art, London

GENIA CHEF
(USSR, Aktjubinsk b.1954 / act: Berlin)
126

Diana and Victoria
ct: Artist

GENIA CHEF
(USSR, Aktjubinsk b.1954 / act: Berlin)
127

Diana and Victoria
ct: Artist

MICHAL CHELBIN
(Israël b.1974
160

Untitled #1
ct: Rosenfeld Gallery, Tel Aviv

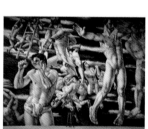

ZOYA and RUTI
ZOYA CHERKASSY
(Israël 1976)
RUTI NEMET
(Irsaël 1977)
55

Yoavb: The Complete Portfolio
ct : Rosenfeld Gallery, Tel Aviv

BRUNO CHERSICLA
59

Giorgio Strehler
ct: ArtPlus, Trieste

JUDY CHICAGO
(USA, Chicago b.1939 / act: New Mexico, New Mexico)
59

Do A Good Turn from *Resolutions: A Stitch in Time*
wk: Jacquelyn Moore
ph: Donald Woodman
ct: Artist, New Mexico

ELVIO CHIRICOZZI
(Italy b.1965)
119

Ne cielo ne terra
ct: Il Politico, Roma

NANCY CHUNN
(USA b.1969)
52

All Fall Down
ph: John Lamka
ct: Ronald Feldman Fine Arts, New York

RICARDO CINALLI
(Argentina, Froylan Palacios b.1948 / act: London)
132

Homenaje Humanista para el Nuevo Milenio (Humanistic Homage for the New Millennium)
ct: Artist and Foundation Ax
ex: 'Projecto Culutral: Cinalli - Peruchena' Foundation Ax, Cruz del Sur, Punta del Este, Uruguay

MAT COLLISHAW
(England, Nottingham b.1966 / act: London)
159

The Awakening of Conscience Kateline
ph: Stephen White
ct: The Lisson Gallery, London
ex: 'Duty Free Spirits' Lisson Gallery 28.10-19.12.1997

KEITH COTTINGHAM
(USA, California, Los Angeles b.1965 / act: San Francisco)
99

Fictitious Portrait: Double
ct: Ronald Feldman Fine Arts, New York

WILL COTTON
(USA b.1965)
56

Love Me
ct: Mary Boone Gallery, New York

RENÉE COX
(Jamaica, Colgate b.1960)
22

Yo Mama's Last Supper
ct: Robert Miller Gallery, New York
ex: 'Renée Cox: American Family' Robert Miller Gallery 10.10–10.11.2001

DALZIEL + SCULLION
MATTHEW DALZIEL
(Scotland, Irvine b.1957)
LOUISE SCULLION
(Scotland, Helensburgh b.1966)
91

Drift (detail)
ph: Alan Dimmick

WIM DELVOYE
(Belgium, Wervik b.1965)
111

Wedgewood Concrete Mixer
ct: Andre Simoens Gallery, Knokke-Zoute,
Belgium

SUSAN DERGES
(England, London b.1955 / act: London)
227

Aquae
ct: Michael Hue-Williams Fine Art

REINEKE DIJKSTRA
(The Netherlands, Sittart b.1959 / act:
Amsterdam)
95

Abigail: Herzliya Air Force Base: **April 10
1999** + *Abigail: Palmahim Israeli Air Force
Base:* **December 18 2000**
ct: Galerie Max Hetzler, Berlin

BRACO DIMITRIJEVIC
(Sarajevo b.1948)
44

*Triptychos Post Historicus: Edouard Manet,
Portrait of Carolus-Duran, 1876*
ct: The Barber Institute of Fine Arts, The
University of Birmingham, England

KATHERINE DOYLE
(USA, San Francisco b.1952 / act: New
Hampshire)
140

Diana and Actaeon
ct: Tatistcheff Gallery, New York

MARLENE DUMAS
(South Africa, Capetown b.1953 / act:
Amsterdam)
175

Miss Pompadour
pc: Amsterdam
ct: Artist and Frith Street Gallery, London

TRACEY EMIN
(UK, London b.1963 / act: London)
179

My Bed
ct: Lehmann Maupin, New York

SUMER EREK
(Cyprus, Limassol b.1959 / act: London)
80

Upside Down House
ph: Leonie Purchas
ct: www.chaosccc.com
ex: Clissold Park, Stoke Newington
Festival, London

ELGER ESSER
(Germany, Stuttgart b.1967 / act:
Düsseldorf)
159

Cap d'Antifer, Etretat
ct: Michael Hue-Williams Fine Art Ltd,
London

JOHN PAUL EVANS
(England b.1965 / act: Cardiff)
141

Miners' Memorial
pr: 'Mining' by Albert Hodge at the east
façade of Mid Glamorgan County Hall,
Cardiff
ct: Artist

ÍNCI EVINER
(Turkey, Ankara b.1956 / act: Istanbul)
213

Milk
ct: Artist

STEFANIA FABRIZI
(Italy, Roma b.1958 / act: Rome)
118

La Veronica
in: Sant'Andrea al Quirinale, Rome 06-
31.07.2000

ALAN FELTUS
(USA, Washington DC b.1943)
139

Alone Together
ct: Forum Gallery, New York

RACHEL FEINSTEIN
(USA, Arizona, Fort Defiance b.1971 / act:
New York)
53

Yesterday
ct: Corvi-Mora, London

CARLEE FERNANDEZ
(USA, California, Santa Ana b.1973 / act:
California, Los Angeles)
230

Hugo Parlier
ph: Josh White
ct: Acuna-Hansen Gallery, Los Angeles

FISCHLI and WEISS
PETER FISCHLI
(Switzerland b.1952)
DAVID WEISS
(Switzerland b.1946)
87

London: British Air
ct: Galerie Hauser and Wirth and
Presenhuber, Zürich

SYLVIE FLEURY
(Switzerland, Geneva b.1961)
50

Razor Blade
ct: Galerie Hauser and Wirth and
Presenhuber, Zürich

CEAL FLOYER
(Pakistan, Karachi b.1968 / act: London)
88

Light Switch 1992
ct: Lisson Gallery, London

THIERRY FONTAINE
(France, La Réunion b.1969 / act: France)
194

La Réunion: Sculpture #3
ct: f a projects, London

KATSURA FUNAKOSHI
(Japan, Iwate, Morioka b.1951)
249

Panther Lurking in the Library
ph: Norihiro Ueno
pc / ct: Annely Juda Fine Art

ANYA GALLACCIO
(Scotland, Paisley b.1963 / act: London)
39

Chasing Rainbows #2
ph: Shigeo Anzai
ct: Artist
ex: 'Real Life: New British Art' Tokyo
MOCA, Japan

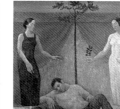

ALBERTO GALVEZ
(Italy b.1963)
130

*Hacia el arbol hermano con las dies con-
tadas*
ct: Il Politico, Rome

PAOLA GANDOLFI
(Italy b.NOT GIVEN)
212

Clitemnestra
ct: Il Politico, Rome

FRANK O.GEHRY
(Canada, Toronto b.1929)
11

Guggenheim Bilbao Museoa
(Guggenheim Museum Bilbao)
ph: Erika Barahona Ede
© FMGB Guggenheim Bilbao Museoa

SHADIFARIN GHADIRIAN
(Iran, Tehran b.1974 / act: Iran)
264

Untitled
ct: Artist

GHAZEL
(Iran, Tehran b.1966 / act: France)
191

*Me: being 'cool' was showing-off with your
two wheels when we were teenagers*
ct: Artist

GILBERT and GEORGE
(Italy b.1943 and England b.1942)
176

Pissed
ct: Lehmann Maupin, New York

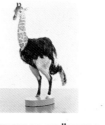

ROBERT GOBER
(USA, Connecticut, Wallingford b.1954 /
act: New York)
214

Untitled
ph: Liz Deschenes
ct: Artist

ANTHONY GOICOLEA
(USA b.1971 / act: Chicago)
98

Blizzard
ct: RARE, New York

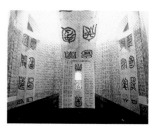

NAN GOLDIN
(USA, Washington b.1953 / act: New
York)
86

Valerie on the stairs in yellow light, Paris
ct: Matthew Marks Gallery, New York

ANDY GOLDSWORTHY
(England, Cheshire b.1956)
82

À la mémoire des arbres
ex: 'Silent Spring' Galeri Lelong 31.05.-
21.07.2001
ct: Galerie Lelong, Paris

DOUGLAS GORDON
(Scotland, Galsgow b.1966 / act: Glasgow
and Cologne)
25

24H Psycho,
ph: John Riddy
ct: Lisson Gallery, London
ex: 'Spellbound' Hayward Gallery 02-
05.1996

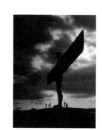

ANTONY GORMLEY
(Britain, London b.1950 / act: London)
29

Angel of the North
ct: Artist
ex: Gateshead, Tyne and Wear

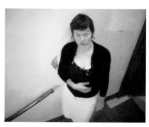

THOMAS GRÜNFELD
(Germany, Opladen b.1956 / act: Cologne)
19

Misfit-Giraffe
ph: Winfried Petzi, Munich
ct: Artist

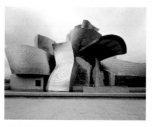

WENDA GU
(China, Shangai b.1955 / act: New York)
258

Babel of the Millennium
ct: San Francisco Museum of Modern Art

ELI GUR-ARIE
(Israel b.1964)
149

Untitled
ct: Rosenfeld Gallery, Tel Aviv

GEORGY GURJANOV
(Russia b.1961)
125

Sailors
ct: Artist

ANDREAS GURSKY
(Germany, Leipzig b.1955 / act:
Düsseldorf)
89

Singapore – Symex
ct: Galerie Monika Sprüth, Köln

HAI BO
(China, Jilin Province, Changchun
b.1962)
97

Middle School
ct: The Red Mansion Ltd, London

MONA HATOUM
(Lebanon, Beirut b.1952 / act: London)
189

Corp étranger
ct: Jay Jopling/White Cube, London

RON HASELDEN
(England, Kent b.1944)
37

Maid of the Mist
ph: Edward Woodman
ct: Museum of Installation, London

TIM HAWKINSON
(USA b.1960 / act: Los Angeles)
34

Überorgan
ph: Arthur Evans
ct: MASS MoCA: Massachusetts Museum
of Contemporary Art

SEAN HENRY
(England b.1965 / act: London)
101

Sic Transit Gloria Mundi
ct: Forum Gallery, New York

IGNACIO HERNANDO
(Spain, Jaca b.1964 / act: Barcelona)
212

Serie azul H
ct: Galeria Alejandro Sales, Barcelona

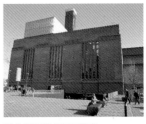

**JACQUES HERZOG
and PIERRE de MEURON**
(Switzerland b.1950)
11

Tate Modern
ph: Edward Lucie-Smith 2002

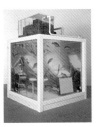

DAMIEN HIRST
(UK, Bristol b.1965 / act: Devon)
180

Love Lost
ct: White Cube, London

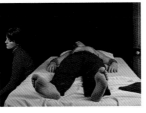

PAUL HODGSON
(England, Shropshire 1972 / act: London)
129

Rehearsal
ct: Artist

NOAM HOLDENGREBER
(Israel b.1965 / act: Tel Aviv)
128

The Masters: Untitled
ct: Artist

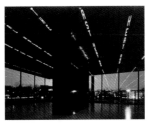

JENNY HOLZER
(USA, Ohio, Gallipolis b.1950 / act: New
York, Hoosick)
58

Installation View
in: Neue Nationalgalerie, Berlin

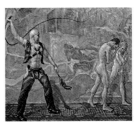

DELMAS HOWE
(USA, Texas, El Paso b.1935 / act: New
Mexico)
112

Study for an Expulsion
ph: Judd Bradley
ct: Artist

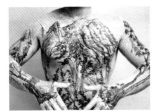

HUANG YAN
(China, Jilin b.1966)
202

Body, Tattoo, Landscape
ct: Hanart: T.Z.Gallery, Hong Kong

**MALCOLM NELSON
JAGAMARRA**
(Australia, Western Desert b.1955)
15

Milky Way Dreaming
ct: Rebecca Hossack Gallery, London

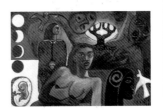

EDUARDO KAC
(Brazil, Rio de Janeiro b.1962)
244

The Eighth Day
ct: Institute for Studies in the Arts, Arizona
State University, Tempe

ROBYN KAHUKIWA
(New Zealand, Māori b.1940)
262

*Oriori: Te Wairua, Te Manawa, Te Ao Māra-
ma (The Spiritual Soul, The Heart, The
World of Light)*
ph: John Casey, Silver Image
ct: Artist

VALERY KATSUBA
(Russia, Sergeevichi b.1965)
54

Morning in the Pinewood
ct: Artist

DIARMUID KELLEY
(Scotland, Stirling b.1972)
107

Housewife's Choice
ct: Offer Waterman and Co, London

MIKE KELLEY
(USA b.1954 / act: California)
56

Arena #11: Book Bunny
ct: Metro Pictures, New York

MIKE KELLEY
(USA b.1954 / act: California)
56

*Nostalgic Depiction of the Innocence of
Childhood*
ct: Metro Pictures, New York

AFSHAN KETABCHI
(Iran, Tehran b.1966 / act: Tehran)
190

*What I have in common with Rudabeh and
Aurelia*
ct: Artist
ex: 1st Iranian Festival of Contemporary
Art 2001

AISHA KHALID
(Pakistan, Faisalabad b.1972)
255

Untitled
ct: Corvi-Mora, London

HOSSEIN KHOSROJERDI
(Iran b.1957 / act: Iran)
149

The Pyramids Began Here
ex: Sharjah Biennial 2001
ct: Artist

JOHN KIRBY
(b.1949)
153

Jeremiah Lamenting the Destruction of Jerusalem
ct: Angela Flowers Gallery, London

VICTOR KOEN
(Greece, Thessaloniki b.1967 / act: New York)
226

Meta4
ct: www.chaosccc.com

KOMAR and MELAMID
VITALII KOMAR
(Russia, Moscow b.1943)
ALEKSANDR MELAMID
(Russia, Moscow b.1945) (act: USA)
123

The Wings Will Grow
ct: Ronald Feldman Fine Arts, New York

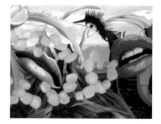

JEFF KOONS
(USA, Pennsylvania b.1955 / act: New York)
8

Lips
cl: Sammlung Deutsche Bank
ct: Deutsche Guggenheim Berlin

JIRI KRATOCHVIL
(Czech Republic b.1946)
235

Mercury
ph: Edward Woodman
ct: Museum of Installation, London

BARBARA KRUGER
(USA b.1945)
57

Untitled: everything will be okay / everything will work out / everything is fine
ct: Mary Boone Gallery, New York

OLEG KULIK
(USSR, Kiev b.1961 / act: Moscow)
169

Deep into Russia
ct: Art Kiosk, Brussels, Belgium

YAYOI KUSAMA
(Japan, Matsumoto City b.1941 / act: USA)
38

Narcissus Garden
ct: Ota Fine Arts
ex: 'Facts of Life' Hayward Gallery

JANE LACKEY
(USA, Tennessee, Chattanooga b.1948 / act: Michigan, Bloomfield Hills)
240

Receptors: Smear
ph: Tim Thayer
ct: Artist, Cranbrook Academy of Art

CHRISTOPHER LE BRUN
(England, b 1951)
145

Dante and Virgile : The Embarkation
ct : Marlborough Fine Arts, London

MICHAEL LEONARD
(India, Bangalore b.1933 / act: London)
142

Stretch
ct: Artist

SOL LEWITT
(USA b.1928)
30

Maquette for Vertical Progression No.7
ph: Stephen White
ct: Lisson Gallery, London
ex: 'Sol LeWitt: Wall Pieces' Lisson Gallery 21.05-04.07.1998

 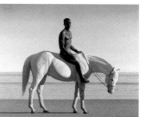

DAVID LIGARE
(USA, Illinois, Oak Park b.1945 / act: California, Salinas)
138

Areta: Black Figure on White Horse
ct: Koplin Gallery, Los Angeles

LIU DAHONG
(Shanghai, Shangdong, Qingdao b.1962 / act: Shanghai)
147

Sacrificial Altar (detail)
ct: Artist

CARLO MARIA MARIANI
(Italy, Rome, b.1931)
113

Head Rack
ct: Artist and Carol Lane

ROBERTO MARQUEZ
(Mexico, Mexico City b.1959 / act: New Jersey, Jersey City)
136

El doble
ct: Riva Yares Gallery, Scottsdale and Santa Fe, New Mexico

The MARTINCHIKS
SVETLANA MARTINCHIK
(b.1965)
IGOR STEPIN
(b.1967)
47

Planet Aiishana: The Ho People
ph: D.James Dee
ct: Ronald Feldman Fine Arts, New York

ANDREA MARTINELLI
(Italy, Prato b.1965 / act: Prato)
157

La donna nella città
ct: Frissiras Museum, Athens

MONA MARZOUK
(Egypt, Alexandria b.1968 / act: Egypt)
265

Untitled (#3)
ct: Marco Noire Contemporary Art, Torino

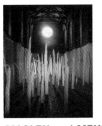

MASLEN and MEHRA
TIM MASLEN
(Australia, Perth b.1968)
JENNIFER MEHRA
(UK, London b.1970)
228

Drift
ex: Dilston Grove, London 23.08-
16.09.2001
ct: Artists

MASLOV and KUZNETSOV
OLEG MASLOV
(Russia, Kursk, Lgov b.1965)
VICTOR KUZNETSOV
(Russia, Mariy Republic, Loshkar Ola
b.1965)
125

After the Shipwreck
ct: Art Kiosk, Brussels, Belgium

TONY MATELLI
(USA, Chicago b. 1971 / act: New York)
45

Very, Very First Man: Necessary Alteration
ct: Leo König Inc., New York

HIROYUKI MATSUKAGE
(Japan, Fukuoka b.1965)
72

Star
ct: Mitsubishi-Jisho Artium
ex: Mizuma Art Gallery

YANNIS MELANITIS
(Greece, Athens b.1967 / act: Athens)
234

Bio-Robotic Symbiosis #2
pr: N.Sgouros
pc: P.Prokopiou and S.Kousidou
ct: www.chaoscc.com

ERBOSYN MELEDBEKOV
(Kazakhstan b.1964)
192

Pol Pot #6: Project Invasia
ct: Artist

BORIS MIKHAILOV
(Kharkov (former Soviet Union) b.1938 /
act: Kharkov and Berlin)
94

Untitled from *Case History*

KEITH MILOW
(UK b.1945)
30

Canon
ct: Nohra Haime Gallery, New York

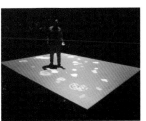

TATSUO MIYAJIMA
(Japan b.1957 / act: Japan, Ibaragai)
39

Floating Time
ph: Norihuro Ueno
ct: Fuji Television Gallery
ex: 'Facts of Life' Hayward Gallery

KOJI MIZUTANI
(Japan, Nagoya b.1951)
65

Merry 1,2,3
ct: Bolton and Quinn, London
ex: 'Tokyo Life' Selfridges, London 01-
31.05.2001

JONATHAN MONK
(England, Leicester b.1969 / act: Berlin)
71

In Search of Gregory Peck
ct: Lisson Gallery, London

FRANK MOORE
(USA, New York b.1953 / act: New York)
238

Human Genome Project
ct: Sperone Westwater, New York

YASUMASA MORIMURA
(Japan, Osaka b.1951)
69

Self-Portrait Actress: after Rita Hayworth A
ct: Artist and Luhring Augustine, New York

MRZYK and MORICEAU
PETRA MRZYK
(German b. 1973)
JEAN-FRANÇOIS MORICEAU
(France b.1974)
61

Untitled
ct: Air de Paris, Paris

RON MUECK
(Australia, Melbourne b.1958 / act:
London)
101

Mother and Child
ct: James Cohan Gallery, New York

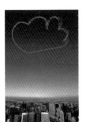

VIK MUNIZ
(b. 1961, São Paulo, Brazil)
85

Empire State
ct: Creative Time In. NY.

JUAN MUÑOZ
(Spain, Madrid 1953-2001)
35

Double Bind
Unilever, London
ct: Attilio Maranzano, Siena
ex: Turbine Hall, Tate Modern, London
12.06.2001-17.02.2002

TAKASHI MURAKAMI
(Japan, Tokyo b.1962)
64

Hiropon
ct: Marianne Boesky Gallery, New York

AHMAD NADALIAN
(Iran, Sangsar, b.1963 / act: Tehran)
83

Riverart
The 'River Art' project took place at the
Haraz River near the village of Poloor, 65
kilometers from the Tehran-Amol road.
ct: Artist
ex: Haraz River, Poloor

BARBARA NAHMAD
(Italy, Milan b.1967 / act: Milan)
164

Untitled: Couple of Women
ct: Artist

BARBARA NAHMAD
(Italy, Milan b.1967 / act: Milan)
165

Untitled: Couple of Men
ct: Artist

MASATO NAKAMURA
(Japan, Akita, Odate b.1963)
66

Family Mart
ct: Bolton and Quinn, London

ZORAN NASKOVSKI
(Yugoslavia, Vojvodina, Izbiste b.1960)
170

The Origin of the World
dr: Zoran Naskovski
ac: Nelly
ed: Marko Glusac
ph: Vesna Pavlovic
ms: W.A.Mozart *XXI Concert for Piano*
(Andante)

ADI NES
(Israel b.1966)
24

Last Supper
ct: Dvir Gallery, Tel-Aviv, Israel

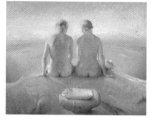

ODD NERDRUM
(Sweden, Helsingborg b.1944)
152

Summit
ct: Forum Gallery, New York

SHIRIN NESHAT
(Iran, Qazvin b.1957 / act: New York)
12

Women of Allah
ph: Gronchi FotoArte
ct: Fondazione Teseco per l'Arte, Pisa

**TIM NOBLE &
SUE WEBSTER**
(England, Stroud b.1966 / act: London)
(England, Leicester b.1967 / act: London)
45

The New Barbarians
ct: Modern Art, London

**TIM NOBLE &
SUE WEBSTER**
(England, Stroud b.1966 / act: London)
(England, Leicester b.1967 / act: London)
40

The Undesirables
ct: Modern Art, London

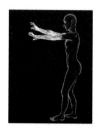

TIMUR NOVIKOV
(USSR, St.Petersburg b.1958 / act:
Russia)
122

*Grand Duchess Elizabeth of Russia before
becoming a Nun*
ct: Art Kiosk, Belgium

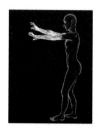

MARINA NÚÑEZ
(Spain, Palencia b.1966)
211

Ciencia Ficción
ct: Galeria Alejandro Sales, Barcelona

ELISABETH OHLSON
(Sweden b.1961)
20

Last Supper
ex: 'Ecce Homo'

MARILENE
MARILÈNE OLIVER
(England, Essex b.1977 / act: London)
208

I Know You Inside Out
ct: Artist

CATHERINE OPIE
(USA, Ohio b.1961)
199

Untitled
ct: Regen Projects, Los Angeles

JULIAN OPIE
(England, London b.1958 / act: London)
53

You see an office building (3)
ph: John Riddy
ct: Lisson Gallery, London
ex : 'Julian Opie' Lisson Gallery
06.07.1996

ORLAN
(France, St.Etienne b.1947)
205

Operation: Seduction versus Seduction
ct: Art Kiosk, Belgium

PEPÓN OSORIO
(Puerto Rico b.1955)
18

No Crying Allowed in the Barbershop
ct: Ronald Feldman Fine Arts, New York
ex: Real Art Ways, Hartford, Connecticut

TONY OURSLER
(USA, New York b.1957 / act: New York)
75

The Influence Machine
ph: P.Taghizadeh
ct: Lisson Gallery, London
ex: Soho Square, London 19.07.2000

TONY OURSLER
(USA, New York b.1957 / act: New York)
75

Gag
pf: Tony Oursler
ct: Metro Pictures, New York

TONY OURSLER
(USA, New York b.1957 / act: New York)
75

Dedoublement
ph: Andrew Whittuck
ct: Lisson Gallery, London

PANAMERENKO
(Belgium b.1940)
218

Archaipteryx
ct: Ronald Feldman Fine Arts, New York

PHILIPPE PERROT
(France, Paris b.1967 / act: Paris)
156

Père, aubergine, navet, carotte
ph: Bertrand Huet
ct: Art:Concept, Paris

RAYMOND PETTIBON
(USA, AZ, Tucson b.1957 / act: California, Hermosa Beach)
60

No Title: mimicked in its
ph: Joshua White
ct: Regen Projects, Los Angeles

FABRIZIO PLESSI
(Italy, Reggio Emilia b.1940 / act: Venice and Mallorca)
9

Waterfire
ct: ArtPlus, Trieste
ex: Correr Museum, Piazza San Marco,

PAUL PLETKA
(USA b.1946)
137

Looking for Heaven
ct: Riva Yares Gallery, Santa Fe, New Mexico

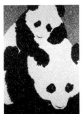

ROB PRUIT
(USA, Washington DC b.1964)
51

Pa
ct: Gavin Brown's enterprise, Corp., New York

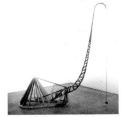

MARTIN PURYEAR
(USA b.1941)
16

Untitled
ct: Donald Young Gallery, Chicago

MARC QUINN
(England, London b.1964 / act: London)
144

Jamie Gillespie
ct: Jay Jopling/White Cube, London

IMRAN QURESHI
(Pakistan, Hyderabad b.1972)
256

A Lover waiting for his Beloved
ct: Corvi-Mora, London

MICHAEL RAPOPORT
(Kazakhstan b. 1948 / act: Israel)
149

Untitled #7
ct: Rosenfeld Gallery, Tel Aviv

NEO RAUCH
(Germany, Leipzig b.1960)
63

Händler
cl: Sammlung Deutsche Bank
ct: Galerie EIGEN+ART
ex: Deutsche Guggenheim Berlin

RAVINDER REDDY
(India, Andhra Pradesh, Suryapet b.1956 / act: Visakhapatnam)
250

Untitled
ct: Deitch Projects, New York
ex: Deitch Projects, 08.09-27.10.2001

PAUL REID
(Scotland b.1975)
144

The Heliades
ct: The Scottish Gallery, Edinburgh
ex: 'Paul Reid' New York 03.2002

DAVID REMFRY
(England, Sussex b.1942 / act: USA, New York)
154

Untitled
ct: Artist

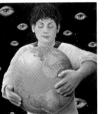

LITHIAN RICCI
(Italy b.?)
119

Hacker
ct: Il Polittico, Rome

ELIAS RIVERA
(USA b.1937)
137

In the Heart of the Crowd
ct: Riva Yares Gallery, Santa Fe, New Mexico

ALEXIS ROCKMAN
(USA, New York b.1962 / act: New York)
236

The Farm
ct: Gorney Bravin + Lee, New York

ROEE ROSEN
(Israel b.1963 / act: Tel Aviv)
100

Justine Frank's The Stained Portfolio of 1927
ct: Rosenfeld Gallery, Tel Aviv

THOMAS RUFF
(Germany, Zell am Harmersbach b.1958 / act: Düsseldorf)
172

Nudes lac 15
ct: Zwirner and Wirth, New York

JEAN RUSTIN
(France, Montigny-lès-Metz / act: Paris)
152

Study after Six Pensioners
ct: Jean Rustin Foundation, Antwerp

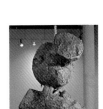
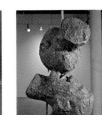

ALISON SAAR
(USA b.1956)
17

Kiss on a Rope
ct: Phyllis Kind Gallery, New York

JOSEP SANTILARI
(Spain, Badalona b.1959)
102

Envasats
ct: Sala d'Art: Artur Ramon, Barcelona

PERE SANTILARI
(Spain, Badalona b.1959)
102

Pa i Formatge
ct: Sala d'Art: Artur Ramon, Barcelona

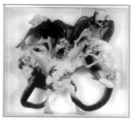

IRIS SCHIEFERSTEIN
(Germany, Lich b.1966 / act: Berlin)
233

Life Can Be So Nice: Life
ct: Die Neue Aktionsgalerie, Berlin

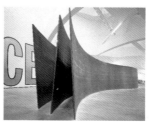

RICHARD SERRA
(USA, San Francisco b.1939)
32

Snake
ph: Erika Barahona Ede
© FMGB Guggenheim Bilbao Museoa

BRUNO SERRALONGUE
(France b.1968 / act: France)
88

Firework, Sérandon, 14 July 2000 #9
ct: Air de Paris, Paris

ANDRES SERRANO
(USA, New York City b.1950 / act: Brooklyn)
167

A History of Sex: Antonio and Ulrike
ct: Paula Cooper Gallery, New York

CINDY SHERMAN
(USA, New Jersey, Glen Ridge b.1954)
71

Untitled #205
ct: Metro Pictures, New York

CINDY SHERMAN
(USA, New Jersey, Glen Ridge b.1954)
110

Untitled #205
ct: Metro Pictures, New York

CHIHARU SHIOTA
(Japan, Osaka b.1972 / act: Berlin)
43

Breathing from Earth
ct: Asian Fine Arts Berlin / Prüss and Ochs
ex: Maximiliansforum München

YINKA SHONIBARE
(England, London b.1962 / act: London)
111

Diary of a Victorian Dandy: 11:00 hours
ct: Stephen Friedman Gallery, London

SHAHZIA SIKANDER
(Pakistan, Lahore b.1969 / act: New York City)
252

Sly Offering
ct: Judy and Robert Mann

LARS SILTBERG
(Sweden, Stockholm b.1968 / act: Sweden, Göteborg)
186

Man on Ice
ct: Artist

LARS SILTBERG
(Sweden, Stockholm b.1968 / act: Sweden, Göteborg)
186

Man on Water
ct: Artist

LARS SILTBERG
(Sweden, Stockholm b.1968 / act: Sweden, Göteborg)
186

Man on Air
ct: Artist

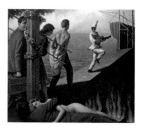

STEFANO di STASIO
(Italy, Napoli b.1948 / act: Rome)
117

A sud del tempo
ct: Artist

REBECCA STEVENSON
(England, London b.1971 / act: London)
209

Cold-Rose: Blue
ct: Artist

ADAM STRAUS
(USA, Florida, Miami Beach b.1956 / act: USA)
219

Space Junk
ct: Nohra Haime Gallery, New York

TOMAS STRUTH
(Germany, Geldern b.1954 / act: Düsseldorf)
89

San Zaccaria, Venedig
ct: Galerie Max Hetzler, Berlin

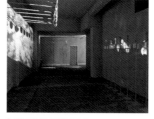

LOUISE SUDELL
(England, Middlesex b.1960)
42

Electric and Amor
ph: Edward Woodman
ct: Museum of Installation, London

HIROSHI SUGIMOTO
(Tokyo, Japan 1948 / act: New York and near Tokyo)
158

Henry VIII
ct: Deutsche Guggenheim Berlin

SUI JIANGUO
(China, Shan Dong, Tsing Tao b.1956)
146

Clothed Discobolus
ct: Hanart:TZ Gallery, Hong Kong

JOHN SUMMER
(USA, Colorado Springs b.1974 / act: London)
210

The Dude
ct: Artist

SUN YUAN and PEN YU
(China b.1972 and 1974)
181

Soul Killing
installation
ct: Artists

SAM TAYLOR-WOOD
(UK, London b.1967 /act: London)
160

Pietà
ct: Jay Jopling/White Cube, London

OLGA TOBRELUTS
(USSR, Leningrad b.1970 / act: Russia, St.Petersburg)
124

Sacred Figures: Naymi (Naomi)
ct: Artist
ex: 'Heaven' Düsseldorf Kunsthallle and Tate Gallery

LILIANE TOMASKO
(Spain, Barcelona)
107

Pillow
ct: Galería Carles Taché, Barcelona

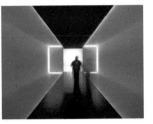

JAMES TURRELL
(USA b.1943)
36

The Light Inside
ct: Museum of Fine Arts, Houston
ex: 'Bernardo Bellotto and the Capitals of Europe' Museum of Fine Arts, Houston 09.2001

KEITH TYSON
(England, Cumbria, Ulverston b.1969)
222

Molecular Compound
ct: Kettle's Yard, Cambridge, England

DINO VALS
(Spain, Zaragoza b. 1959 / act: Spain)
134

Between Earth and Heaven: Per Luctam / Criptodídimo / Per Luctum
pc: Houston
ct: Artist

NAZARIO
NAZARIO LUQUE VERA
(Spain, Sevilla, Castilleja del Campo b.1944)
104

El sueño de Endymion or Vanitas III
ct: Il Politico, Rome

JEAN-LUC VERNA
(France b.1966 / act: Nice)
200

Zeus or Poseidon, Greek bronze, antiquity / Iggy Pop (American Ceasar) / Siouxsie dance intro 'Premature Burrial',
© JLV / Michel Cohen / Balleor / tatouages: Expérience Interdite, Nice
ct: Air de Paris, Paris

JEAN-LUC VERNA
(France b.1966 / act: Nice)
201

Degas, Ballerine de 14 ans / Harry (Blondie), live in Paris
© JLV / Michel Cohen / Balleor / tatouages: Expérience Interdite, Nice
ct: Air de Paris, Paris

GUILLERMO PÉREZ VILLALTA
(Cádiz, Tarifa b.1948)
131

Via Crucis
ct: Galeria Soledad Lorenzo

BILL VIOLA
(USA, New York b.1951 / act: California, Long Beach)
161

The Quintet of the Astonished
cl: Artist
ct: Anthony d'Offay, London

ANTONIO VIOLETTA
(Italy)
120

L'aurora (Dawn)
ph: P.Cesavlei?, Bologna
ct: Art Plus, Trieste

CATHERINE WAGNER
(USA, San Francisco b.1953 / act: San Francisco)
243

86 Degree Freezers: 12 Areas of Concern and Crisis
ct: Stephen Wirtz Gallery, San Francisco and Jack Shainman Gallery, New York

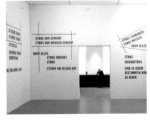

LEE WAGSTAFF
(England b.1969)
204

The Oracle
ct: Patrick Brillet Fine Art, London

LAWRENCE WEINER
(b.1942)
30

Nach Alles (After All)
cl: Sammlung Deutsche Bank
ct: Deutsche Guggenheim Berlin

RACHEL WHITEREAD
(England, London b.1963 / act: London)
78

Monument
ex: Trafalgar Square, London
ph: Mike Bruce
ct: Anthony d'Offay Gallery, London

RACHEL WHITEREAD
(England, London b.1963 / act: London)
79

Basement
ph: Mike Bruce
ct: Deutsche Guggenheim, Berlin

GAIL WIGHT
(USA b.1960)
242

Zoo Kit
ct: Artist, Los Angeles, California

T. J.WILCOX
(USA, Washinton, Seattle b.1965 / act: USA)
70

Marlene Dietrich
ct: Metro Pictures, New York

MICHELLE WILLIAMS
(England, London b.1979 / act: London)
168

Sunday Afternoon
ct: Artist
ex: 'Bloomberg New Contemporaries'
Camden Arts Centre, London

PER WIZÈN
(Sweden, Norrköping b.1966 / act: Sweden, Malmö)
128

Untitled: Figure Undressing by Piero della Francesca, Reclining Body after Carel Fabritius, Bed and Background by Caravaggio, Vermeer, Ingres and Giorgione
ct: Artist

RICHARD WOODS
(England, Cheshire b.1966 / act: London)
81

Tabley House
ct: Modern Art, London

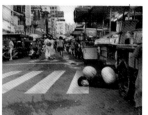

ERWIN WURM
(Carinthia, Spittal an der Drau b.1955 / act: Austria, Vienna)
93 .

Taipei Outdoor Sculpture
ct: Art:Concept, Paris

HIRO YAMAGATA
(Japan b.1948 / act: Los Angeles)
221

NGC6093
ex: Ace Gallery / ct: Ace Gallery, New York

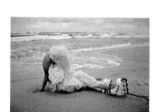

VITA ZAMAN
(Lithuania b.?)
68

Leisure: Girl
ct: Danielle Arnaud Contemporary Art, London

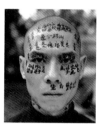

ZHANG HUAN
(China b.1965)
196

Family Tree
ct: Luhring Augustine, New York

ZHANG WANG
(China b.1962)
261

Ornamental Rock
ct: Hanart:TZ Gallery, Hong Kong

ZAVOD PROJEKT ATOL
(Slovenija b ?)
245

Makrolab Mark II, Rottnest Island, Australia
ct: Zavod Projekt Atol, Ljubljana, Slovenija

Numbers refer to the illustrations

ct:	courtesy
cl:	collection
ph:	photography
wk:	work
in:	installed
pf:	performance
pr:	provenance
dr:	director
ac:	actor
ed:	editor
ms:	music
pc:	private collection
ex:	exhibition

Chapter openers

Page 07 Martin Puryear, *Untitled* (detail)
Page 27 Tim Noble and Sue Webster, *The New Barbarians* (detail)
Page 49 Takashi Murakami, *Hiripon* (detail)
Page 77 Keith Cottingham, *Fictitious Portrait: Double* (detail)
Page 109 Liu Dahong, *Sacrificial Altar* (detail)
Page 163 Andres Serrano, *A History of Sex: Antonio and Ulrike* (detail)
Page 185 Zhang Huan, *Family Tree 2001* (detail)
Page 217 Iris Schieferstein, *Life Can Be So Nice: Life* (detail)
Page 247 Ravinder Reddy, *Untitled* (detail)